Canon EOS 7D

Michael Guncheon

MAGIC LANTERN GUIDES®

Canon
EOS 7D

Michael Guncheon

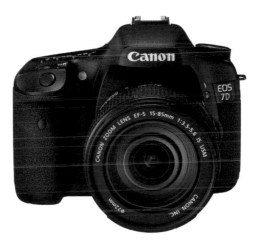

LARK
PHOTOGRAPHY
BOOKS

A Division of Sterling Publishing Co., Inc.
New York / London

Editor: Kevin Kopp
Book Design: Michael Robertson
Cover Design: Thom Gaines

Library of Congress Cataloging-in-Publication Data

Guncheon, Michael A., 1959-
 Canon EOS 7D / Michael A. Guncheon.
 p. cm. -- (Magic lantern guides)
 ISBN 978-1-60059-664-3
 1. Canon digital cameras--Handbooks, manuals, etc. 2. Photography--Handbooks, manuals, etc. 3.
Single lens reflex cameras--Handbooks, manuals, etc. 4. Photography--Digital techniques--Handbooks,
manuals, etc. I. Title.
 TR263.C3G954 2010
 771.3'3--dc22
 2009048968
10 9 8 7 6 5 4 3 2

Published by Lark Books, A Division of
Sterling Publishing Co., Inc.
387 Park Avenue South, New York, N.Y. 10016

Text © 2010, Michael A. Guncheon
Photography © 2010, Michael A. Guncheon unless otherwise specified

Distributed in Canada by Sterling Publishing,
c/o Canadian Manda Group, 165 Dufferin Street
Toronto, Ontario, Canada M6K 3H6

Distributed in the United Kingdom by GMC Distribution Services,
Castle Place, 166 High Street, Lewes, East Sussex, England BN7 1XU

Distributed in Australia by Capricorn Link (Australia) Pty Ltd.,
P.O. Box 704, Windsor, NSW 2756 Australia

This book is not sponsored by Canon.

If you have questions or comments about this book, please contact:
Lark Books
67 Broadway
Asheville, NC 28801
(828) 253-0467

Manufactured in Canada

ISBN 13: 978-1-60059-664-3

For information about custom editions, special sales, premium and corporate purchases, please
contact Sterling Special Sales Department at 800-805-5489 or specialsales@sterlingpub.com.

For information about desk and examination copies available to college and university professors,
requests must be submitted to academic@larkbooks.com. Our complete policy can be found at
www.larkbooks.com.

Contents

Introducing the Canon EOS 7D

Canon started a new revolution in digital photography when it introduced the 5D Mark II camera in September 2008, bringing high-quality, High-Definition (HD) video to a digital SLR (D-SLR). Soon, Canon brought video to their Rebel line with the T1i. Now the company has answered the needs of photographers who are looking for many of the performance characteristics of the 5D Mark II, but who don't need a 35mm-frame sensor or its cost: the Canon EOS 7D, made available in September 2009.

The EOS 7D offers quick start-up, fast memory card writing speeds, and other dedicated controls that match the performance of many top pro cameras. The chassis is constructed using magnesium, which is both lightweight and extremely rigid, allowing the camera able to stand up to years of use. The body consists of a specially engineered polycarbonate. While more expensive to manufacture, this again helps create a lightweight, yet strong, unit. The exterior of the camera is ergonomically designed and textured to provide for a solid grip.

© Canon Inc.

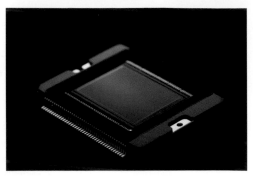

The 7D's body measures only 5.8 x 4.4 x 2.9 inches (148.2 x 110.7 x 73.5 mm), and weighs just 28.9 ounces (820 g) without a lens. Yet the EOS 7D offers a newly developed 18 megapixel (MP) image sensor, as well as additional features and a high degree of technological sophistication at an affordable price. In many ways, it sets the bar for all other D-SLRs in this price range.

The new sensor incorporates improved circuitry and an advanced color filter that increases sensitivity and improves color fidelity. A key feature of this new CMOS sensor is low power consumption, enabling you to record HD video through the Live View shooting feature.

At the heart of the image processing circuitry are two Digital Image Core 4 (DIGIC 4) processors. These special chips are the latest in a long line of Canon-designed processors. By doubling the image processors, Canon has boosted the EOS 7D's continuous shooting speed to eight frames per second with bursts of up to 126 JPEGs or 15 RAW images when used with an appropriate memory card. The DIGIC 4 processors are not just about shooting speed; they provide fast image processing, improved light sensitivity, and low image noise.

Canon has used its EF-S lens mount for this camera. Introduced with the original Digital Rebel (EOS 300D), this mount accepts all standard Canon EF lenses. In addition, it accepts compact EF-S lenses, built specifically for small-format sensors. EF-S lenses can only be used on cameras designed expressly to accept them.

One of the biggest changes to the 7D compared to other EOS cameras is the new 19-point autofocus system. This system, designed for the 7D, offers rapid and accurate focus comparable to cameras costing two and three times as much.

OVERVIEW OF FEATURES

There are a number of exciting and useful features in the EOS 7D that will help you have a great photographic experience. Before we get into a detailed look at the functions and operations, let's take a quick look at some of the highlights offered in the 7D:

O New Canon-designed and built 18MP, APS-C-sized CMOS sensor.

O High-Definition video recording with full manual exposure control. 1920 x 1080 resolution at 30, 25, and 24 frames per second (fps) progressive recording; 1280 x 720 at 60 and 50 fps (progressive) recording; and standard definition 640 x 480 at 60 and 50 fps (progressive) recording, all with audio.

O Two DIGIC 4 image processors for high-speed, low-noise performance.

O New Clear View II LCD monitor, a large, bright, and sharp three inch (7.6 cm) high-resolution color display with anti-reflective and scratch-resistant coatings, and automatic brightness control.

O Shoots eight fps and up to 94 frames consecutively at maximum JPEG resolution (15 frames continuously in RAW and six shots RAW+JPEG). Supports UDMA Compact Flash (CF) cards for a maximum burst of 126 frames JPEG.

O ISO range of 100 – 6400 extendable to 100 – 12800.

O Live View shooting mode with Face Detection AF.

O Integrated sensor cleaning system and Dust Delete Data system.

O Six preset and three User-defined custom Picture Style settings.

O High-speed focal plane shutter—up to 1/8000 second— with flash sync up to 1/250 second and rated for 150,000 cycles.

O Entirely re-designed 19-point autofocus system with improved focus tracking, and new AF point selection modes including AF point expansion, zone AF and spot AF.

O New focus technologies, including intelligent Macro AF and Light Source detection AF.

O New multi-layer 63-zone intelligent Focus Color Luminance (iFCL) metering system that is tightly integrated with the new 19-point AF system to achieve unprecedented metering accuracy.

O The first EOS camera with a 100% display of image with 1x magnification.

O New intelligent viewfinder display with transparent LCD overlay (rather than fixed indicators) that can be adjusted or hidden completely.

O New Dual Axis electronic level and tilt system that can be displayed in the viewfinder or the LCD monitor.

○ Quick Control screen that provides fast access to camera settings without going into menus.

○ User-activated noise subtraction for long exposures.

○ High ISO noise reduction.

○ Auto Lighting Optimizer for automatic adjustment of scene brightness and contrast.

○ Lens peripheral illumination correction for automatic compensation of light fall-off at the corners of the image.

○ New Custom Control interface to rearrange and redefine many of the 7D buttons for particular shooting styles.

○ The first EOS camera with a built-in flash that can act as a master controller for wireless Speedlite control.

○ Wireless shooting with optional WFT-EFA. Allows for Wi-Fi transfer of images and master control of up to ten WFT-equipped 7Ds for simultaneous shooting.

○ Battery memory system for management of up to six batteries for optimum battery performance.

GETTING STARTED IN TEN BASIC STEPS

Here are ten steps that will make it easier to record good photos with your 7D. You will probably modify them with experience.

1. Adjust the eyepiece: Use the dioptric adjustment knob to the right of the viewfinder to make the focus through your eyepiece as sharp as possible. You can adjust it with a fingertip. (See page 51.)

2. Set **[Auto power off]** for a reasonable time: The default duration in the Set-up 1 menu ♥˙ is merely 30 seconds. I guarantee this will frustrate you when the camera has turned itself off just as you are ready to shoot. Perhaps it is more realistic to try **[4 min.]**. (See page 103.)

3. Choose a large file size (L for JPEG, or RAW): This determines your image recording quality. Select Shooting 1 menu ◘˙, then press ◉ and use Quick Control dial ○ to select your desired image size (see page 87). You are usually best served by choosing one of the high-quality options.

4. Set your preferred shooting mode: Use the Mode dial on the top left shoulder of the camera to select any of the exposure shooting modes (see pages 132 – 140) or fully-automatic modes (see page 130). If using any of the exposure modes, select a Picture Style. (see pages 60 – 65).

5. Choose AF mode: Autofocus (AF) mode is set by pressing the AF·DRIVE button. The LCD monitor then displays several AF mode options. The selected mode displays in the camera settings on the LCD. Use the Main dial 🔄 to select AF mode. A good place to start on this camera is AI Servo AF. (See page 148.)

6. Select drive mode: Drive mode is selected by pressing AF·DRIVE. Select either Single shooting □, High-speed continuous shooting 🔲H, Low-speed continuous shooting 🔲, Self-timer:10sec 🕐, or Self-timer:2sec/Remote control 🕐2. (See pages 142 – 144.) The LCD indicates the mode the camera is in. Depending on the shooting mode, not all drive modes will be available.

7. Choose metering mode: Metering mode is set via the ⊛·WB button. Use 🔄 to select the metering mode as displayed on the LCD panel. Choose from four different metering modes: evaluative ⊛, partial ◪, spot ⊡, or center-weighted average ⊏⊐. Press ⊛ or tap the shutter release button to confirm. ⊛ is a good starting point. (See page 161.)

8. Select white balance: Auto white balance **AWB** is a good place to start because the EOS 7D is designed to generally do well with it. To set, press ⊛·WB. (See page 69.) The different white balance choices display on the monitor; use ○ to select one. After making your choice, the selected white balance appears in the camera settings display on the LCD.

9. Pick an ISO setting: Though any setting between 100 and 400 works extremely well, you can generally set higher ISO sensitivity (with less noticeable noise) with the EOS 7D than with other digital cameras. (See pages 158 – 160.) Press the ISO·⊞ button, located immediately behind 🔄. The LCD monitor displays a range of ISO speeds to choose from. Use 🔄 to select. You can even change ISO without having to take your eyes away from the viewfinder. When you press the ISO button the information display in the bottom of the viewfinder shows the current ISO setting. Use 🔄 to rotate through the ISO choices.

10. Set a reasonable review time: The default review time on the LCD monitor is only two seconds. That's very little time to analyze your photos, so I recommend the eight-second setting, which you can always cancel by pressing the shutter button. If you are worried about using too much battery power, just turn off the review function altogether. Review time is set in ◘˙. (See page 89.)

CONVENTIONS USED IN THIS BOOK

When the terms "right" and "left" are used to denote placement of buttons, features, or to describe camera techniques, it is assumed that the camera is being held in the shooting position, unless otherwise specified.

Pixel counts on image sensors are always approximate. The EOS 7D has approximately 17.90 million pixels, but is considered an 18 megapixel camera.

When describing the functionality of the EOS 7D, it is assumed that the camera is being used with genuine Canon accessories, such as Speedlites, lenses, and batteries.

Custom Functions are indicated by the Canon nomenclature of C.Fn, followed by the group number (which is indicated by roman numerals), and then by the Custom Function number. For example, C.Fn II-3 is the Highlight tone priority Custom Function, the third item located in group two.

We are now ready to explore the features, functions, and attributes of the Canon EOS 7D in detail. Before we go any further, let me first acknowledge that this book would be impossible to write without the help of many people. Thank you to Rudy Winston, Chuck Westfall, and Kevin McCarthy at Canon. I would also like to thank the gang at Lark Books for all of their support, especially Haley Pritchard, Kevin Kopp, Kara Arndt, and Marti Saltzman. And finally, a great deal of the accuracy of this book is made possible by my wife, Carol.

Getting Started

PREPARING THE CAMERA

The Canon EOS 7D is a sophisticated piece of equipment. With proper setup, good handling practices, and careful maintenance, this technology can help take your photography to the next level. There are several things you'll want to take care of before you get into the shooting functions and start recording.

DATE/TIME

Date and time are established by going to the Set up 2 menu ♥². Use ○ to select [Date/Time]. Press ⊛ to enter the adjustment mode. Once there, use ○ to step through each parameter on the screen. When you are on a setting, press ⊛ to enter the adjustment mode and use ○ to adjust the value. Press ⊛ again to accept the setting. Continue using ○ and ⊛ to adjust the date, time, and/or to format the date/time display. Once the date and time are correct, use ○ to highlight [OK], then press ⊛ again to confirm your selections and exit the adjustment mode.

> **TIP:** When traveling, keep your camera set to local time. This will help you if you need to figure out when a picture was taken. If the time zone change is great and you don't change to local time, your image's time/date might make you think the picture was taken the day before or after you actually took it.

A special battery located inside the battery compartment holds the date and time in memory even when you remove the LP-E6 battery. This date/time battery has a life of about five years. If you notice that the 7D loses date and time when you change the LP-E6, then the date/time battery needs to be replaced. The battery is a CR-1616 lithium button-style battery and is fairly easily installed once the LP-E6 is removed from the battery compartment.

BATTERIES

Canon has included a high-performance battery for the 7D. At 1800mAh in capacity, the lithium ion LP-E6 battery is a great improvement over previous Canon batteries. Milliamp hours (mAh) indicate a battery's capacity to hold a charge. Higher mAh numbers mean longer-lasting batteries.

Although the camera is designed for efficient use of battery power, it is important to understand that power consumption is highly dependent on how long features such as flash, autofocus, the LCD, Live View, and video recording are used. The more the camera is active, the shorter the battery life, especially with regard to use of the LCD, built-in flash, Live View, and video recording. Be sure to have backup batteries. And it is always a good idea to shut the camera off if you are not using it.

> Canon's LP-E6 battery allows the 7D to keep track of its charge level.

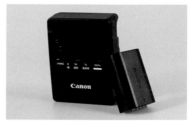

Canon estimates that at 73°F (23°C), the battery will last approximately 1,000 shots when flash is not used (or 800 shots with 50% flash usage). Lower temperatures reduce the number of shots. In addition, it is never wise to expose your camera or its accessories to heat or direct sunlight (i.e., don't leave the camera sitting in your car on a hot or a cold day!).

When you use the Live View feature, the number of shots drops to 230, or 220 shots with 50% flash usage. The approximate length of time you can shoot continuously with Live View is one hour and 30 minutes at 73°F (23°C) with a fully charged battery. When shooting video, the battery lasts approximately one hour and 20 minutes at 73°F (23°C).

I recommend that you have one or two extra batteries, particularly when you travel. This way one battery can be on the charger, one in the camera, and one in your pocket. For safety, when the battery is not on the charger or in the camera, be sure to use the battery cover that came with the battery. If you don't use the cover, the contacts could short and lead to damage to the battery, or even a fire—not something you want to happen in your pocket!

‹ The blue that shows through the rectangle in the battery cover can be used to indicate a fully-charged battery.

The battery cover can act as a good reminder of whether or not a battery is charged. There is a small rectangular opening that reveals either the blue portion of the battery label or the dark gray portion. I place the cover so the blue portion shows on all of my batteries that are charged and ready to go.

NOTE: Refer to the menu chapter (page 84) to see how the 7D can use ♥ to keep track of the charge levels and performance of all of your batteries.

The LP-E6 is rated at 7.2 volts and it takes about two and a half hours to fully charge on the LC-E6 charger included with the camera. Rechargeable batteries lose a bit of charge every day, but this doesn't mean you should leave the battery on the charger all the time. Get in the habit of just charging your battery the day you need it, or possibly the day before.

CAUTION: Never operate the 7D with very low battery power (the battery icon is blinking). If the 7D is writing to the memory card and the battery runs out of power, it could corrupt the directory on the CompactFlash card and possibly cause you to lose all the pictures on the card.

The charger has a built-in voltage and frequency converter, so it is not necessary to use a transformer when you travel—the charger handles voltages from 100 – 240 and 50 – 60 hertz frequencies. You will, however, need an adapter to change the physical layout of the plug, depending on the country you travel to.

An optional battery grip, BG-E6, attaches to the bottom of the camera and can be used with one or two LP-E6 batteries. If two batteries are loaded, power is initially drawn from the battery having the higher voltage. Once the voltage level of the two batteries is the same, power is drawn from both packs. When used, the BG-E6 replaces the internal battery of the 7D. The grip also has an adapter, BGM-E6, which allows six AA-size batteries to be used.

A nice feature of the battery grip is that it duplicates several controls on the camera so that they are just as easily accessed whether the camera is being held vertically or horizontally. The duplicated controls include a shutter button, AE lock button ✳, power switch, Main dial ⌒, **AF-ON**, and AF point selection button ⊞/🔍.

› The BG-E6 battery grip greatly extends the amount of time you can shoot with the 7D, and allows you to easily use a number of the camera's controls.

The AC adapter kit (ACK-E6) is useful to those who need the camera to remain consistently powered up (e.g., for scientific lab work, in-studio use, and lengthy video shooting). You can charge the battery in the car using the CBC-E6 12v charger.

> **NOTE:** There are a few limitations if you use AA batteries with the grip. The 7D will not let you perform a manual cleaning of the image sensor. The battery indicator may show that there is no (or little) power left in the batteries

MEMORY CARDS

The Canon EOS 7D uses CompactFlash (CF) memory cards. You will need sizeable cards to handle this camera's image files; anything less than 1GB will fill up too quickly, particularly if you shoot RAW+JPEG. Memory cards are sturdy, durable, and difficult to damage. One thing they don't like is heat, so make sure you store them properly.

‹ You will want a high-capacity CF card for use with the 7D's 18MP sensor.
© SanDisk Corporation.

> **NOTE:** Memory cards are not affected by current airport screening systems.

The 7D is designed to support CF cards with Ultra Direct Memory Access or UDMA. UDMA is an improved way of accessing (reading and writing) the data on the card. UDMA is specified in terms of speed rating and modes. The modes range from 0 – 6. Mode zero is about 16 million bytes per second (MB/sec), and Mode 6 is about 133MB/sec. These are theoretical speeds, but modes aren't a speed rating (there is a separate figure for that; just because a card is UDMA 6 doesn't necessarily mean it is rated at 133MB/sec.) In order to achieve the maximum burst speed and continuous shooting performance specified for the 7D, you'll want to use UDMA (Mode 6) CF cards with fast write speeds—the faster the better.

UDMA-capable slots, including the one in the EOS 7D, have no problem using regular CF cards. (You just won't get the speed performance of UDMA.) But when you use UDMA cards, make sure you also use a UDMA reader so you get the speed advantage when downloading images to your computer.

To remove the memory card from your camera, simply open the card slot cover on the right side of the body. Press the small gray release button below the card to release the card from the camera. Carefully grab the edge of the card to remove it.

> The CF card loads beneath a latched door on the right side of the camera.

CAUTION: Before removing the memory card, it is a good idea to turn the camera off. Even though the EOS 7D automatically shuts itself off when the memory card door is opened, make sure the access lamp on the back of the camera near the bottom right is not illuminated or flashing. This habit of turning the camera off allows the camera to finish writing to the card. If you should open the card doorslot and remove the card before the camera has written a set of files to it, there is a good possibility you will corrupt the directory or damage the card. You may lose not only the image being recorded, but also potentially all of the images on the card.

FORMATTING YOUR MEMORY CARD

Before you use a memory card in your camera, it must be formatted specifically for the EOS 7D. To do so, go to ❤ and then use ○ to highlight **[Format]**. Press ⊛ and the Format menu appears on the LCD. It tells you how much of the card is presently filled with images and how big the card is. Use ○ to move the choice to **[OK]**, press ⊛, and formatting begins. You will see a screen showing the progress.

CAUTION: Formatting your memory card erases all images and information that has been stored, including protected images. Be sure that you do not need to save anything on the card before you format. (Transfer important images to a computer or another downloading device before formatting the card.)

∧ Format your memory card every time you go out to shoot a new batch of images. This will help avoid corrupted image files. Just make sure you have downloaded all previous pictures that you want to keep. © Kevin Kopp

It is important to routinely format a memory card to keep its data structure organized. However, never format the card in a computer. A computer uses different file structures than a digital camera and may either make the card unreadable for the camera or may cause problems with your images. For trouble-free operation, always format your card rather than erasing all the images.

NOTE: My experience is that if memory cards are going to fail, they usually fail right at first use or in the first few days of use. Always test a new card by formatting it, taking many pictures and/or recording video, and then downloading the images and video to a computer. Resist the temptation to buy a new card and pop it, unopened, in your camera bag at the start of a long trip. Open it up and test it to make sure it works.

RESETTING CONTROLS

The EOS 7D's menu system and Quick Control screen provide many opportunities to fine-tune and customize its many settings. If at some point you want to reset everything, you can restore the camera to its original default settings by going to the Setup 3 menu ❤️ and selecting **[Clear settings]**, then pressing ⑱. You can clear all camera settings, copyright data, or just the Custom Function settings. Also in menu ❤️, you can check which version of firmware (the software that runs the camera) the camera uses.

CLEANING THE CAMERA

A clean camera minimizes the amount of dirt or dust that can reach the sensor. A good kit of cleaning materials should include the following: A soft camel hair brush to clean off the camera, an antistatic brush and micro-fiber cloth for cleaning the lens, a lint-free towel or chamois for drying the camera in damp conditions, and a small rubber bulb to blow debris off the lens and the camera.

Always blow and brush debris from the camera before rubbing it with any cloth. For lens cleaning, blow and brush first, then clean with a micro-fiber cloth. If you find there is residue on the lens that is hard to remove, you can use lens-cleaning fluid, but be sure it is made for camera lenses. Never apply the fluid directly to the lens, as it can seep behind the lens elements and get inside the body of the lens. Apply with a cotton swab, or just spray the edge of your micro-fiber cloth. Rub gently to remove the dirt, and then buff the lens with a dry part of the cloth, which you can wash in the washing machine when it gets dirty.

TIP: If your lens came with a lens shade, always use it. If your lens didn't come with one, buy a properly sized one. There is no better protection for your lens than a lens shade.

You don't need to be obsessive, but remember that a clean camera and lens help ensure that you don't develop image problems. Dirt and residue on the camera can get inside when changing lenses. If these end up on the sensor, you will have image problems. Dust on the sensor appears as small, dark, out-of-focus spots in the photo (most noticeable in light areas, such as sky).

You can minimize problems with sensor dust if you turn the camera off when changing lenses (preventing a dust-attracting static charge from building up). Keep a body cap on the camera and lens caps on lenses when not in use. You should regularly vacuum your camera bag so that dust and dirt aren't stored with the camera.

Lastly, watch where you put the lens cap when you take it off your lens. Placing it in a linty pocket is a good way to introduce dust onto your lenses.

AUTOMATIC SENSOR CLEANING

The 7D has a built-in system to combat the dust that is inherent with cameras that use removable lenses. This system uses a two-pronged approach: (1) The camera self-cleans to remove dust from the sensor, and (2) it employs a dust detection system to remove dust artifacts from images using software on your computer.

The low-pass filter in front of the sensor is attached to a piezoelectric element that rapidly vibrates at camera power-up and power-down. While self-cleaning at power-up just before taking pictures seems like an obvious time to clean the sensor, why clean it at power-down? Cleaning at power-down prevents dust from sticking to the sensor when the camera sits for long periods of time.

< Sensor cleaning technology has made it much easier than it was a couple of years ago to avoid dust accumulation on D-SLR sensors.

Self-cleaning can be enabled and disabled under ♥². Use ○ to highlight [Sensor cleaning] and press ⊕. In the Sensor cleaning submenu, select [Auto cleaning ⊡] and press ⊕. From there you can choose to enable or disable self-cleaning, then press ⊕ to accept your selection. You can also engage the self-cleaning function immediately ([Clean now ⊡]) or start the manual sensor cleaning procedure (see page 31).

NOTE: In order to prevent overheating, the self-cleaning operation cannot be engaged within three seconds of any other operation. It also stops working if it is run five times within ten seconds. After a brief delay (usually ten seconds) it will be available for use.

In the event that there is still dust on the sensor, the EOS 7D's Dust Delete Data feature can be used. By photographing an out-of-focus, patternless, solid white object (such as a white sheet of paper), the image sensor is able to detect the shadow cast by dust stuck to the low-pass filter. Coordinates of the dust are embedded in the image metadata. Canon's Digital Photo Professional (supplied with the 7D) can use this data to automatically remove the dust spots in the image.

To store the Dust Delete Data in the 7D:

1. Set up a well-lit white card.
2. Use a lens with a 50mm focal length or greater.
3. Set the lens for manual focus (MF).
4. Set the lens focus to infinity ∞. If the focus scale is not printed on the lens, turn the focus ring clockwise while viewing the lens from the front of the camera.
5. In ◘▪, select **[Dust Delete Data]** and press ⊕. Highlight **[OK]** and press ⊕.
6. The 7D will execute an auto cleaning cycle and then ask you to press the shutter when ready.
7. Compose the frame so that the white card entirely fills the frame and press the shutter. If the camera is not able to capture the data properly it will ask you to try again. If the camera is new, there may be no dust on the sensor and the process will fail.

To use the Dust Delete Data function, open the image in Canon's Digital Photo Professional software. In the Adjustment menu, choose Apply Dust Delete Data. The software will attempt to repair the dust spots in the image.

NOTE: The Dust Delete Data can only be used by Canon software.

MANUAL SENSOR CLEANING

The EOS 7D allows you to clean the sensor, but there are precautions to be taken. You must do this carefully and gently, indoors and out of the wind—and at your own risk! Your battery must be fully charged so it doesn't fail during cleaning (or you can use the optional AC adapter). The sensor unit is a precision optical device, so if the gentle cleaning described below doesn't work, you should send the camera to a Canon Service Center for a thorough cleaning.

To clean the sensor, turn the camera on and go to ♈. Using ○, highlight [Sensor cleaning] and press ⑤. Use ○ in the Sensor cleaning submenu to highlight [Clean manually] and press ⑤, then follow the instructions. You'll see options for [OK] and [Cancel]. Using ○, select [OK] and press ⑤. The LCD turns off, the mirror locks up, and the shutter opens. Take the lens off. Then, holding the camera face down, use a blower to gently blow any dust or other debris off the bottom of the lens opening first, and then blow off the sensor. Do not use brushes or compressed air because these can damage the sensor's surface. Turn the camera off when done. The mirror and shutter will return to normal. Put the lens back on.

> **CAUT**ION: Canon specifically recommends against any cleaning techniques or devices that touch the surface of the imaging sensor. If manual cleaning doesn't work, contact a Canon Service Center for cleaning.

Never leave a D-SLR without a body cap for any length of time. Lenses should be capped when not in use and rear caps should always be used when a lens is not mounted. Also, make sure you turn off the camera when you change lenses. These practices help to prevent dust from reaching the sensor.

Controls and Functions

It is easy to be overwhelmed by the variety of controls when you first take a look at the 7D. You may find there are some that you do not need or will not use. This book explains all the features on the EOS 7D, and helps you master those that are most important to you. Don't feel guilty if you don't use every option packed into the camera. Learn the basic controls, then explore any additional features that work for you. You can always delve further into this book and work to develop your EOS 7D techniques and skills at some point in the future. But remember: the best time to learn about a feature is before you need it—you can't "waste film" with digital cameras. So shoot as much as you want, and then erase those images that don't work.

OVERVIEW

The EOS 7D uses icons that are common to all Canon cameras to identify various buttons, dials, and switches found on the camera. The EOS 7D often uses two controls to manage the most common and important functions.

MODE DIAL

Located on the top left shoulder of the camera, the Mode dial is used to select the 7D's shooting mode. It is useful to think of this control as having three sections as outlined below.

> **NOTE:** For more complete information about the functions found on the Mode dial, see pages 130 – 140 in the chapter entitled Shooting and Drive Modes.

> Use the Mode dial to set the different shooting modes available on the 7D.

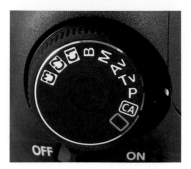

Fully-Automatic: The first section on the Mode dial is the automatic section, which contains two settings: Full Auto □ and Creative Auto ⓒⒶ. When set to □, the only shooting adjustments you can make are to select a particular image quality recording (a combination of pixel count, which is resolution; and quality, also known as level of compression) and to determine whether you want to use the self-timer. This is a useful mode if you hand the camera to someone else to take a picture. Very few buttons will operate so they can't accidentally put the camera into the "wrong" mode.

With ⓒⒶ, you are given access to a few more settings, including Picture Styles and continuous drive modes. This mode also gives access to two easy-to-use exposure adjustments available through the Quick Control button (ⓠ): Background and Exposure

> The Creative Auto mode gives you a bit more control than the Full Auto mode, including sliders to adjust background sharpness and overall image brightness.

Exposure Shooting Modes: Canon doesn't use a specific term to describe the next group of settings on the Mode dial, but an appropriate name might be "exposure," because these modes only affect exposure settings (in contrast to the fully-automatic selections, which control such functions as white balance, focus, etc., in addition to the exposure settings). The five modes in this section are common on every SLR, whether a film-type

or digital camera, from Canon or another manufacturer. While the icons or acronyms may be slightly different among the various cameras, they all perform the same duties. The five choices on the 7D are Program AE (**P**), Shutter-Priority AE (**Tv**), Aperture-Priority AE (**Av**), Manual exposure (**M**), and Bulb (**B**).

Camera User Settings: This last Mode dial section allows you to recall stored camera settings from three different memories. They are labeled **C1**, **C2**, and **C3**.

MAIN DIAL

Located behind the shutter button on the top right of the camera, allows you to use your shooting finger to set exposure as well as other functions. works alone when setting shutter speed and aperture. For a number of other adjustments, it works in conjunction with buttons that are pressed and released, or that are held down while is turned.

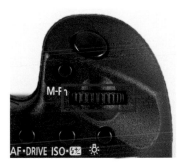

‹ The Main dial is conveniently positioned behind the shutter release button. This makes it easy to control with your index finger.

SHUTTER BUTTON

The EOS 7D features a soft-touch electromagnetic shutter release. When you partially depress the shutter button, you activate such functions as autoexposure and autofocus. But this camera is fast enough that there is minimal speed advantage in pressing the button halfway before exposure. It does help, however, when you are dealing with moving subjects, to start autofocusing early, so the camera and lens then have time to find your subject.

M-Fn *MULTI-FUNCTION BUTTON*

This button, found on the top right front of the camera, between the shutter button and ⌂, is aptly named. When the camera is in AF selection mode, this control is used to change the AF area selection mode between single-point AF, Zone AF, and 19-point AF. When you use flash, the **M-Fn** button is used for flash exposure lock (FEL). This button can also be programmed to set autoexposure lock (AE lock), to turn on RAW+JPEG shooting, or to activate the two-axis level indicator in the viewfinder.

⊡·WB *METERING MODE SELECTION/*
WHITE BALANCE SELECTION BUTTON

The ⊡·WB button is located behind the Main dial ⌂. When ⊡·WB is pressed, use ⌂ to select from four different metering modes: evaluative ⊡, partial ⊡, spot ⊡, and center-weighted average ⊡. (See pages 160 – 163 to learn more about metering in the EOS 7D.) To adjust white balance, press ⊡·WB and use ○ to select one of nine white balance options. (See pages 67 – 72 for information about choosing the right white balance setting.)

During adjustment, you can view the settings on the LCD panel on the top of the camera or on the LCD monitor on the back of the camera. This button does not work when the camera is in □ or ⒸⒶ.

AF·DRIVE *AF MODE SELECTION/*
DRIVE MODE SELECTION BUTTON

The AF·DRIVE selection button is located behind ⌂ and immediately to the right of ⊡·WB. To select an AF (autofocus) mode, make sure your lens is in AF mode and press AF·DRIVE. Use ⌂ to choose from **ONE SHOT**, **AI FOCUS**, and **AI SERVO**. When the camera is in □ or ⒸⒶ, AF mode is locked to **AI FOCUS** mode. (See pages 148 – 150 for more information about autofocus.)

The drive mode is set by first pressing AF·DRIVE, and adjusted using ○ to select from Single shooting (□), High-speed continuous (⎐H), Low-speed continuous (⎐), or Self-timer (10 sec./Remote control ⌖), and 2 sec/Remote control (⌖₂). The drive options are more limited while the EOS 7D is in one of its two fully-automatic shooting modes. (See pages 142 – 144 for more information on drive modes.)

^ Increase you chances of getting a shot at the peak moment of action by using High-speed continuous drive mode. © Kevin Kopp

> **NOTE:** When you shoot with your eye away from the eyepiece (e.g. timer mode), stray light entering the viewfinder can cause inaccurate exposure metering. Canon supplies a viewfinder cover located on the camera strap. It is necessary to remove the rubber eyecup on the viewfinder to attach the cover.

ISO·⚡ *ISO SPEED SETTING/ FLASH EXPOSURE COMPENSATION BUTTON*

The ISO·⚡ button is located behind 🔘 to the right of AF·DRIVE. After pressing ISO·⚡, use 🔘 to adjust ISO speed. The range varies depending on how you have set C.Fn I-3 (ISO Expansion). Normally it ranges from 100 – 6400 and also has an Auto mode. With ISO Expansion enabled, the ISO range is 100 – 12800, including Auto. The highest ISO setting in this mode is labeled H and represents 12800.

To adjust flash exposure compensation ⚡, press ISO·⚡ and then use ◯ to override flash exposure in 1/3-stop increments. Increments can be changed to 1/2-stop in C.Fn I-1 (Exposure level increments). (Learn more about exposure compensation on page 164.) You have three places to look when adjusting either of these settings: the viewfinder, the LCD panel on the top of the camera, or the LCD monitor on the back of the camera.

When the EOS 7D is in ▢ or **CA**, this button does not function. The camera will be in ISO Auto and no flash exposure compensation is applied.

☀ LCD ILLUMINATION BUTTON

Located to the right of ISO·**⏣** and behind 🌣, this button illuminates the LCD panel on the top of the camera. The LCD panel will stay illuminated for six seconds. This button is also used when registering an AF point (see page 154).

⊞/🔍 AF POINT SELECTION/MAGNIFY BUTTON

The outside button on the back of the camera in the upper right corner is the ⊞/🔍 button. Press ⊞/🔍 to display the currently selected AF selection modes. There are three selection modes by default: Single-point AF, Zone AF, and 19-point AF auto select. You can also enable Spot AF and AF point expansion via C.Fn III-6 (Select AF area selection mode). Use M-Fn to select the mode. Once set, use either a combination of 🌣 and ○, or ✼ to select the AF points or zones. Learn more about AF on pages 150 – 154. When the EOS 7D is in ▢ or **CA** shooting modes, the camera is automatically set for 19-point AF auto select and ⊞/🔍 will not function, though in Playback mode it still magnifies images.

> Some buttons serve dual purposes and are designated by white and blue icons, with blue signifying functions you apply during Playback mode.

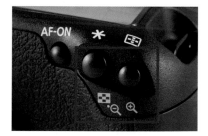

This button has a different purpose during Live View shooting. ⊞/🔍 can be used to magnify the focus frame. With the first press of ⊞/🔍, the display magnifies about 5x; a second press magnifies the display about 10x. The third press returns the display to normal view. This is a powerful tool. Even if you normally use the viewfinder for composition, turning on Live View shooting and using this focus checking method is a great option when you are facing difficult focusing situations.

The function of ▦/☌ changes when the EOS 7D is in Playback mode. During image playback, press ▦/☌ to magnify from 1.5 – 10x the original size. To move around the magnified image use the Multi-controller ⁙. Use the Playback button ▶ to return to an unmagnified display.

NOTE: You cannot magnify the image during Image Review (immediately after image capture). You can only magnify it during Playback.

This button is also used during direct camera printing to crop the image before printing. Press ▦/☌ to decrease the trimming frame (more of the image will be cropped) and use ⁙ to move the trimming frame around the image.

This button is duplicated on the optional BG-E7 battery grip to allow for easy access when you hold the camera in a vertical shooting position. (In this case, the corresponding button is in the same relative position as the one intended for horizontal shooting.) The vertical shooting version is only active when the vertical grip's on/off switch is In the on position.

✳/▦·☌ AE LOCK/INDEX/REDUCE BUTTON

To the left of ▦/☌ is the ✳/▦·☌ button. Press this and the EOS 7D locks the exposure at the current setting. Press ✳/▦·☌ again to re-lock the exposure setting if you reframe the shot and want to lock-in a new exposure.

The exposure that is locked depends on which metering mode is selected. With ⃞, ⊡, and ▣, the exposure lock uses the center AF point. With ▨, AE lock is set for the selected AF point, whether selected manually or by the camera. If the lens is in manual focus, the center focus point is used. ✳/▦·☌ will not function when the EOS 7D is in ☐ or ⒸⒶ shooting mode, though it will function to reduce magnification during Playback.

During Playback, press ✳/▦·☌ once to display a grid of four images (index display). Press ✳/▦·☌ again to display a nine-image grid. In both displays, a blue border surrounds the currently selected image. Use ◯ or ⁙ to move the blue highlight through the grid. Press ▦/☌ to return to single-image display from the four-image index display; press ▦/☌ twice to return to single-image display from the nine-image display.

During Playback, if the image has been magnified by pressing ⊞/🔍, use ✳/⊡·🔍 to reduce the magnification.

✳/⊡·🔍 is also used during direct camera printing to crop the image before printing. Press ✳/⊡·🔍 to increase the trimming frame (less of the image will be cropped), and use ⁜ to move the trimming frame around the image.

Again this button is duplicated on the optional BG-E7 battery grip to allow for easy access while holding the camera in a vertical shooting position. (In this case, the corresponding button is in the same relative position as the one intended for horizontal shooting.) The vertical shooting version is only active when the vertical grip's on/off switch is in the on position.

> When you use the exposure shooting modes, point your camera and lock exposure with the AE lock button, then reframe to compose, even as a vertical photo.

AF-ON *AF START BUTTON*

On the back of the camera to the left of ✱/▣·⊖ is the **AF-ON** button. When the lens is in AF mode, use **AF-ON** or press the shutter release button halfway to start autofocus. When the 7D is set for **ONE SHOT** AF, **AF-ON** is pressed, and the 7D has achieved focus, the camera beeps and a focus confirmation light ● appears in the lower right section of the viewfinder indicating that focus lock has been achieved. If the EOS 7D is unable to acquire proper focus lock, the indicator flashes and the camera doesn't beep.

NOTE: You will not be able to take a picture until focus has been confirmed.

When the camera is set for **AI SERVO** AF, press **AF-ON** or press the shutter release button halfway to initiate continuous focus tracking, starting with the center focus point (when in 19-point AF auto select) or with the manually selected AF point. Because focus is tracked continuously, ● will not light and the camera will not beep, even when focus has been achieved. **AF-ON** does not normally function when the EOS 7D is in ▢ or ⟨CA⟩ shooting modes, though it does function in Live View mode.

Since depressing the shutter release button halfway performs the same function as **AF-ON**, you might wonder when you would use **AF-ON**. Because the shutter release also starts the exposure evaluation, there may be instances when you want to lock focus differently than exposure. In this case you would first frame the scene for focus and press **AF-ON**, then reframe for exposure and press ✱/▣·⊖ to lock exposure, and, lastly, press the shutter to take the picture.

Because the autofocus sensors are located in the viewfinder area, the AF sensors are blocked when the EOS 7D is in Live Shooting mode. There are three additional options for autofocus: AFQuick, AFLive, and Face Detection AF ⌣ (see page 184). With all three, it is important that you continue to hold down **AF-ON** until the camera beeps and the autofocus is locked. Depending on which Live View AF mode you are in, the confirmation will be indicated either by the red AF point being displayed (AFQuick mode), by the Live View AF point turning green (AFLive mode), or by the face detection frame turning green (AF ⌣ mode).

NOTE: When recording video, the **AF-ON** button will not function when Live View AF mode is set for AF▣▣▣.

The **AF-ON** button is another one that is duplicated on the BG-E7 battery grip to allow for shooting while holding the camera in a vertical shooting position. The vertical shooting version is only active when the vertical grip's on/off switch is in the on position.

LIVE VIEW/MOVIE SHOOTING SWITCH

This switch surrounds the START/STOP button on the back of the camera to the right of the viewfinder, and sets the 7D to either Live View shooting (⬜) or Movie shooting mode (🎥). When this switch is set for ⬜, you still have to press START/STOP to turn on the Live View display. With Movie shooting, the display appears when the switch is set for Movie shooting. This switch also controls what is available in the last shooting menu.

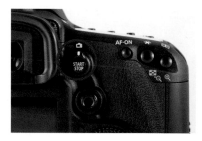

> Use the switch to the right of the viewfinder to activate Live View or Movie shooting.

START/STOP *START/STOP BUTTON*

Depending on whether you are recording in ⬜ or 🎥, this button, located on the back of the camera to the right of the viewfinder, either turns on the Live View display or starts video recording.

RAW/JPEG/🖨 *ONE-TOUCH RAW+JPEG/DIRECT PRINT BUTTON*

If you normally shoot using either JPEG or RAW recording quality, this button (located on the back of the camera to the left of the viewfinder) can be used to temporarily shoot both files. If you shoot JPEG, it is useful for those times when you may need the extra processing capability that RAW offers. If you shoot RAW, use this button when you know that you might have to quickly hand off a file to someone without going through the whole RAW processing workflow.

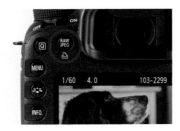

‹ Whether your selected file format is RAW or JPEG, you can toggle to record both at the same time using this button.

When the EOS 7D is connected to a printer, this button is used to quickly print the currently displayed image.

NOTE: Like ✳/❏·🔍 and ❏/🔍, this button has two labels, with the blue one indicating that the function is used during Playback.

⊡ QUICK CONTROL BUTTON
This control engages the Quick Control screen on the LCD monitor, a powerful feature that makes photographing with the 7D quick and easy. Find it on the back of the camera in the top left corner. Once the Quick Control screen is displayed, use ✤ to highlight each of the displayed shooting parameters. When a parameter is highlighted, use 🖮 to change the value that appears on the LCD monitor. The Quick Control screen is explained later in this chapter (see page 53).

MENU *BUTTON*
The Digital EOS 7D has several menus for use when capturing and viewing images, as well as for setting up the operation of the camera. This button, located near the top of a column of buttons to the left of the LCD monitor, is used to display any of the camera menus on the LCD monitor, and also to exit menus and submenus.

The menu structure consists of eleven menu tabs: four red Shooting menus dealing with image and movie capture; two blue Playback menus to control LCD display options, image transfer, and printing; three yellow Set-Up menus; a brown Custom Functions menu that allows you to customize many of the 7D's features; and a green My Menu that lets you build your own set of options. Once you have pressed MENU, navigate through the menu tabs by using 🖮, and use ◯ to navigate each menu option.

> The Menu button is near the top of a vertical column of buttons next to the LCD monitor.

If you are in ☐ or 🅒🅐, several menus and many menu items will not be available. If you can't find a menu item as you continue through this book, check to see if the camera is in one of the fully-automatic shooting modes.

NOTE: When adjusting settings in the menus, be sure to press 🅢🅔🅣, located in the center of the Quick Control dial ○, to accept (OK) the setting; otherwise the 7D reverts to the previous setting.

⚡ *PICTURE STYLE SELECTION BUTTON*

Located below MENU, the ⚡ button is a quick way to access the six built-in image effect settings (Picture Styles) and the three User-defined styles. Press ⚡ to display the list of Picture Styles, and then use either ○ or ⚙ to highlight the Picture Style you want to use. Press 🅢🅔🅣 or the shutter release button to accept the setting. Press INFO. to make modifications to the Picture Styles. You can also access Picture Styles with this button during Live View Shooting. This button does not function when the EOS 7D is in either ☐ or 🅒🅐 mode. However, you can access a limited number of Picture Styles when in 🅒🅐 via the Quick Control screen.

INFO. *BUTTON*

The first duty of INFO., which is located directly below ⚡, is to cycle through the various display modes during Image Review and Playback. The display modes include: Single image display, including aperture, shutter speed, and folder and file number; single image display with image size and quality, and current/total number of images captured; shooting information display with histogram and

extensive metadata about the image; and, lastly, a dual histogram display that shows the RGB and Brightness histograms, along with pared down shooting information. Press INFO. repeatedly to cycle through these four options.

When you are shooting, INFO. cycles through three different displays on the LCD monitor: a shooting functions display, a camera settings display, and the Electronic level. There is also a mode where the display is blank. The order is: shooting functions, blank, camera settings, and Electronic level. You can remove any of the three displays using the Set-up 3 menu (♥⋮), [INFO. button display options].

Using the LCD monitor, the shooting functions display duplicates information found on the LCD panel (on the top of the camera). This is useful when the EOS 7D is in a position where you are not able to see the top of the camera, but still want to see shooting settings like Drive mode, AF mode, or exposure settings.

The camera settings display covers items like Picture Style, color space, white balance shift or bracketing, and rotation settings, just to name a few. This is also the best place to check to see approximately how many more images can be stored on the memory card.

‹ The new Electronic level feature on the 7D can be invaluable for recording a straight horizon, or when taking a series of pictures to be stitched into a panorama.

The Electronic level is a new feature in EOS cameras, and it premieres in the 7D. This two-axis level allows you to level the camera horizontally and vertically. Each hash mark on the level represents 1° of tilt. The current tilt amount of the camera is indicated by a horizon line, which is divided into an inner horizon line (representing vertical tilt) and an outer horizon line (indicating horizontal tilt). When the camera is not level, the horizon lines are red. When they both turn green, the camera is level.

When the 7D is in Live View shooting mode, INFO. cycles through five displays, including a plain display, exposure display, controls display,

histogram, and Electronic level. During Movie shooting mode, the displays are similar, except there is no histogram display.

During direct camera-to-printer printing, press **INFO.** to change the trimming frame from horizontal to vertical orientation.

▶ PLAYBACK BUTTON

Located directly below **INFO.**, the ▶ button puts the camera into Playback mode and displays the last image captured. Press the button again to put the EOS 7D into shooting mode. You can also use the Playback button to exit from magnified playback of images. To play back video, first press ▶, then press ⓢ to start Playback.

NOTE: While Image Review and Playback appear the same on the LCD monitor, there are differences. Image Review occurs automatically after you take the picture; Playback occurs only after you press ▶. But probably the biggest difference is that you can't magnify the image during Image Review, only during Playback

🗑 ERASE BUTTON

Below ▶ is the 🗑 button, which is used to delete an image or video during either Image Review or Playback. When you press 🗑, you are given the choice to [Erase] or [Cancel]. Protected images can't be erased. You can select multiple images for deletion by first going to the Playback 1 menu ▣, [Erase images], scrolling through your images using ○ (or 🔄 to jump through images 10 at a time), then pressing ⓢ to select each image you want to delete. When all images have been selected, press 🗑 to delete the images.

You can also use 🗑 to lengthen the review time after image capture. If you normally work with a short review time, press 🗑 to keep the just-captured image on the LCD monitor until you press either the shutter release button or 🗑 (again) to cancel the delete function.

✣ MULTI-CONTROLLER

The ✣ is located on the back of the camera, below and to the right of the viewfinder. This control is similar to the mouse on a computer. You can move it in eight directions, and also push it in. Press the button in the center during AF selection to select the center AF point. You can also use ✣ to select other AF points, to adjust white balance settings, to move around a magnified playback image, or to move the focus frame when using Live View shooting. With practice, you can use this one control to navigate through the menu system, pressing up and down to cycle through the menu options and pressing left and right to move across the menu tabs.

‹ The Multi-controller, in combination with the Quick Control screen, offers quick access to many 7D settings.

✣ is also used to navigate the Quick Control screen. Press ⓠ to turn on the Quick Control screen. Use ✣ to select the setting you want to adjust. Use ◯ or 🔄 to change the setting. Press ⓠ or tap the shutter release button to exit the Quick Control screen.

◯ QUICK CONTROL DIAL

This is the large dial that surrounds ⊕ on the back of the camera. Think of this control as the scroll wheel on a mouse. When you press a button like ⊡·WB, use ◯ to scroll through the white balance settings. Other

‹ The Quick Control dial is designed to be operated by your right thumb. With practice, you can adjust exposure compensation without taking your eye away from the viewfinder.

buttons that work in conjunction with ○ include AF•DRIVE and ISO•🔆. From the time you press a button, you have six seconds in which to use ○ to adjust a setting before the camera returns to normal operation. You can also use ○ to scroll through menu and Custom Function options.

When you shoot, if the Quick Control dial switch (see below) is unlocked (◠), turning ○ adjusts exposure compensation if the camera is in **P**, **Tv**, or **Av** exposure shooting modes. If the camera is in **M** mode, ○ is used to set aperture.

Quick Control Dial Switch: Normally you would keep this switch in the unlocked position. However, if you want to lock down the dial so you don't accidentally change an exposure setting, change this setting to LOCK▶.

⊛ SET BUTTON
Centered within the ○ dial, this button is used to accept selection of menu options, as well as settings during other operations. It can also be programmed for other functions while in Shooting mode by using C.Fn IV-1. Possible functions include image Quality, Picture Style, menu display, image playback, and Quick Control screen.

DEPTH-OF-FIELD PREVIEW BUTTON
Located on the front left of the camera near the lens release button, the Depth-of-Field Preview button is used to stop down the lens to the current aperture setting. Although this darkens the image in the viewfinder, this button can be a good tool to check which elements in the scene are in focus. If you don't use this feature often, you can reprogram this button using C.Fn IV-1. Possible functions include AF stop, ✱ (AE lock), ONE SHOT/AI SERVO toggle, IS start, and switching to a registered AF function.

POWER SWITCH
The power switch is found on the top left of the camera next to the Mode dial. In the ON position, this causes the camera to operate as long as the battery contains a charge and as long as the Auto power off setting allows.

∧ You want to save battery power, but you also do not want your camera to shut itself off too early. I'd rather set the Auto power off control for a long time so that my camera is powered up for those golden moments that I don't want to miss. I carry extra batteries in the field in case the power drains to empty. © Jeff Wignall

AUTO POWER OFF

All digital cameras automatically shut off after a period of inactivity to conserve power. The EOS 7D has a selection for [Auto power off] in the Set-up 1 menu (♥˙) (color code yellow) that can be used to turn off the power after a set duration of idleness.

Although Auto power off helps to minimize battery use, you may find it frustrating when you try to take a picture, only to find that the camera has shut itself off. For example, you might be shooting a football game and the action may stay away from you for a couple of minutes. If Auto power off is set to [30 sec.], the camera may be off as the players move toward you. When you try to shoot, nothing happens because the camera is powering back up. You may miss the important shot. In this case, try changing the setting to [4 min.] or [8 min.] so the camera stays on when you need it.

Access the Auto power off function through the camera's menus. Press MENU and advance to ♥˙ using 🖾. When ♥˙ is highlighted, use ◌ to highlight [Auto power off], the first item in this menu, and press ⊛. You are given seven different choices, ranging from 1 – 30 minutes (including the [Off] option that prevents the camera from turning off automatically). Scroll with ◌ to highlight the desired duration and press ⊛ to select it.

RESETTING CONTROLS

With all the controls built into the EOS 7D, it is possible to set so many combinations that at some point you may want to reset everything. You can restore the camera to its original default settings by going to the Set-up 3 menu ♥⁞, selecting **[Clear all camera settings]**, then pressing ⓢ. This menu option does not clear language, date/time, video system, copyright data, Custom Functions, My Menu settings, or Camera User Settings. There are separate functions for clearing those settings in their respective menus. Also in ♥⁞, you can check which firmware (the software that runs the camera) version the camera uses.

THE VIEWFINDER

The EOS 7D uses a standard eye-level, reflex viewfinder with a fixed pentaprism. Images from the lens are reflected to the viewfinder by a quick return, semi-transparent half-mirror. The mirror lifts for the exposure, then rapidly returns to keep viewing blackout to a very short period. The mirror is also dampened so that its bounce and vibration are essentially eliminated. This is the first EOS digital that shows 100% of the actual image area captured by the sensor. The eyepoint is about 22 mm, which is good for people with glasses. (The higher the eyepoint number, the farther your eye can be from the viewfinder and still see the whole image.)

The viewfinder features a non-interchangeable, precision matte focusing screen. It uses special micro-lenses to make manual focusing easier and to increase viewfinder brightness. The viewfinder provides 1.0x magnification. The viewfinder also includes Canon's new Intelligent Viewfinder technology that uses LCD elements to superimpose AF information, a spot metering circle and composition grids. The display

> The viewfinder's diopter adjustment slider is on the right side of the viewfinder housing.

includes a great deal of data about camera settings and functions, though not all the data are available at once.

There is no eyepiece shutter to block light entering the viewfinder when it is not against the eye (which affects exposure metering). However, an eyepiece cover, conveniently stored on the camera strap, is provided instead. It is necessary to remove the eyecup to attach the eyepiece cap.

NOTE: See the diagram under the back flap for details of information displayed in the viewfinder.

VIEWFINDER ADJUSTMENT

The EOS 7D's viewfinder features a built-in diopter (a supplementary lens that allows for sharper viewing). It is surprising how often this control is overlooked. The diopter helps you get a sharp view of the focusing screen so you can be sure you are getting the correct sharpness as you shoot. For this to work properly, you need to adjust the diopter for your eye. The adjustment knob is just above the eyecup, slightly to the right. Fine-tune the diopter setting by looking through the viewfinder at the AF points. Then rotate the dioptric adjustment knob until the AF points appear sharp. You should not look at the subject that the camera is focused on, but at the actual points on the viewfinder screen. If you prefer, you can also use the information at the bottom of the screen for this purpose.

While some people can use this adjustment to see through the camera comfortably with or without eyeglasses, I have found that the correction isn't really strong enough for most who wear glasses regularly (like me).

THE LCD MONITOR

The LCD monitor is probably the one digital camera feature that has most changed how we photograph. Recognizing its importance, Canon has put a large three-inch (7.6 cm), high-resolution LCD screen on the back of the camera. With about 920,000 pixels, this screen has excellent sharpness, making it extremely useful for evaluating images. The LCD features a new fluorine coating to reduce smudges, three anti-reflective coatings, and an extremely durable scratch-resistant coating.

NOTE: You can adjust the brightness of the LCD monitor in the Set-up 2 menu (♥²). See page 106.

> It is hard to overestimate the value of a digital camera's LCD monitor. Make sure you adjust its brightness to make viewing data and images easier.

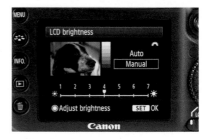

The EOS 7D's LCD monitor can also display a graphic representation of exposure values, called a histogram (see pages 169 – 171). The ability to see both the recorded picture and an exposure evaluation graph means that under- and overexposures, color challenges, lighting problems, and compositional issues can be dealt with on the spot. Flash photography in particular can be checked, not only for correct exposure, but also for other factors, such as the effect of lighting ratios when multiple flash units and/or reflectors are used. No Polaroid film test is needed. Instead, you can see the actual image that has been captured by the sensor.

In addition, the camera can rotate images in the LCD monitor. Some photographers love this feature, others hate it, but you have the choice. The auto rotate function (see page 104) displays vertical images properly without holding the camera in the vertical position—but at a price: The image appears smaller on the LCD. On the other hand, you can keep the image as big as possible by not applying this function, but a vertical picture will appear sideways in the LCD.

You can also magnify an image up to 10x in the monitor by repeatedly pressing ⊕ when in Playback mode. Using the Multi-controller ✳, you can scroll through the enlarged photo to inspect it. It is a good practice to check focus using this method.

> **NOTE:** Magnification is only possible during Playback, not Image Review. Image Review happens right after you take the picture. You can jump to Playback from Image Review by pressing ▶ while the image is displayed.

While the image is magnified, you can use 🔄 to scroll back and forth through your other images. This way you can compare details in images without having to re-zoom on each one. Use 🔲·⊖ to reduce magnification of the image. While you can repeatedly press 🔲·⊖ to get back to normal display, the quickest way is to press ▶. If you press 🔲·⊖ when the image isn't magnified, it brings up an image display of four images with the first press of the button, or nine images with the second one. This allows you to jump quickly through your pictures four or nine images at a time.

Since the LCD is an important tool to help evaluate images, it is important to adjust it properly. You can manually set a level of LCD brightness by using ♥, and selecting **[Manual]**. Or, you can let the 7D adjust LCD brightness automatically (use ⊛ to scroll to **[Auto]**). An ambient light sensor, located on the back of the camera, allows the LCD to get brighter as ambient light increases. This helps you see images on the monitor in bright conditions. To save power, you can also turn off the display manually by using the **INFO.** button.

The LCD is not just for displaying images. It is also designed to display shooting information and is always operational when the camera is on. When not used to change menu settings or to play back an image, the LCD displays the current camera settings: exposure, white balance, drive settings, metering type, focusing type, resolution, and much more.

QUICK CONTROL SCREEN

As mentioned above, when the 7D is not in menu mode or playing back an image, it displays the shooting settings on the LCD monitor. This display expands on the information that is shown in the viewfinder. In addition, it also provides quick access to many of the camera's settings.

By pressing ⓠ, you can turn this display into an interactive camera-setting menu called the Quick Control screen. Once the Quick Control screen is displayed, use ✦ to highlight each of the displayed shooting parameters. When a parameter is highlighted, use 🖑 to change the value that appears on the LCD monitor.

> The Quick Control screen is an extremely useful tool for adjusting many of the 7D's settings.

This new Quick Control screen offers easy access to some settings that would normally require multiple button presses to change. For example, to set auto exposure bracketing, normally you would need to first press MENU, then use 🖑 to select ◘⁚, use ◯ to select **[Expo. comp./AEB]**, press ⑳ to enter the submenu and then use 🖑 to set the bracketing range, and, finally, press ⑳ to accept the setting. Setting image recording quality would require similar steps. When you use the Quick Control screen, not only do you merely highlight the parameter and use 🖑 to change the value, it is not necessary to press ⑳ to accept the setting. Just tap the shutter release button to exit and the setting is accepted.

If you want a little more guidance when using the Quick Control screen, press ⑳ when the parameter is highlighted. This will call up the normal menu options for that parameter (if there is one). For example, use the ⑳ button to see a list of all the possible ISO speeds, or if you don't remember which control to use to adjust the autoexposure bracketing range.

NOTE: In ☐ shooting mode, you can only use the Quick Control screen to choose image recording quality and to select Single shooting ☐ Drive mode or Self-timer:10sec/Remote control ⧖⟳. When in 🄲🄰, you also have access to Low-speed continuous shooting ⧉, a limited selection of Picture Styles, flash mode control (Auto flash ⚡ᴬ, Flash on ⚡, and Flash off ⊘) and special Background and Exposure adjustments (see page 131).

As previously mentioned, you can press **INFO.** to cycle through various displays on the LCD monitor. One of the choices is the Camera Settings screen. You can gain a great deal of information about how the 7D is configured from this one display, rather than diving into various menus. This information includes:

O Remaining capacity on the memory card in megabytes (MB) or gigabytes (GB).

O Current color space

O Current white balance shift and bracketing setting

O Long exp. noise reduction status

O High ISO speed noise reduction level

O Auto power off timer setting

O Wireless image transfer failure status

O Red-eye reduction enabled status

In addition, you can see the shooting mode for each Camera User Setting (**C1**, **C2**, and **C3**) at the top of the Camera Settings screen.

THE SENSOR

The EOS 7D has a newly designed 18 megapixel (MP) sensor (5184 x 3456 pixels), which is remarkable in a camera of this class, especially given the EOS 7D's price and speed. It can easily be used for quality magazine reproduction across two pages.

Because the EOS 7D's APS-C sized CMOS sensor (22.3 x 14.9 mm; APS stands for Advanced Photo System) covers a smaller area (small-format sensor) than a 35mm film frame, it records a narrower field of view than a 35mm film camera. To help photographers who are used to working with 35mm SLRs visualize this narrower field of view, a cropping factor of 1.6 is applied to the lens focal length number. Thus, on the EOS 7D, a 200mm lens has a field of view similar to that of a 320mm lens on a 35mm camera. Remember, the focal length of the lens doesn't change, just the view seen by the EOS 7D's sensor.

This focal length conversion factor is great for telephoto advocates because a 400mm telephoto lens acts like a 640mm lens on a 35mm camera. However, at the wide-angle end, a lens loses most of its wide-angle capabilities; for example, a 28mm lens acts like a 45mm lens. But since the EOS 7D accepts Canon EF-S lenses (see page 231), which are specially designed for this size image sensor, you can use the Canon 10-22mm zoom if you want to shoot wide-angle pictures. It offers an equivalent 16-35mm focal length.

Though small-format, the sensor in the EOS 7D demonstrates improvements in sensor technology. It adds more pixels than other EOS models, on the same size image sensor. Obviously, then, each pixel has to be smaller. In the past, this would have meant problems with noise, sensitivity, dynamic range, and reduced continuous shooting speed. However, this sensor's 18 megapixels offer great signal-to-noise performance, dynamic range, and ISO speed range. And despite the larger number of pixels, the continuous shooting speed for JPEG images is impressive.

Low noise characteristics are extremely important to advanced amateur and professional photographers who want the highest possible image quality. The EOS 7D gives an extraordinarily clean image with exceptional tonalities and images can be enlarged with superior results.

Several other factors contribute to the improved imaging quality. Canon has worked hard on the design and production of its sensors. (They are one of the few D-SLR manufacturers that make their own sensors.) The microlens—the microscopic lens in front of each pixel—has increased light-gathering ability, improved light convergence, and reduced light loss. The area that is sensitive to light on each pixel has also been increased.

In addition, the camera has an improved low-noise, high-speed output amplifier as well as power-saving circuitry that also reduces noise. With such low noise, the sensor offers more range and flexibility in sensitivity settings. ISO settings range from 100 – 6400 (expandable to 12800).

The on-chip RGB primary color filter uses a standard Bayer pattern over the sensor elements. This is an alternating arrangement of colors with 50% green, 25% red, and 25% blue; full color is interpolated from the data. In addition, an infrared cut-off, low-pass filter is located in front of the sensor. This two-part filter is designed to prevent the false colors, and the wavy or rippled look of surfaces (moiré) that can occur when photographing small, patterned areas with high-resolution digital cameras.

∧ Custom Function III-13 sets the mirror so it can lock during long exposures. You press the shutter release twice—once to move the mirror, and the second to make the exposure.
© Kevin Kopp

MIRROR LOCKUP

For really critical work on a tripod, such as shooting long exposures or working with macro and super telephoto lenses, sharpness is improved by eliminating the vibrations caused by mirror movement. This is accomplished by locking up the mirror in advance using the EOS 7D's mirror lockup function. However, it also means the viewfinder is blacked out and the drive mode is Single shooting □.

Mirror lockup is set with C.Fn III-13 (see page 122). Once set, the mirror locks up when the shutter button is pressed. Press the shutter button again to make the exposure. The mirror flips back down if you don't press the shutter within 30 seconds.

Use a remote switch or one of the self-timers to keep all movement to a minimum. With the self-timer, the shutter goes off after the timer counts down (either two or ten seconds after the mirror is locked up), allowing vibrations to dampen. When you use one of the self-timers with Bulb exposure (see page 139) and mirror lockup, you must keep the shutter depressed during the self-timer countdown, or the countdown will stop.

File Processing and Formats

Canon has long offered exceptionally strong in-camera processing capabilities. The reason the EOS 7D delivers such exceptional images using JPEG is that Canon's latest version of their high-performance processor, called DIGIC 4, builds on the technology of its predecessors.

THE POWER OF DIGIC 4 PROCESSING

Canon's reputation for producing high-quality images is a result of its unique DIGIC Imaging Engine. The 7D is equipped with the most recent version, DIGIC 4, which intelligently translates the image signal as it comes from the sensor, optimizing that signal as it is converted into digital data. In essence, it is like having your own computer expert making the best possible adjustments as the data file is processed for you. DIGIC 4 works on the image in-camera, after the shutter is clicked and before the image is recorded to the memory card, improving color balance, reducing noise, refining tonalities in the brightest areas, and more. In these ways, it has the potential to make JPEG files superior to unprocessed RAW files, reducing the need for RAW processing. (See pages 76 – 83 for more information about JPEG and RAW files.)

> The innovative DIGIC 4
processor improves speed
and image quality over
earlier versions.
© Canon Inc.

The EOS 7D uses two of these amazing chips in order to speed processing even more, resulting in an incredible eight fps (frames per second) continuous shooting speed, even when shooting RAW. But the DIGIC 4 chips are not just about speed. Color reproduction of highly saturated, bright objects is also considerably improved. Auto white balance is better, especially at low color temperatures (such as tungsten light). In addition, false colors and noise, which have always been a challenge for digital photography, have been reduced (something that RAW files cannot offer). The ability to resolve detail in highlights is also improved.

DIGIC 4 also enhances the EOS 7D's ability to write image data to the memory card in both JPEG and RAW, enabling the camera to utilize the benefits offered by high-speed memory cards. It is important to understand that this does not affect how quickly the camera can take pictures. Rather, it affects how fast it can transfer images from its buffer (special temporary memory in the camera) to the card. It won't change the shots per second, but it will improve the quantity of images that can be taken in succession. Even at maximum resolution, the camera has a burst duration of 126 JPEG or 15 RAW frames, or six RAW + Large/Fine JPEGs (this occurs only with the fastest memory cards—UDMA).

During either of the continuous shooting drive modes, each image is placed into a buffer before it is recorded to the memory card. The faster the memory card is, the faster the buffer is emptied, allowing more images to be taken in sequence. If the buffer becomes full, **buSY** appears in the viewfinder and the camera stops shooting until the card-writing can catch up.

In addition to the optimizing technology of DIGIC 4, you can choose a Picture Style to control how the camera performs further image processing. This can be especially helpful if you print image files directly from the camera without using a computer, or when you need to supply a particular type of image to a client. Some photographers compare Picture Styles to choosing a particular film for shooting. Picture Styles are applied permanently to JPEG files. (If using RAW files, the Picture Style can be changed during "processing" using Canon's Digital Photo Professional software.)

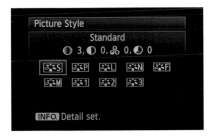

‹ Different Picture Styles allow you to adjust such aspects of an image as sharpness, contrast, saturation, and color tone.

Display Picture Styles via ◻️, [Picture Style], or by pressing the ⧉ button (in the column of buttons to the left of the LCD). Use ◯ or ⌂ to select the Picture Style you wish to use. Then press ⊛ or tap the shutter release button to save the selection. There are six preset Picture Styles and three user-defined styles:

⧉S STANDARD
Standard is the default style for the ☐ and ㊙ shooting modes. During in-camera processing, color saturation is enhanced and a moderate amount of sharpening is performed on the image. Standard offers a vivid and crisp image with a normal amount of contrast.

⧉P PORTRAIT
Portrait places an emphasis on pleasing skin tones. While the contrast is the same as Standard, skin tones have a slightly warmer look. Sharpening is reduced in order to produce a pleasing, soft skin texture.

^ For autumn mountain scenes like this, Landscape Picture Styles deepens the blue sky and makes the greens and yellows pop. © Kevin Kopp

⊞ LANDSCAPE

With Landscape, saturation is high, with an emphasis on blues and greens. There is also a boost in saturation in the yellows. The image is sharpened even more than the Standard mode to display details. Don't be afraid to use this during cloudy days to help bring out more color.

⊞ NEUTRAL

If you plan to "process" the image on your computer, either through Canon's Digital Photo Professional software or another image software program, this may be the mode to choose. There is virtually no image sharpening. Color saturation is lower than other modes, and contrast is lower, too. Since other Picture Styles increase saturation, Neutral may be a good style to choose when you shoot in bright or high-contrast situations. Picture details may be more prevalent with this setting. Don't rule it out for candid portraits that may occur in bright lighting situations.

⊞ FAITHFUL

This is the choice when you need to accurately capture the colors in a scene. Saturation is low and almost no sharpening is applied to the image. Contrast is also toned down. Accurate color reproduction is

achieved when the scene is lit with 5200K lighting (K stands for Kelvin, see page 69 for explanation).Otherwise, you might think of this setting as similar to Neutral, except that the color tone is a bit warmer. Like Neutral, this mode is designed with further image processing via computer in mind.

⊞⊞M MONOCHROME

This allows you to record pure black-and-white images to the memory card and to automatically view the image in black-and-white on the LCD. Sharpness is the same as the Standard mode, and contrast is enhanced. As with the other Picture Styles, Monochrome permanently changes JPEG files—you can't get the color back. Another option is to shoot in color and then convert images to black and white in an image-processing program—and do so with more control.

PICTURE STYLE PROCESSING

With all of the Picture Styles (except Monochrome), you can control the degree of processing applied to four aspects of an image:

- ◐ **[Sharpness]:** Refers to the amount of sharpening that is applied to the image file by the camera.
- ◑ **[Contrast]:** Increases or decreases the contrast of the scene that is captured by the camera.
- ⅗ **[Saturation]:** Influences color richness or intensity.
- ◐ **[Color tone]:** Helps the photographer decide how red or how yellow to render skin tones, but also affects other colors.

With the Monochrome Picture Style, the ⅗ and ◐ settings are replaced with **[◐ Filter effect]** and **[⊘ Toning effect]**. The parameters for Filter effect offer four tonal effects that mimic what a variety of colored filters do to black-and-white film. A fifth setting, **[N:None]**, means that no filter effects are applied. Each Filter effect color choice makes the color similar to your selection look lighter, while the color opposite your selection on the color wheel records darker.

The Monochrome Filter effects are:

O **[Ye:Yellow]**: This is a modest effect that darkens skies slightly and gives what many black-and-white aficionados consider the most natural looking grayscale image.

O **[Or:Orange]**: This is next in intensity. It does what red does, only to a lesser degree. It is better explained if you understand the use of red (see next description).

O **[R:Red]**: This is dramatic. It lightens anything that is red, such as flowers or ruddy skin tones, while darkening blues and greens. Skies turn quite striking, and sunlit scenes gain in contrast (the sunny areas are warm-toned and the shadows are cool-toned, so the warms get lighter and the cools get darker).

O **[G:Green]**: This makes Caucasian skin tones look more natural, and foliage gets bright and lively in tone.

Of course, if you aren't sure what these filters will do, you can take the picture and see the effect immediately on the LCD monitor.

The other Monochrome parameter, Toning effect, adds color to the black-and-white image so it looks like a toned black-and-white print. Your choices include: **[N:None]**, **[S:Sepia]**, **[B:Blue]**, **[P:Purple]**, and **[G:Green]**. Sepia and blue are the tones we are most accustomed to seeing in such prints.

MODIFYING PICTURE STYLES

Once the Picture Styles are displayed on the LCD monitor, highlight the one you want to adjust and press **INFO**. A series of adjustment sliders will be displayed. Highlight the parameter you want to adjust using ◌ or ✷ and press ⊛. Then use ◌ or ✷ to adjust the parameter. A white pointer shows the current setting and the gray pointer shows the default setting for that Style. You must use ⊛ to accept the setting. If you leave this menu screen without pressing ⊛, the adjustment is cancelled.

At the bottom of the screen is a **[Default set.]** button that you can highlight to reset the parameters that you have altered. Parameter numbers displayed in blue indicate a setting that has been changed from the default values. Use **MENU** to return to the Picture Style menu.

The adjustment slider for Sharpness ◐ is set up differently than the other sliders. Sharpness is generally required at some point in digital photography. It overcomes, among other things, the use of a low-pass filter in front of the image sensor (to reduce problems caused by the image sensor's pixel grid). The low-pass filter introduces a small amount of image blur, so image sharpening compensates for this blur. The adjustment slider's setting indicates the amount of sharpness already applied to the style. A setting of zero means that almost no sharpening has been applied to the image. You'll notice that the ◐ parameter's default setting is the only one that changes from Picture Style to Picture Style.

USER-DEFINED PICTURE STYLES

The 7D allows you to use a particular Picture Style as a base setting and then modify it to meet your own photographic needs. This allows you to create and register a different set of parameters that you can apply to image files while keeping the preset Picture Styles. You do this under the options for [User Def. 1], [User Def. 2], or [User Def. 3].

While specific situations may affect where you place your control points for these flexible options, here are some suggestions to consider:

Create a Hazy or Cloudy Day Setting: Make one of the User-defined sets capture more contrast and color on days when contrast and color are weak. Increase the scales for Contrast ◐ and Saturation ⅋ by one or two points (experiment to see what you like when you open the files on your computer or use the camera for direct printing). You can also increase the red setting of ◐ (adjust the scale to the left).

Create a Portrait Setting: Make a set that favors skin tones. Start with ▣▣▣ as your base, then reduce ◐ by one point while increasing ⅋ by one point (this is very subjective; some photographers may prefer less saturation) and warming skin tones (by moving ◐ toward the red—or left—side) by one point.

⌃ You can use Picture Styles to simulate the look of favorite films, increasing contrast and saturation for dramatic images.

Create a Velvia Look: Start with ⬛, increase ◐ two points, ◑ one point, and ⅋ by two points to create photos that are highly saturated.

You can also download custom picture styles from Canon's Picture Style website at http://web.canon.jp/imaging/picturestyle/index.html. These custom styles can be uploaded into any of the 7D's three User-defined styles by using the USB connection to the camera. (You'll need Canon's EOS Utility software that is included with the camera.) The custom styles can also be used with Canon's Digital Photo Professional software to change styles after capture in RAW images.

NOTE: Downloaded Picture Styles can only be loaded into the User-defined styles and will be deleted if you reset all camera settings using **[Clear settings]** in ❤.

COLOR SPACE

The 7D has a color space setting in the ■: menu. A color space is the range of colors, or gamut, that a device can produce. Cameras have color spaces, monitors have color spaces, and printers have color spaces. (While not technically accurate, you can think of different color spaces as different sized boxes of crayons.)

The two choices for [Color space] on the 7D are [sRGB] and [Adobe RGB]. [sRGB] is the default setting for the camera and is used as the color space for the fully-automatic modes, ☐ and ⒸⒶ. It is also the color space for most computer monitors. If you are capturing images for the web, [sRGB] will work fine. [Adobe RGB], as the name implies, was developed by Adobe to deal with creating images for print output. This larger color space (think bigger box of crayons) contains more colors that can be produced by most of today's printers.

Choosing between [sRGB] and [Adobe RGB] is not as complicated as JPEG vs. RAW. [Adobe RGB] doesn't take up more room on the card or require special RAW processing software. But you do need to check to make sure that your image-processing program can handle Adobe RGB—most do.

There are many times when it is difficult to see the difference between the two color spaces. Try an experiment with some test shots in both. You won't see the difference on the LCD, so print them out and then see if you can tell the difference.

> **NOTE:** When you use [Adobe RGB], image file names begin with "_MG" rather than "IMG".

WHITE BALANCE

White balance (WB) is an important digital camera control. It addresses a problem that has plagued film photographers for ages: How to deal with the different color temperatures of various light sources. While color adjustments can be made in the computer after shooting, especially when shooting RAW, there is a definite benefit to setting WB properly from the start. The EOS 7D helps you do this with an improved Auto white balance ▣▣▣ setting that makes colors more accurate and natural

than earlier D-SLRs. In addition, improved algorithms and the DIGIC 4 processors make **AWB** more stable as you shoot a scene from different angles and focal lengths (which is always a challenge when using this setting). Further, WB has been improved to make color reproduction more accurate under low lights.

While **AWB** gives excellent results in a number of situations, many photographers find they prefer the control offered by presets and Custom WB ⟟⟟ settings. With nine separate WB presets, plus WB compensation and bracketing, the EOS 7D's ability to carefully control color balance is greatly enhanced. It is well worth the effort to learn how to use the different WB functions so you can get the best color with the most efficient workflow in all situations (including RAW). This is especially important in strongly colored scenes, such as sunrise or sunset, which can fool **AWB**.

> The lighting and strong colors in this scene might have fooled the camera if I had relied on Auto white balance. Instead, I used Shade WB and fill flash to get the proper color rendition, concentrating on the snake instead of my camera settings so as not to get bit!

The preset WB settings are not difficult to learn, so using them should become part of the normal photography decision-making process. However, they can only be used with the exposure shooting modes (see pages 132 – 140). In ☐ and 🅒🅐 shooting modes, white balance is set for 🄰🅆🄱 and cannot be changed. The more involved Custom WB 💺 setting is also a valuable tool to understand and use so you can capture the truest color in all conditions (see pages 72 – 73).

To set white balance, press 🔘·WB to display a list of WB choices on the LCD monitor and LCD panel. Next, use ◯ to choose the WB setting you want, then press 🔘. The information displays on the LCD monitor and LCD panel show an icon of the WB setting that you selected.

WB settings fall within certain color-temperature values, corresponding to a measurement of how cool (blue) or warm (red) the light source in the scene is. The measurement is in degrees Kelvin, abbreviated K. Unlike air temperature, the higher the number, the cooler, or bluer, the light source. Conversely, the lower the number, the warmer, or redder, the light source.

WHITE BALANCE PRESETS

The following is a list of the white balance presets available on the EOS 7D.

🄰🅆🄱 Auto (Color temperature range of approximately 3000K — 7000K): This setting examines the scene for you, interprets the light it sees (in the range denoted above) using the DIGIC 4 processor (even with RAW), compares the conditions to what Canon's engineers have determined works for such readings, and sets a white balance to make colors look neutral (i.e., whites appear pure, without color casts, and skin tones appear normal).

🄰🅆🄱 can be a useful setting when you move quickly from one type of light to another, or whenever you hope to get neutral colors and need to shoot fast. Even if it isn't the perfect setting for all conditions, it often gets you close enough so that only a small adjustment is needed later using your image-processing software. However, if you have time, it is often better to choose from the WB settings listed on the following pages, because colors are more consistent from picture to picture. While 🄰🅆🄱 is well designed, it can only interpret how it "thinks" a scene should look. If the camera sees your wide-angle and telephoto shots of the same subject differently in terms of colors, it readjusts for each shot, often resulting in inconsistent color from shot to shot.

> White balance helps render color correctly in your recorded images.

White balance
Color temp.

AWB

K ‹ 5200 ›

☀ Daylight (approximately 5200K): This setting adjusts the camera to make colors appear natural when you shoot in sunlit situations between about 10 A.M. and 4 P.M. (depending on the time of year). At other times, when the sun is lower in the sky and has more red light, the scenes photographed using this setting appear warmer than normally seen with our eyes. This setting makes indoor scenes under incandescent lights look very warm, indeed.

🏠 Shade (approximately 7000K): Shadowed subjects under blue skies can end up very bluish in tone, so this setting warms the light to make colors look natural, without any blue color cast. (At least that's the ideal—individual situations affect how the setting performs.) The Shade setting is a good one to use any time you want to warm up a scene (especially when people are included), but you have to experiment to see how you like this creative use of the setting.

🌥 Cloudy (approximately 6000K): Even though the symbol for this setting is a cloud, think of it as the Cloudy/Twilight/Sunset setting. It warms up cloudy scenes as if you had a warming filter, making sunlight appear warm, but not quite to the degree that the Shade setting does. You may prefer 🌥 to 🏠 when shooting people, since the effect is not as strong. Both settings actually work well for sunrise and sunset, giving the warm colors that we expect to see in such photographs. However, 🌥 offers a slightly weaker effect. You really have to experiment a bit when using these settings for creative effect. Make the final comparisons on the computer.

☀ Tungsten Light (approximately 3200K): This is designed to give natural results with quartz lights. It also reduces the strong orange color that is typical when photographing lamp-lit indoor scenes with daylight-balanced settings. Since this control adds a cool tone to other conditions, it can also be used creatively (to make a snow scene appear bluer, for example).

☀ White Fluorescent Light (approximately 4000K): Though the **AWB** setting often works well with fluorescents, the ☀ setting is more precise and predictable. Fluorescent lights usually appear green in photographs, so this setting adds magenta to neutralize that effect. (Since fluorescents can be extremely variable, and since the EOS 7D has only one fluorescent choice, you may find that precise color can only be achieved with the Custom WB setting.) You can also use this setting creatively any time you wish to add a warm pinkish tone to your photo (such as during sunrise or sunset).

⚡ Flash (approximately 6000K): Light from flash tends to be a little colder than daylight, so this warms it up. According to Canon tech folks, this setting is essentially the same as ☁ (the Kelvin temperature is the same); it is simply labeled differently to make it easy to remember and use. I find both ⚡ and ☁ to be good, all-around settings that give an attractive warm tone to outdoor scenes.

■K Color Temperature (2500K – 10,000K): With this setting, you can directly set the color temperature by a number value in degrees Kelvin. This can be useful if you use a color temperature meter or know the color temperature of the illumination source. With Live View, you can "dial-in" WB using ■K by watching the LCD monitor as you adjust the color temperature value.

To use ■K via the Quick Control screen, press ⃞ and use ✶ to highlight the WB setting. Press ⊛ to bring up the White balance screen. Use ○ to select ■K and then use 🞥 to select the color temperature value. Press ⊛ or lightly tap the shutter release button to accept the setting and exit.

To "dial in" white balance during Live View shooting, press ▣·WB. The list of WB choices overlays the Live View screen on the LCD monitor. Next, use ○ to choose ■K, then use 🞥 to adjust the color temperature setting while you watch the image on the LCD monitor. Even if you aren't using Live View for shooting, this is a great way to set WB in difficult situations. This method also works for movie mode.

⬛ USING CUSTOM WHITE BALANCE

A very important tool for the digital photographer, Custom white balance is a setting that even many seasoned shooters often don't fully understand. It is a precise and adaptable way of getting accurate or creative white balance. It has no specific white balance K temperature, but is set based on a specific neutral tone in the light in the scene to be photographed. However, it deals with a significantly wider range than AWB (between approximately 2000K–10,000K). That can be very useful.

The ⬛ setting lets you use either a white (or gray) target on which the camera sets white balance. First, take a picture of the white or gray card, which is in the same light as your subject. It does not have to be in focus, but it should fill the image area. (Avoid placing the card on or near a highly reflective colored surface.) Be sure the exposure is set to make this object gray to light gray in tone, and not dark (underexposed) or washed out white (overexposed).

TIP: I like to use a card or paper with small black print on it rather than a plain white card. This way, if I can see the type, I haven't overexposed the image.

Next, go to ⚙ and highlight [Custom WB], then press ⊛. The last shot you took (the one for white balance) should be displayed in the LCD monitor. If not, use ○ to choose the image you shot of the white or gray object.

When you have the target image displayed in the LCD monitor, push ⊛. A dialog box asks you if you want to use the white balance information from the current image to set a Custom white balance. Highlight [OK], press ⊛, and ⚖ is set to measure that stored shot. A note appears, "Set WB to ⚖," as a reminder. This reminds you that there is one more step to this process: You must choose the ⚖ setting for white balance.

To take that final step, press ⊛ again to acknowledge the reminder, and then either lightly tap the shutter or press MENU to exit ⚙. Then use ○ to highlight [White balance] and press ⊛. Then select ⚖ and press ⊛. The camera is now set for your Custom white balance.

You can save a series of white balance reference images on your memory card ahead of time that you can flip through. This is useful if you need to switch between different lighting conditions but don't have the time to set up a card to capture the image.

The procedure just described produces neutral colors in some very difficult conditions. However, if the color of the lighting is mixed (for example, the subject is lit on one side by a window and on the other by incandescent lights), you will only get neutral colors for the light that the white card was in. Also, when you shoot in reduced spectrum lights, such as sodium vapor, you will not get a neutral white under any WB setting.

You can also use ⚖ to create special color for a scene. In this case, you set the WB on a color that is not white or gray. You can use a pale blue, for example, to generate a nice amber color. If you balance on the blue, the camera adjusts this color to neutral, which in essence removes blue, so the scene has an amber cast. Different strengths of blue provide varied results. You can use any color you want for white balancing— the camera works to remove (or reduce) that color, which means the opposite color becomes stronger. (For example, using a pale magenta increases the green response.)

WHITE BALANCE CORRECTION

The EOS 7D goes beyond the capabilities of many cameras in offering control over WB: There is actually a white balance correction feature built into the camera. You might think of this as exposure compensation for white balance. It is like having a set of color-balancing filters in four colors (blue, amber, green, and magenta) and in varied strengths. Photographers accustomed to using color-conversion or color-correction filters will find this feature quite helpful in getting just the right color.

> The white balance correction, or "shift," menu also doubles as the white balance bracketing menu.

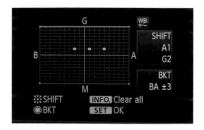

The setting is not difficult to manage. First, go to ◘°, highlight **[WB SHIFT/BKT]** and press ⊛. A menu screen appears with a graph that has a horizontal axis from blue to amber (left to right) and a vertical axis from green to magenta (top to bottom). You move a selection point within that graph using ✥. You must press ⊛ or press straight down on ✥ before you leave this setting to lock in the value.

As you change the position of the selection point on the graph, an alphanumeric display titled **[SHIFT]** on the right of the screen shows a letter for the color (B, A, G, or M) and a number for the setting. For example, a white balance shift of three steps toward blue and four to green displays B3 and G4.

For photographers used to color-balancing filters, each increment of color adjustment equals 5 MIREDS of a color-temperature changing filter. (A MIRED is a measuring unit for the strength of a color temperature conversion filter.) Remember to set the correction back to zero when conditions change. The LCD monitor and the viewfinder information display show �l when white balance correction is engaged.

WHITE BALANCE AUTO BRACKETING

When you run into a difficult lighting situation and want to be sure of the best possible WB settings, another option is white balance autobracketing. This is actually quite different than autoexposure bracketing (see page 166). With the latter, three separate exposures are taken of a scene; with white balance autobracketing, you take just one exposure and the camera processes it to give you three different WB options.

> NOTE: Using white balance bracketing delays the recording of images to the memory card. In other words, the burst mode of the camera is reduced and the number of shots in a row is one-third the normal number. Pay attention to the access lamp in the bottom right corner of the back of the 7D to gauge when the camera has finished recording the extra images.

White balance autobracketing allows up to +/- 3 steps (again, each step is equal to 5 MIREDS of a color-correction filter) and is based on whatever white balance mode you have currently selected. You can bracket from blue to amber, or from green to magenta. Keep in mind that even at the strongest settings, the color changes are fairly subtle. 🔲 on the LCD monitor appears, letting you know that white balance auto bracketing is set.

> NOTE: White balance bracketing records an original image at the currently selected white balance setting, then internally creates an additional set of (1) a bluer (cooler) image and a more amber (warmer) image, or (2) a more magenta and a greener image (useful in fluorescent lighting). Unlike exposure bracketing, you only need to take one shot—and you don't have to set the drive setting to 🔲.

To access white balance autobracketing, go to ◘¦ and select [WB SHIFT/BKT], then press ⊕. The graph screen with the horizontal (blue/amber) and vertical (green/magenta) axes appears on the LCD monitor. Rotate ◯ to adjust the bracketing amount: To the right (clockwise) to set the blue/amber adjustment, then back to zero and to the left (counter clockwise) for green/magenta. (You can't bracket in both directions.) You can also shift your setting from the center point of the graph by using ⁚. Press ⊕ to accept your settings.

The obvious use of this feature is to deal with tricky lighting conditions. However, it has other uses as well. You may want to add a warm touch

to a portrait but are not sure how strong you want it. You could set the WB to 🔆, for example, then use white balance autobracketing to get the tone you're looking for. (The bracketing gives you the standard 🔆 white-balanced shot, plus versions warmer and cooler than that.) Or, you may run into a situation where the light changes from one part of the image to another. Here, you can shoot the bracket, then combine the white balance versions using an image-processing program. (Take the nicely white-balanced parts of one bracketed photograph and combine them with a different bracketed shot that has good white balance in the areas that were lacking in the first photo.)

RAW AND WHITE BALANCE

Since the RAW file format allows you to change WB after the shot, some photographers have come to believe that it is not important to select an appropriate WB at the time the photo is taken. While it is true that **AWB** and RAW give excellent results in many situations, this approach can cause consistency and workflow challenges. WB choice is important because when you bring RAW files into software for processing and enhancement, the files open with the settings that you chose during initial image capture. Sure, you can edit those settings in the computer, but why not make your initial RAW image better by merely tweaking the WB with minor revisions at the image-processing stage rather than starting with an image that requires major correction? Of course there will be times that getting a good WB setting is difficult, and this is when the RAW software WB correction can be a big help.

FILE FORMATS

JPEG OR RAW

The EOS 7D records images as either JPEG or RAW files. There has been a mistaken notion that JPEG is a file format for amateur photographers, while RAW is a format for professionals. This is really not the case. Pros use JPEG and some amateurs use RAW. (Technically, JPEG is a compression scheme and not a format, but the term is commonly used to denote a format, and that is how we will use it.)

^ With memory card capacity becoming so large, it makes sense to use the largest file size and best quality settings nearly all of the time. So the real choice is between JPEG or RAW. The 7D produces both with great quality.

There is no question that RAW offers some distinct benefits for the photographer who needs them, including the ability to make greater changes to the image file before the image degrades from over-processing. The EOS 7D's RAW format (called CR2 and originally developed by Canon for the EOS-1D Mark II) includes revised processing improvements, making it more flexible and versatile for photographers than previous versions. It can also handle more metadata and is able to store processing parameters for future use.

However, RAW is not for everyone. It requires more work and more time to process than other formats. For the photographer who likes to work quickly and wants to spend less time at the computer, JPEG may offer clear advantages and, with the EOS 7D, even give better results. This might sound radical considering what some "experts" say about RAW in relation to JPEG, but I suspect they have never shot an image with an EOS 7D set for high-quality JPEGs.

It is important to understand how the sensor processes an image. It sees a certain range of tones coming to it from the lens. Too much light (overexposed), and the detail washes out; too little light (underexposed), and the picture is dark. This is analog (continuous) information, and it must be converted to digital, which is true for any file format, including both RAW and JPEG. The complete digital data is based on 14 bits of

color information, which is changed to 8-bit color data for JPEG, or is placed virtually unchanged into a 16-bit file for RAW. (The fact that RAW files contain 14-bit color information is a little confusing since this information is put into a file that is actually a 16-bit format.) This occurs for each of three different color channels used by the EOS 7D: red, green, and blue. Remember that the DIGIC 4 processor applies changes to JPEG files, while RAW files have very little processing applied by the camera.

Both 8-bit and 16-bit files have the same range from pure white to pure black because that range is influenced only by the capability of the sensor. If the sensor cannot capture detail in areas that are too bright or too dark, then a RAW file cannot deliver that detail any better than a JPEG file. But it is true that RAW allows greater technical control over an image than JPEG, primarily because it starts with more data, meaning there are more "steps" of information between the white and black extremes of the sensor's sensitivity range. These steps are especially evident in the darkest and lightest areas of the photo. So it appears the RAW file has more exposure latitude and that greater adjustment to the image is possible before banding or color tearing becomes noticeable.

JPEG format compresses (or reduces) the size of the image file, allowing more pictures to fit on a memory card. The JPEG algorithms carefully look for redundant data in the file (such as a large area of a single color) and remove it, while keeping instructions on how to reconstruct the file. JPEG is therefore referred to as a "lossy" format because, technically, data is lost. The computer rebuilds the lost data quite well as long as the amount of compression is low.

It is essential to note that both RAW and JPEG files can give excellent results. Photographers who shoot both (RAW + ◢L) use the flexibility of RAW files to deal with tough exposure situations, and the convenience of JPEG files when they need fast and easy handling of images.

Which format will work best for you? Your own personal way of shooting and working should dictate that decision. If you deal with problem lighting and colors, for example, RAW gives you a lot of flexibility in controlling both. If you can carefully control your exposures and keep images consistent, JPEG is more efficient.

NOTE: The RAW/JPEG button allows you to shoot a majority of your photos in one format and then quickly (and temporarily) switch to capturing both formats. See page 94.

In addition to the fact that it holds 14 bits of data, the RAW file offers some other advantages over JPEG. Because RAW more directly captures what the sensor sees, stronger correction can be applied to it (compared to JPEG images) without problems appearing. This can be particularly helpful when there are difficulties with exposure or color balance.

The disadvantage to RAW files is that you must process the image using RAW processing software on your computer. A RAW file needs to be processed: You can't print a RAW file directly from your computer and you can't post it for viewing on a website.

Canon supplies a dedicated software program with the EOS 7D called ZoomBrowser EX (Windows) or ImageBrowser (Mac). Both programs are specifically designed for CR2 files and allow you to open and smartly process them. You can also choose other processing programs, such as Phase One's Capture One or others, which make converting from RAW files easier. These independent software programs are intended for professional use and can be expensive (although some manufacturers offer less expensive solutions).

One disadvantage to using third-party programs is that they may not support Canon's Dust Delete Data system (see page 30) to automatically remove dust artifacts in your images. Also, Picture Styles may not be supported in software other than Canon's.

Whatever method you choose to gain access to RAW files in your computer, you have excellent control over the images in terms of exposure and color of light. The RAW file contains special metadata (shooting information stored by the camera) that has the exposure settings you selected at the time of shooting. This is used by the RAW conversion program when it opens an image. You can make modifications to the exposure without causing too much harm to the image. (However, you can't compensate for really bad exposure in the first place.) White balance settings can also be changed. If you use Canon's software, you can even change Picture Styles after the fact.

IMAGE SIZE AND QUALITY

The EOS 7D offers a total of nine choices for image-recording quality, consisting of combinations of different file formats, resolutions (number of pixels), and compression rates. But let's be straight about this: Most photographers will shoot the maximum image size using RAW, the highest-quality JPEG setting, or the new M RAW and S RAW formats. There is little point in shooting smaller image sizes except for specialized purposes. After all, the camera's high resolution is what you paid for!

All settings for recording quality are selected in Shooting 1 menu ◘˙ under **[Quality]**, or by using the Quick Control screen and highlighting the current file recording setting. Press ☉ and two rows of settings will appear. The top row, which is adjusted via ⌂, contains the three different RAW settings, 𝗥𝗔𝗪, **M** 𝗥𝗔𝗪 (medium-size RAW files), and **S** 𝗥𝗔𝗪 (small-size RAW files). Use the dash found in the first position (−) when you don't want to record any RAW files.

The bottom row shows the 3 JPEG file sizes along with the two JPEG compression options, for a total of six different options (◢L, ◢L, ◢M, ◢M, ◢S, and ◢S), plus the dash mark. (Make your selections with ◯.) The symbols depict the level of compression; the letter stands for the resolution size of the image file (large, medium, and small). Less compression (higher quality) is indicated by the smoother curve on the icon, while more compression (lower quality) is indicated by the stair-step look to the curve. Once you have made your selection on both rows, press ☉ to accept the setting. The chart on page 83 shows how these different settings affect the number of megapixels used and the image size.

The smaller RAW files are a rather new development in digital photography. As image sensors contain more and more pixels, the file sizes are getting bigger and bigger. Often photographers don't need all the resolution the image sensor can provide, but they still like the advantages of shooting and processing RAW files. Canon has answered that call by introducing smaller RAW files. At first there was just one smaller size, now there are two.

The most useful settings are ◢L (the largest image size for JPEG, 18 megapixels, resulting in an approximate file size of 6.6MB) and 𝗥𝗔𝗪 (always 18 megapixels; since it is uncompressed, no compression symbol is displayed; it results in an approximate file size of 25.1MB).

^ If you normally record JPEGs, try toggling to RAW + JPEG when you suddenly find a situation where the light is just right and the composition looks great. The extra image data allows you the capacity to make a really big print if you decide to do so.

NOTE: Near the top of the Quality menu is a status line that shows the current selection, the size of the image file in megapixels, the dimensions of the image file in pixels, and the number of images—at the current image-recording quality that will fit in the currently available space on the memory card.

The EOS 7D can record both RAW and JPEG simultaneously. This option can be useful for photographers who want added flexibility. It records images using the same name prefix, but with different formats designated by their extensions: .JPG for JPEG and .CR2 for RAW. You can then use the JPEG file (which takes advantage of the DIGIC 4 processor) for printing at a photo kiosk or sending to a friend via email. And you still have the RAW file for use when you need its added processing power. (RAW+▲L setting cannot be used by □ and CA modes).

If you find yourself frequently switching between quality settings, you can set C.Fn (Custom Function) IV-1 (see pages 123 – 126) to change the functionality of ⑨. When this function is utilized, you won't have to press MENU to call up the display and then navigate to [Quality]. You simply press ⑨ and the Quality menu appears on the LCD monitor.

Then it is just a matter of selecting the desired item using ⌂ (RAW selections) or ○ (JPEG selections) and pressing ⊕, and you can start shooting at the new setting.

The RAW file initially appears in your RAW conversion software with the same processing details as the JPEG file (including white balance, color matrix, and exposure), all of which can be altered in the RAW software. Though RAW is adaptable, it is not magic. You are still limited by the original exposure, as well as by the tonal and color capabilities of the sensor. Using RAW is not an excuse to become sloppy in your shooting simply because it gives you more options to control the look of your images. If you do not capture the best possible file, your results will be less than the camera is capable of producing.

Each recording quality choice influences how many photos can fit on a memory card. Most photographers shoot with large memory cards because they need the space required by the high-quality files available on this camera. It is impossible to give exact numbers of how many JPEG images fit on a card because this compression technology is variable. You can change the compression as needed (resulting in varied file sizes), but remember that JPEG compresses each file differently depending on what is in the photo and how much data is redundant. For example, a photo with a lot of detail does not compress as much as an image with a large area of solid color.

That said, the chart on the next page gives you an idea of how large these files are and how many images may fit on a 4GB memory card. The figures are based on actual numbers produced by the camera using such a card. (JPEG values are always approximate.) Also, the camera uses some space on the card for its own purposes and for file management, so you do not have access to the entire 4GB capacity for image files.

You can immediately see one advantage that JPEG has over RAW in how a memory card is used. Even if you use the highest-quality JPEG file at the full 18 megapixels, you can store nearly four times the number of photos compared to what you can store when you shoot RAW.

QUALITY	MEGAPIXELS	FILE SIZE (APPROX MB)	POSSIBLE SHOTS	MAX BURST
RAW + ◢ L	Approx 17.9/17.9	25.1 + 6.6	122	6
M RAW + ◢ L	Approx 10.1/17.9	17.1 + 6.6	164	6
S RAW + ◢ L	Approx 4.5/17.9	11.4 + 6.6	217	6
RAW	Approx 17.9	25.1	155	15
M RAW	Approx 10.1	17.1	229	24
S RAW	Approx 4.5	11.4	345	38
◢ L	Approx 17.9	6.6	593	94
◢ L	Approx 17.9	3.3	1169	469
◢ M	Approx 8.0	3.5	1122	454
◢ M	Approx 8.0	1.8	2178	2178
◢ S	Approx 4.5	2.2	1739	1739
◢ S	Approx 4.5	1.1	3297	3297

All quantities are approximate, based on the photographic subject, brand and type of memory card, ISO speed, and other possible factors.

The Menu System and Custom Functions

The heart of the 7D's control system is its menus, which can be viewed on the LCD monitor located on the back of the camera. Menu systems and LCD monitors are two important features that help define digital cameras. In fact, D-SLR menus are the indispensable way to control a great number of settings found in these sophisticated cameras. Still, in some cameras, menus are a "necessary evil" because they are not always easy to navigate. Canon has put a great deal of thought into the design of the EOS 7D's menus so that they can be used efficiently.

USING THE MENUS

Press the Menu button (MENU), located on the back of the camera near the top left corner of the LCD monitor, to gain access to the EOS 7D's menus. All menu controls, or items, are found in the camera's eleven menus, which are grouped into five categories based on their use. These categories, intuitively named in order of appearance within the menu system, are Shooting ◘, Playback ⊒, Set-up ♀, Custom Functions ◘., and My Menu ★.

After pressing MENU to display the menu tabs, you can scroll left or right from one menu to another in a couple of different ways: (1) use the Main dial ⌂, located on the top of the camera just behind the shutter button, or (2) use the Multi-controller ☼, found on the back of the camera near the top right corner of the LCD monitor.

A large number of items to control various camera functions are found within the menus. You can highlight them by scrolling down (or back up as needed) with either the Quick Control dial ○ (the biggest dial on the back of the camera) or ⁘. Press the Set button ㉂, located in the middle of ○, to select and apply the item you want. Additionally, some items have further options to choose from, which require you to again scroll and make selections using ○ or ⁘ and ㉂. To back out of a menu, press MENU.

Understanding the menu system is necessary in order to fully benefit from using the LCD monitor and the Custom Functions. When the camera is first used, pressing MENU takes you to the Shooting 1 menu ◘⁺. After that, pressing MENU takes you to the last menu you selected, even if you have just powered the camera on.

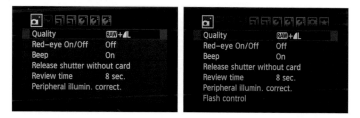

There are fewer menu tabs when you are in one of the fully-automatic shooting modes (left) than in the exposure shooting modes (right).

NOTE: Items marked with an asterisk in all menus are not available in the fully-automatic shooting modes (□, ㉽, as selected on the Mode dial), where the camera controls all settings.

◘⁺ SHOOTING 1 MENU (RED)

The Shooting category with its four red-coded menus is for items that obviously affect actual photography:

QUALITY
The 7D has myriad image file recording choices. When this menu item is selected, there are two main options available: The one for RAW files is controlled by ⟳, and the one for JPEG is controlled by ○.

^ Make sure you choose recording quality appropriately. You can always reduce a file's size without degradation, but you can't increase the size without also increasing image artifacts.

When you shoot RAW files, you can choose from the following resolutions:

- o [-]: None. Use if you want to shoot JPEG only.
- o [RAW]: Highest possible pixel count (approximately 18 megapixels MP) and file size (approximately 25 megabytes MB).
- o [M RAW]: Medium RAW (approx. 10.1MP; approx. 17MB).
- o [S RAW]: Small RAW (approx. 4.5MP; approx. 11.4MB).

When shooting JPEG, you select both the quality (higher or lower amount of file compression) and the pixel count (resolution: large, medium, and small).

- o [-]: None. Use if you want to shoot RAW only.
- o [◢L]: (Default) Highest possible pixel count (approximately 18 megapixels) and quality/file size (approximately 6.6MB).
- o [◢L]: High resolution (approx. 18MP) and high compression (file size approx. 3.3MB).
- o [◢M]: Approx. 8.0MP; approx. 3.5MB.
- o [◢M]: Approx. 8.0MP; approx 1.8MB.
- o [◢S]: Approx. 4.5MP; approx. 2.2MB.
- o [◢S]: Approx. 4.5MP; approx. 1.1MB.

As indicated, choose ◢L (least compressed and highest pixel count, or resolution) to apply the maximum JPEG file quality and size. For the least resolution and maximum compression, choose ◢S, which gives you the smallest file size.

You can also choose to shoot RAW+JPEG formats simultaneously. Make your choice for each format from the options described above by turning the appropriate dial, then confirm with ⊛. If you select [-] for both RAW and JPEG, you will record as ◢L.

RED-EYE ON/OFF

Red-eye is caused when the light from the built-in or camera-mounted flash reflects off the back of people's eyes (retinas). The 7D can emit a strong light from the front of the camera near the shutter button. This causes people's irises to narrow, which reduces the amount of flash light that enters and reflects back from their eyes.

O **[On]**: (Default) Causes the bright light to shine and reduces red-eye.

O **[Off]**: No light is emitted from the front of the camera.

BEEP

For times when you want to be a bit more discreet in your picture taking, this function controls the audible signal for focus and self-timer.

O **[On]**: (Default) Sound is audible.

O **[Off]**: No sound when focus locks or for self-timer.

RELEASE SHUTTER WITHOUT CARD

When you are first going through the 7D and all of its features and functions, you may not care about capturing pictures when you press the shutter. You just want to experiment with the camera's controls.

O **[Enable]**: (Default) This setting allows you to "take a picture" without a memory card in the 7D. The 7D shows you the image in review, but since it is not recorded anywhere, the image disappears when the review period is over.

O **[Disable]**: This will not allow you to fire the shutter when there is no memory card in the camera. This is generally the setting to use once you get through that initial learning period. There is probably nothing more frustrating than taking a picture and not realizing that you don't have a memory card installed in the camera.

REVIEW TIME

This option controls how long the image stays on the LCD immediately after you take the picture. I typically set this to eight seconds (it really doesn't use that much more battery power than a shorter duration).

○ **[Off]**: The image will not show in the LCD after recording. I use this when I don't want my subjects, most often children, to keep running to the camera to see the image. Checking the LCD breaks the mood and stops subjects from doing whatever they are doing when I want to photograph them.

○ **[2 sec.]**: (Default) For me, this is too short to properly evaluate the image.

○ **[4 sec.]**

○ **[8 sec.]**

○ **[Hold]**: The image will display until you press another camera button or until the Auto power off function takes effect.

PERIPHERAL ILLUMIN. CORRECT.

Canon introduced this feature into their professional camera lines a few years back, and have now brought it into other models. Peripheral illumination correction refers to the fact that all lenses have some light falloff at the edges of their optics. This appears as subtle (and not so subtle) vignetting (darkening of the image near its edges and corners). Since Canon builds their own lenses, they know how much falloff each lens model has. When you attach a lens to the 7D, the lens communicates so that the camera knows which model lens is attached.

○ **[Enable]**: (Default) The 7D adjusts the image to reduce the vingetting. If you are using a third-party lens, or an older Canon lens, the feature will be disabled.

○ **[Disable]**: No correction will occur, even if the data is available to do so.

Peripheral illumin. correct.
Attached lens
EF24-105mm f/4L IS USM

Correction data available
 Correction
Enable
Disable

‹ You can reduce the darkness that sometimes occurs around the edge of your frame (vignetting) by enabling the Peripheral illumination correction feature.

FLASH CONTROL*

This not only provides control for the built-in flash, it also offers extensive control of the EX series II Canon Speedlites. For years, photographers who don't use external flashes on a daily basis have been frustrated because it is hard to remember how to set various settings on a Speedlite. The Flash control menu item has solved that problem.

Besides allowing access to external Speedlite functions (Speedlite control is model-dependent), this menu item offers options that allow you to disable flash firing, set built-in flash functions, control external Speedlite Custom Function settings, and clear external Speedlite Custom Functions. Learn more about this advanced and powerful menu item in the flash chapter.

◘˙ SHOOTING 2 MENU * (RED)

NOTE: The options in this menu are not available for the fully-automatic shooting modes. For those modes, Shooting 4 menu ◘⋮ becomes ◘˙ (see pages 95 – 98).

EXPO.COMP./AEB

Exposure compensation is a way to override the exposure automatically set by the 7D when in **P**, **Tv**, and **Av** modes. When this option is selected, a scale from –5 to +5 is presented on the LCD monitor (0 is the default). By rotating ○, you set the exposure brighter or darker; press ⊛ to accept the setting. The compensation value will be displayed on the scale in the viewfinder, the LCD monitor, and the LCD panel (located on top of the camera). Exposure compensation is not reset when you power off the camera, so make sure you keep an eye on the scale.

The 7D can also automatically "bracket" your exposure. Bracketing involves taking one picture with normal exposure, then one image underexposed (from normal) and one that is overexposed. If the camera is in either of the continuous drive modes (❏⌁ or ❏⌁H), the three shots are taken with one shutter button press. Otherwise the shutter release needs to be depressed three times. Until all three shots are captured, the

bracketing icon will blink on the LCD panel and ✱ will blink in both the viewfinder and the LCD monitor. AEB is reset when the camera is turned off, unless Custom Function C.Fn I-4, **[Bracketing auto cancel]**, is set to **[Off]**.

While bracketing was an invaluable tool when shooting film, its original purpose isn't quite as important now that digital cameras include the histogram display and image review on the LCD monitor. But a new digital technique—high dynamic range (HDR) photography—has brought bracketing, and in particular autobracketing, to the forefront. HDR handles difficult exposure situations by merging several identically composed images that have been recorded at different exposure settings. This is usually done with special software in the computer during post processing. A tripod while shooting, also, is helpful.

NOTE: The Quick Control screen (see page 53) is a quick way to access both exposure compensation and AEB. Once you learn how to use that screen, you'll rarely go back to using this menu item.

AUTO LIGHTING OPTIMIZER

This recent introduction to EOS cameras is an exposure correction mode that makes use of the power and design of the DIGIC 4 image processing chips in the 7D. By evaluating the image after capture, the camera can correct over and underexposure while still maintaining image details. This setting only affects JPEG images, but you can also apply this correction during RAW processing when you use Canon's software.

O **[Off]**: This option for brightness correction is disabled.

O **[Low]**: A slight amount of correction is applied.

O **[Standard]**: (Default) A good starting point if you want to apply this option.

O **[Strong]**: The highest amount of correction is applied.

‹ The Auto Lighting Optimizer can apply several different degrees of exposure correction to your recorded images.

WHITE BALANCE

Although there is a separate camera control to access this setting (⊡·WB button), you can also choose one of the nine white balance (WB) presets here in the ◘⁚ menu. When you shoot JPEG, white balance is used in creating the recorded JPEG image. When you shoot RAW, the white balance setting is just a piece of data (metadata) recorded in the RAW file header. It can be changed when doing RAW image processing on your computer. Even though you can change RAW white balance later, I recommend that you get it right in the first place—when you shoot the image. The default WB setting is **AWB** (Auto). Learn more about white balance on pages 67 – 72.

> Preset white balance settings adjust your image for color temperature variations in the scene you are recording.

```
White balance
        Color temp.

    AWB            ☼
    ☀             ⚡
    ⌂             ◻⚲
    ☁         K ◄ 5200 ►
    ☀
```

CUSTOM WB

If you use a Custom white balance ◻⚲ setting, you'll need to tell the 7D what image to use as a basis for white balance (see page 72). Once you have captured an image, select this menu item, scroll to the image you want to use as a reference and press ⊛. By storing several different white balance reference images ahead of time, you can quickly set new Custom white balances as you move from location to location. You can also set Custom white balance by pressing ⊡·WB.

WB SHIFT/BKT

Just like exposure compensation and bracketing, you can adjust how the 7D does white balance. Learn more about this tool on page 74.

‹ Pictures shot in sRGB color space may appear more vibrant on your computer's display.
© Kevin Kopp

COLOR SPACE

This setting is for JPEG images. When setting the color space, you decide what palette (range) of colors you want the 7D to use when creating images. Somewhat like choosing between a box of 64 crayons or 128 crayons, choosing a color space can be important depending on how you will use your images.

O **[sRGB]**: (Default) This choice is the smaller color space and is typically the one used by inkjet printers.

O **[Adobe RGB]**: This is a wider gamut of color, but images may look duller on computer displays or in inkjet prints than sRGB color space.

‹ The Adobe RGB color space has a wider gamut, or range, than sRGB, and is often used for reproduction in commercial printing.

When using RAW format, color space is selected on the computer during image processing. When the camera is set for Adobe RGB, file names will begin with an underscore: _MG_0201 vs. IMG_0201.

During ☐ and ⚙ shooting, color space is automatically set for sRGB. When you shoot video, the color space is set automatically to the HD video color space.

PICTURE STYLE

Much like choosing from assorted film stocks to make images appear differently, the 7D allows you to customize the "look" of your images and videos via Picture Styles. There are six presets that you can use or modify, with ⬛ (Standard) as the default. There are also three User-defined Picture Styles that allow you to create your own look. Canon includes software for creating custom Picture Styles on your computer. You can also visit http://web.canon.jp/imaging/picturestyle/ to download additional Picture Styles. (Learn more about Picture Styles beginning on page 60.)

> When you access Picture Styles through the Shooting 2 menu, you can see at a glance how the parameters of each option have been set.

Picture Style	◐,◑,♣,◐
⬛S Standard	3 , 0 , 0 , 0
⬛P Portrait	2 ,−1, 0 , 0
⬛L Landscape	4 , 0 , 0 , 0
⬛N Neutral	0 , 0 , 0 , 0
⬛F Faithful	0 , 0 , 0 , 0
⬛M Monochrome	3 , 0 , N , N
INFO. Detail set.	SET OK

📷 SHOOTING 3 MENU * (RED)

NOTE: Shooting 3 menu is not available in the fully-automatic shooting modes.

DUST DELETE DATA

Canon's Digital Photo Professional software can be used to automatically eliminate persistent dust that may have accumulated on the 7D's sensor. This menu option shows you the date and time of the last Dust Data capture, and it also takes you through the process of capturing the Dust Delete Data reference file. Learn more about dealing with dust beginning on page 28.

ONE-TOUCH RAW+JPEG

If you normally shoot in JPEG mode, the RAW/JPEG button may be a useful tool. For those times when you want a RAW image (for example, in difficult exposure situations and when you know you will print the image at a large size), press RAW/JPEG to set the file recording mode temporarily to RAW+JPEG. Once you have taken the picture, the file recording mode reverts back to the original setting.

This is also a useful button if you normally shoot only RAW. There may be times when you also want to record a JPEG file so you can quickly email or transfer a shot without processing a RAW file. In this case, if the file recording is set to RAW, pressing ᴿᴬᵂ⁄ᴊᴾᴱᴳ adds a JPEG file (RAW+JPEG) to the image capture.

Use this menu item to set both the RAW resolution (RAW, M RAW, or S RAW) and the JPEG resolution/compression (◢L, ◢L, ◢M, ◢M, ◢S, or ◢S).

◘ SHOOTING 4 MENU (RED)

This menu tab is available when the Live View shooting/Movie shooting switch, located on the back of the camera to the right of the viewfinder, is set for Live View ◘. More details about these menu functions are found on pages 172 – 197, in the chapter called Live View & Movie Shooting.

‹ The Shooting 4 menu controls Live View shooting.

Live View shoot.	Enable
AF mode	Quick mode
Grid display	Off
Expo. simulation	Enable
Silent shooting	Mode 1
Metering timer	16 sec.

NOTE: When the 7D is set for ▢ or CA, this menu becomes Shooting 2 menu ◘ when the Live View shooting/Movie shooting switch is set for Live View ◘. Also, in that circumstance, the menu only contains [Live View shoot.], [AF mode], and [Grid display].

LIVE VIEW SHOOT.

O [Enable]: (Default) The camera allows Live View shooting.

O [Disable]: You are not able to use Live View.

AF MODE

During Live View shooting, the AF sensor is blocked by the reflex mirror. This selection offers alternative AF modes.

> Quick mode is fastest, but Live mode AF will not interrupt the image you are composing on the LCD monitor.

- O **[Live mode]** AF🔲: (Default) Uses the images coming from the image sensor to measure contrasting edges in order to determine proper focus. This method of focusing is slower and not as accurate as AF🔲.
- O **[🙂 Live mode]** AF 🙂: This detects faces in a scene where people are photographed and sets focus to ensure the people are in focus.
- O **[Quick mode]** AF🔲: This selection temporarily flips the reflex mirror down and uses the normal AF sensor for setting focus. While it sounds as if flipping the mirror down and then back up would be slow, it is actually the fastest method of achieving autofocus in Live View.

GRID DISPLAY

This option is useful for image composition.

> The Grid display helps you keep lines level in your image. It is also recommended for copy work to keep objects square.

- O **[Off]**: (Default) No grids are displayed.
- O **[Grid 1]**: A rule-of-thirds grid overlays the Live View Display.
- O **[Grid 2]**: An architectural grid displays.

*EXPO. SIMULATION**

In Live View mode, when this feature is enabled, the 7D tries to simulate on the LCD monitor what the final captured image will look like. There might be instances, such as low-light shooting, when you want to be able to see more detail in the image for focusing or judging composition. Disabling exposure simulation will cause the 7D to try and present a bright image on the LCD monitor no matter whether your exposure setting is under or overexposed.

- O [Enable]: (Default) The brightness in the LCD is close to what you can expect to see in the recorded image.

- O [Disable]: The image presented on the LCD monitor is bright, no matter if your exposure setting is under or overexposed.

TIP: If this option is normally set to [Disable], you can always use the Depth-of-Field Preview button (located on the front of the camera, below the lens release button to the left of the lens mount) to quickly simulate exposure.

When Exposure simulation is set to [Enable], the ExpSIM icon is displayed at the lower right of the LCD monitor. If the 7D is not able to simulate the exposure (i.e., when the camera is set for an extremely overexposed shot), the icon blinks. If the camera is not set for exposure simulation ([Disable] is selected), ◻DISP is displayed instead.

*SILENT SHOOTING**

Though there is less sound when taking a picture in Live View because the reflex mirror is already in the up position, there is still some noise as the shutter is opened, closed, and reset for the next exposure. These options lessen noise even further.

- O [Mode 1]: (Default) This resets the shutter right after the picture is taken.

- O [Mode 2]: The reset happens only after you take your finger off the shutter release, so there will be no reset sound as long as you keep the shutter depressed.

- O [Disable]: This option should be used when you shoot with tilt-shift lenses or close-up tubes. This is required to ensure that exposures are accurate. When you use the built-in flash or a Canon Speedlite, the 7D will not perform the silent shooting function. This option must be selected when using a third-party flash, or else it will not fire.

*METERING TIMER**

By default the metering system stays engaged for 16 seconds when you tap the shutter release button. Use this option if you want the meter to shut off earlier or stay on longer. The range is four seconds to 30 minutes.

♥ *MOVIE SHOOTING MENU (RED)*

This menu tab is available when the Live View shooting/Movie shooting switch is set for Movie mode ♥. More details about these menu functions are found in the Live View & Movie Shooting chapter.

> Canon has been an industry leader in utilizing HD video within their D-SLR cameras.

AF mode	Quick mode
Grid display	Off
Movie rec. size	1920x1080 🖳
Sound recording	On
Silent shooting	Mode 1
Metering timer	16 sec.

AF MODE

This is exactly the same control as found in ▢ (see page 96).

GRID DISPLAY

This is exactly the same control as found in ▢ (see page 96).

MOVIE REC. SIZE

There are three High-Definition (HD) settings and one standard-definition setting for recording video.

 o **[1920x1080]**: Full HD. While 1920 x 1080 represents the number of pixels (horizontal x vertical), there are two different frame rates available for Full HD—30 (default) and 24—representing the number of frames captured per second (fps). 30 fps is the typical frame rate for High-Definition material that originates in video cameras. 24 fps is the typical frame rate used in shooting films that you see in a movie theater. For a more "cinematic" look you would choose **[1920x1080 24]**.

< The biggest
visual difference
between using
the 7D and a
camcorder for
shooting High-
Definition video
is the incredible
depth-of-field
control the 7D
gives you.

THE MENU SYSTEM AND CUSTOM FUNCTIONS

99

O **[1280x720]**: This HD format offers a rate of 60 fps, which can capture scenes that contain a great deal of motion. It is also used when you want to slow down the footage as you edit the movie on a computer.

O **[640x480]**: At 60 fps, this setting is approximately the size of standard definition video.

NOTE: The frame rates are rounded up. In actuality, the 7D records in 29.97, 23.976 and 59.94 frames per second.

SOUND RECORDING
There may be times when audio is not necessary or may not be wanted.

O **[On]**: (Default) Sound will be recorded with your movie.

O **[Off]**: You can turn off all audio recording, whether you use the built-in microphone or an external microphone.

SILENT SHOOTING*
This is exactly the same control as found in \square (see page 97). It only affects still pictures. Shooting video does not use the shutter.

METERING TIMER*
This is exactly the same control as found in \square (see page 98).

This blue-coded menu is the first of two Playback menus that offer several choices for viewing images on the LCD monitor.

PROTECT IMAGES

This is a useful tool to prevent images from being erased. Highlight the item and press ⑤. An image displays in the LCD monitor with a key symbol next to the word [SET] at the top left of the photo. Go through your photos one by one using either ○ or 🖐. Push ⑤ for every image that is a potential keeper. A small ⊠ appears in the information bar at the top of the LCD monitor. Press MENU to exit after protecting the desired image files. Although protecting images prevents them from being erased, formatting a memory card ignores protection and deletes all data from the card.

> Protecting images can
help when you want to
delete a number recorded
photos. Protect the ones
you want to keep, then
erase all images on card
(see next item) to get rid
of the rest.

Protect images
Rotate
Erase images
Print order

ROTATE

If the [Auto rotate] item is not turned on in 🔧', use this selection to rotate captured images. When selected, the last image displayed is presented. Press ⑤ to rotate the image one way, press ⑤ again to rotate it the other way. Press ⑤ again to return to the original orientation. Use ○ or 🖐 to scroll through other images to rotate. Press MENU to exit after rotating the desired image files.

ERASE IMAGES

○ [Select and erase images]: To erase individual images, choose this option and press ⑤. Use ○ to scroll through your images and press ⑤ whenever you want to delete an image. A checkmark is placed next to a 🗑 icon in the upper left corner of the display. Once you have selected the images to delete, press 🗑 to erase the images. You'll be asked to confirm the erasure.

< Erasing images can keep your memory card as well as your image downloads from becoming cluttered with substandard pictures.

O **[All images in folder]**: This allows you to select a folder on your memory card and erase all the images in it.

O **[All images on card]**: This will erase all the images on the card. Why would you erase all the images on the card instead of formatting the card? Formatting the card erases images that are protected (see above item); erasing **[All images on card]** or even **[All images in folder]** leaves protected images alone.

NOTE: Once a file is erased, it is gone for good. Make sure you no longer want an image or video before making the decision to erase it.

PRINT ORDER

You can specify which images print when you bring your memory card to a photo retailer or when you connect the 7D directly to a PictBridge-capable printer. Learn more in the Output chapter (pages 245 – 267).

⊒⁝ *PLAYBACK 2 MENU (BLUE)*

HIGHLIGHT ALERT

This is an important tool for evaluating exposure on the LCD monitor, second only to the histogram. Overexposed areas of an image can extend beyond the dynamic range of the sensor and become pure white in the image (clipped), with no detail.

O **[Enable]**: This will cause overexposed areas to blink on the LCD monitor during Image Review and Playback. While there may be times when overexposing parts of the image is okay, this feature shows you just how much is overexposed.

O **[Disable]**: (Default) No blinking areas will display on the LCD monitor during Image Review or Playback.

AF POINT DISP.

This item identifies the AF point(s) that were used to set focus.

○ **[Enable]**: The playback image shows red AF point overlays to indicate the AF points that were active when the image was captured.

○ **[Disable]**: (Default) No overlays display on AF points.

HISTOGRAM

The 7D offers two types of histograms for evaluating image exposures. This allows you to select which one is displayed during Playback.

> A histogram is a great tool to objectively analyze exposure.

Highlight alert	Disable
AF point disp.	Disable
Histogram	Brightness
Slide show	
Image jump w/	10 images

○ **[Brightness]**: (Default) This shows the overall distribution of tones in the image.

○ **[RGB]**:Shows the tonal distribution within each color channel.

Note that the histogram is based on the JPEG image. If you are shooting RAW only, the histogram is still based on a JPEG file display. Learn more about using histograms starting on page 169.

SLIDE SHOW

This option automatically creates a slide show on the LCD monitor of the images that have been recorded on your memory card. The length of time the images are displayed is user-selectable, and you can also set the show to repeat. You can also choose to filter the files to include in your slide show.

> You can view recorded images in Playback by creating a slide show on your LCD monitor.

O **[All images]**: Includes all still photos and movies.

O **[Folder]**: Select the folder you want to see in a slide show.

O **[Date]**: Select a specific date for stills and movies.

O **[Movies]**: All movies, and only movies, will be played back.

O **[Stills]**: All stills, and only the stills.

IMAGE JUMP W/ 🗠

When you are in Playback mode, normally you scroll through images one at a time using ○. By using 🗠 instead, you can navigate more quickly by jumping past multiple images. This option sets that "jump" quantity. You can also jump by date, folder, movies, or stills. This is useful if you shoot both stills and movies and want to see just the movies that are scattered about in the image folder.

O **[1 image]**

O **[10 images]** (Default)

O **[100 images]**

O **[Date]**

O **[Folder]**

O **[Movies]**

O **[Stills]**

♥' SET-UP 1 MENU (YELLOW)

Color coded yellow, this is the first of three set up menus that present selections to control overall camera operation.

AUTO POWER OFF

The 7D shuts itself off after a period of idleness in order to save battery power. The power-off setting offers six options, ranging from **[1 min.]** (Default) to **[30 min.]**, plus a setting for **[Off]** (the camera will not power off). Even when this option is set to **[Off]**—for example, if you shoot in a studio with the optional AC adaptor—the LCD monitor will turn off after 30 minutes of inactivity.

AUTO ROTATE

The 7D has a positional sensor that can determine if you are holding the camera vertically or horizontally. This information is embedded in the image's file header so that when the image is displayed, it is oriented properly.

> To display photos in Image Review and Playback as large as possible, set the 7D to rotate images only on the computer, not on the LCD.

Auto power off	8 min.
Auto rotate	On
Format	
File numbering	Continuous
Select folder	

O **[On 📷 💻]**: (Default) Images shot with the 7D in a vertical position are rotated to display correctly on the camera's LCD monitor and on your computer's monitor.

O **[On 💻]**: The vertical image is only rotated on the computer's display. I like this option because the image is larger on the 7D's LCD monitor, allowing me to evaluate it more easily. And because I am usually still holding the camera vertically, I don't have to rotate the camera back to horizontal to view the image.

O **[Off]**: The image is not rotated on the LCD (or computer screen). Even if you later set this option to **[On 📷 💻]** or **[On 💻]**, images previously shot will not have embedded orientation data. If you want to rotate the image, you must use **[Rotate]** in ▣.

NOTE: Automatic file rotation on your computer depends on the software you use to view your images.

FORMAT

CompactFlash cards need to be formatted for use in the 7D. This menu item performs this function. It is also a quick, though slightly risky, way to determine how much space (in GB) has been used on your memory card, because that information is displayed on the formatting screen. Formatting should always be done in the camera rather than on the computer.

```
┌─────────────────────────────────────┐
│  Format                        [CF]  │
│            Format card               │
│        All data will be lost!        │
│       ▓▓▓▓▓▓▓▓▓▓▓▓▓▓▓▓▓▓▓            │
│     14.7 GB used          14.9 GB    │
│                                      │
│        ┌──────────┐                  │
│        │  Cancel  │     OK           │
│        └──────────┘                  │
└─────────────────────────────────────┘
```

‹ Format your CompactFlash card often for the health of your image files. But make sure you have downloaded pictures from the card before formatting.

○ [OK]: The formatting process will occur.

○ [Cancel]: No formatting, screen will return to ♥ .

CAUTION: There is no undo for formatting. Formatting ignores any file protection settings. All data will be erased.

FILE NUMBERING

The 7D stores image and movie files in folders. Within each folder, the file names must be unique.

○ [Continuous]: (Default) File numbers increase by increments of one, no matter what memory card is inserted in the camera. If there is a conflict between a new file and an existing file (i.e., if you use a card with files already on it), the new file picks up the number sequence after the last file in the folder. To avoid confusion, use freshly formatted cards or create new folders.

○ [Auto reset]: This option resets the file name to start at 0001 each time you put a memory card in the camera or create a new folder. Once again, if there is a conflict the numbering picks up after the last image in the folder. As above, use freshly formatted cards or create new folders to avoid confusion.

○ [Manual reset]: This allows you to control when to reset the file numbering. When you select this option, a new folder is created and the file numbering is reset to 0001. This is useful when you are photographing in different locations and want to group your images by location.

When you decide how to set your file numbering, consider how you will deal with the images once they are on your computer. I try to avoid the possibility of duplicate file names, and I use folders to group my images. I prefer to use Continuous file numbering, and I keep my shoots organized by using the [Select folder] function (see next item) to create new folders.

NOTE: When the camera reaches folder 999 and image 9999, even if it has sufficient space, it will not be able to record another picture until you replace the memory card.

SELECT FOLDER

This menu item displays a list of the folders on the memory card so that you can select which one you want to record to. It also has an option that allows you to create a new folder.

O **[Create folder]**: Folder names start at 100EOS7D and increase increments by one (e.g. 101EOS7D,102EOS7D, etc.).

You can also use your computer to create a folder-numbering scheme on the memory card. Start with a DCIM folder at the top level. Within that folder, create folders using a naming scheme of 100AAAAA. The first three digits must be numbers only, between 100 and 999, and must be unique. There cannot be two folders that start with the same three digits, even if the last five characters are different. The five following characters can be upper- or lower-case letters from A to Z; numbers; or an underscore. Do not use special characters or spaces.

NOTE: If you use custom folders, you must first format the memory card in the 7D. Do not use the computer to format the card.

❤: SET-UP 2 MENU (YELLOW)

LCD BRIGHTNESS

This menu item allows you to set the LCD monitor's brightness level. Use 🔅 to choose between options.

O **[Auto]**: (Default) A light sensor (located to the upper left of the ◯ dial) automatically adjust brightness for viewing conditions. You can also use ◯ to adjust between three brightness levels.

O **[Manual]**: Control LCD brightness by using ◯ to select from among seven brightness levels. Press ◉ to accept the setting.

DATE/TIME

Use this option to adjust the date and time that is recorded with images. You should check this setting when you travel so that you are able to keep track of when you took pictures. Date and time information is retained in the camera when you change batteries. If you notice that the date and time are reset when you change batteries, you'll need to change the special "date/time" battery, which is a slim button battery (CR1616) located in the battery compartment. The life of this battery is about five years.

● LANGUAGE

There are options for setting your camera in 25 different languages. If you accidentally change the language and can't read the new language to set it back, just look for the comic strip word bubble—●—in the menu. No matter which language the camera is set for, this icon appears. Select it and it will take you to the list of languages.

VIDEO SYSTEM

North America (and a few other countries) uses a system called NTSC for analog television; while a system called PAL is used outside of North America. You need to match the 7D's video setting to the video monitor system when connecting the camera using the A/V terminal (not HDMI). Don't worry if you are not sure which to use. You can't harm anything by using the wrong setting—the television just won't display the 7D's images.

LCD brightness	Auto
Date/Time	10/27/'09 22:16
Language●	English
Video system	NTSC
Sensor cleaning	
VF grid display	Disable

‹ The Set-up menus govern the 7D's infrastructure, allowing for the smooth utilization of the Shooting and Playback operations.

SENSOR CLEANING

The 7D is equipped with an auto cleaning system that vibrates the sensor to shake off any accumulated dust.

O **[Auto cleaning ⌂]**: (Default) This operates automatically to enable the cleaning function when the camera powers-on and powers-off.

O **[Clean now ⌂]**: This lets you choose to start the auto cleaning function immediately.

O **[Clean manually]**: This option to manually clean the sensor should only be used with care. See pages 28 – 31 to learn more about sensor cleaning.

VF GRID DISPLAY*

The 7D has a new LCD overlay technology in the viewfinder. Use this function to hide or display an overlay grid to assist you in composing your shot.

O **[Disable]**: (Default) No grid will display in the viewfinder.

O **[Enable]**: Displays grid as overlay in viewfinder.

♈: SET-UP 3 MENU* (YELLOW)

BATTERY INFO.

This menu item brings up a display that presents valuable information about the battery in your camera. Among other data, this screen will tell you:

1. The remaining battery level as a percentage.
2. The number of pictures taken since the battery was last charged. The shutter count is reset when the battery is recharged.
3. How well the battery is recharging.

> The battery information is invaluable, giving you a good idea of how much shooting you have available on the current charge.

Battery info. — INFO ⊞
⌂ LP–E6
Remaining cap. ▭ 55%
Shutter count 7
Recharge performance ■■■
MENU ↩

Press INFO. to register up to six batteries so you can keep track of performance and charge level. This feature only works with genuine Canon batteries (LP-E6).

INFO. *BUTTON DISPLAY OPTIONS*

Pressing INFO. successively cycles through various displays on the LCD monitor. Use this item to add information to the INFO. display. Highlight a desired option and press ⊕ to select it with a ✓ and add it to the "cycle".

- O [Displays camera settings]
- O [Electronic level]
- O [Displays shooting functions]: This is invaluable when you are shooting. It displays almost all the parameters: exposure settings, file recording mode, metering, white balance, and battery level. More importantly, it gives you access to—and follows—the same layout as the Quick Control screen.

After the last checked option displays, another press of INFO. blanks the screen completely.

CAMERA *USER SETTING* *

There are three user settings on the Mode dial—**C1**, **C2**, and **C3**. These allow you to customize the 7D for your shooting styles. For example, you may want one setting for portraits and another for sports. Use this menu option once you have customized the camera.

- O [Register]: Select one of the Mode dial settings, then ⊕. Select [OK] and confirm ⊕. Your camera's settings will be registered to the selected user setting.
- O [Clear settings]: Select to make the current user settings revert to default.

‹ The ability to customize camera settings for specific situations can save time and deliver consistent results.

COPYRIGHT INFORMATION*

The 7D can embed your name and other copyright information in every image captured by the camera. Entering the data can be a bit tedious using ☼ and ⊙. A better option is to use Canon's EOS Utility software that comes with the 7D. See page 257 for more information.

CLEAR ALL CAMERA SETTINGS*

This is a useful tool when you are first trying out your camera. Many times you'll turn on so many features and options that you'll become a bit overwhelmed. This is particularly the case since you can reprogram several of the camera's controls. This menu returns camera settings to factory-set defaults, clears Custom Functions (C.Fn), and deletes copyright information.

FIRMWARE VER.*

Cameras run on software. Firmware is that portion of the software that can be updated. This option displays the current firmware version. Check the Canon support site on a regular basis to see if the firmware version has been updated. Once a new firmware update is available, follow the procedures that come with the update. It usually requires that you copy the update to a memory card, insert it into the camera, and select [Firmware Ver.] to start the update process. Confirm the version number to make sure the update installed correctly. Always follow the instructions exactly or you may end up with an unusable 7D.

NOTE: Remember that all menus and items marked with an asterisk are not available in the fully-automatic shooting modes.

★ MY MENU * (GREEN)

If you find yourself returning to certain menu items and Custom Functions on a regular basis, the 7D allows you to build your own customized menu. This is a powerful tool that you can use to make camera adjustments easily and quickly. For example, I have built my own menu that has Mirror lockup, Highlight tone priority, Flash control,

Highlight alert, and ISO expansion. Sometimes I will remove one or two items and add other things, like Select folder, if I want to sort images as I shoot; or I might load up the menu with video options if I am shooting video all day.

When you first use the EOS 7D, the My Menu display only has one selection: [My Menu settings]. Through this selection you can build a custom menu using any of the top-level choices in any of the menus, as well as each of the Custom Functions. My Menu can contain up to six selections.

Flash control	
Live View shoot.	
Movie rec. size	1920x1080 ⬚30
Highlight alert	Enable
Select folder	
My Menu settings	

‹ A major asset of My Menu is its flexibility. You can build your own menu, then quickly change or sort the items as desired.

To build a menu, first press MENU and move to the ★ tab. Highlight [My Menu settings], and then press ⊛. From the submenu that then displays, scroll to highlight [Register], and press ⊛ again. A list of every top-level menu option and all Custom Functions, is displayed.

Now scroll to select the desired option and press ⊛ again. Highlight [OK] and press ⊛ to confirm the addition of the selected option to ★. Once selected, the option will be grayed-out so that you can't insert the same option twice.

Repeat the process until you have selected the options you want, up to a maximum of six. Press the MENU button to exit the selection screen, then press MENU again to see the resulting My Menu.

The submenu under [My Menu settings] also allows you the option to sort your menu items once you've added them. Select [Sort] from the submenu and press ⊛. [Sort My Menu] is displayed, showing the current order of your menu items. Scroll to highlight an item you wish to move. Press ⊛ and an up/down arrow appears to the right of the item. Use ○ to move the item up or down in the list. Press ⊛ once the item is in the preferred position. Either repeat these steps to change the position of other items, or press MENU to exit [Sort My Menu].

If you have filled ★ with six items, you must delete an item before you can insert a new one—there is no exchange function. Highlight [Delete] in the [My Menu settings] submenu and press ⊛, then move to highlight an item you wish to delete. Press ⊛ and a dialog asks you to confirm the deletion. Highlight [OK] and press ⊛. Repeat this process if you wish to delete other My Menu items, then press MENU to exit the [Delete My Menu] screen. Similarly you can select [Delete all items] to start with an empty My Menu.

You can customize your EOS 7D so that ★ is displayed every time you press MENU (no matter which menu you were last on). To do so, highlight [Display from My Menu] in the [My Menu settings] screen. Press ⊛, then highlight [Enable], and press ⊛.

NOTE: You can also use Canon's EOS Utility software that comes with the 7D to build your My Menu.

📷 CUSTOM FUNCTIONS

In addition to allowing choices about exposure mode, metering, drive, Picture Style, and so forth, the 7D also permits you to further customize and personalize the camera settings to better fit your method and approach to photography. This is done through the Custom Functions (C.Fn) menu. Some photographers never use these settings, while others use them all the time. The camera won't take better photos by itself when you change these settings, but Custom Functions may make the camera easier for you to take better pictures.

> Custom Function settings are retained—not reset—when the camera is powered off. Make sure you are aware of altered Custom Functions whenever you turn the camera back on. © Rebecca Saltzman

The EOS 7D has 27 different built-in Custom Functions (though they are not available in the fully-automatic shooting modes). They are organized into four groups: C.Fn I: Exposure; C.Fn II: Image; C.Fn III: Autofocus/Drive; and C.Fn IV: Operation/Others.

< The Custom Functions menu represents dozens of functions that give a great deal of control over the operation of the 7D.

Custom Functions are found in the 📷 menu. Once there, navigate to the desired Custom Functions group—I through IV—using ○ and press ⊛. Use ○ to select the Custom Function you want to adjust and again press ⊛. Highlight the setting you want to use and press ⊛ to accept. The new setting will be displayed in blue. The setting number will appear below the function number in the lower left of the LCD monitor. To exit 📷, press MENU or lightly tap the shutter release button.

The current function number is displayed in the upper right corner of the LCD monitor when you are in a Custom Function menu, while all of the function numbers of the selected group and their current settings are displayed at the bottom of the LCD monitor. Settings displayed here in blue indicate that the particular Custom Function is not set for its default.

NOTE: The first selection in each Custom Function is the default setting for the camera.

C.FN I: EXPOSURE

C.FN I-1 EXPOSURE LEVEL INCREMENTS

This sets the size of incremental steps for shutter speed, aperture, exposure compensation, and autoexposure bracketing (AEB).

0: **[1/3-stop]**: The increment is 1/3 stop.

1: [1/2-stop]

C.FN I-2 ISO SPEED SETTING INCREMENTS

As with exposure level increments, you can change the ISO speed increment.

> The bottom of each CF screen shows a numerical list of functions in the group and their current settings. Blue ones signify the setting has been changed from default.

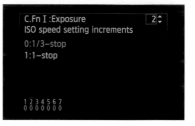

0: **[1/3-stop]**: The increment is 1/3 stop.

1: **[1-stop]**

C.FN I-3 ISO EXPANSION

This setting allows you to extend the ISO speed range into the expanded ISO values.

0: **[Off]**: Normal ISO range of camera, 100 – 6400.

1: **[On]**: Expanded ISO range of camera, 100 – 12800.

NOTE: ISO 12800 is represented by "H"

C.FN I-4 BRACKETING AUTO CANCEL

This function allows the camera to cancel bracketing—both exposure bracketing and white balance bracketing—when the camera powers-off, when camera settings are cleared, when the flash is ready, or when Bulb exposure is selected. If this parameter is set to default **[On]**, exposure bracketing will also be cancelled if a flash is attached to the camera and

is set to fire. If set to [Off] and a flash is used, the bracketing will not be executed, but the amount of bracketing will be remembered.

0: [On]
1: [Off]

C.FN I-5 BRACKETING SEQUENCE

You can change the order of the bracketed shots with this function—both exposure and white balance. Either the first shot or the middle shot is normal exposure. When using white balance bracketing, the + represents amber and green, the – represents blue and magenta.

0: [0, –, +]
1: [–, 0, +]

C.FN I-6 SAFETY SHIFT

Use this function for difficult exposure situations. If the camera is set for **Av** or **Tv** exposure modes, and [Enable (Tv/Av)] is selected, the exposure is adjusted during shooting to produce proper exposure. For example, imagine you have selected [Enable (Tv/Av)] and you shoot in **Tv** mode with a 1/125 shutter speed. If the lens aperture can't open up to let in enough light, the camera changes the shutter speed in order to achieve a proper exposure.

0: [Disable]
1: [Enable (Tv/Av)]

C.FN I-7 FLASH SYNC. SPEED IN AV MODE

This sets the flash sync in Aperture-Priority mode either to automatic adjustment or to a fixed setting. When set for the default (0.[Auto]), you can use flash for slow shutter speeds, which may cause blurred elements in your scene. Option 1 limits the slow shutter speed to no slower than 1/60 second, so there is less blurring. To lessen blur even more, option 2 forces the 7D to always use 1/250 second when a flash is engaged.

0: [Auto]
1: [1/250-1/60 sec. auto]
2: [1/250 sec. (fixed)]

C.FN II: IMAGE

C.FN II-1 LONG EXP. NOISE REDUCTION

This setting engages automatic noise reduction for long exposures. When noise reduction is used, the processing time of the image is a little more than twice the original exposure. For example, a 20-second exposure takes an additional 20 seconds to complete.

> **Though the default setting is [Off], [Auto] is a better choice if you shoot evening or morning shots with long shutter speeds.**

C.Fn Ⅱ :Image 1⏷
Long exp. noise reduction
0:Off
1:Auto
2:On

1 2 3
0 0 0

0: **[Off]**: Long exposure noise reduction is turned off.

1: **[Auto]**: Noise reduction is applied to noise detected on exposures of one second or longer.

2: **[On]**: Noise reduction is turned on for all exposures one second or longer, even if no noise is detected.

C.FN II-2 HIGH ISO SPEED NOISE REDUCT'N

As you increase the apparent sensitivity of the 7D by using high ISO settings, you increase the noise in the image. This Custom Function helps to reduce that noise. When set to **[Strong]**, it decreases the number of shots that can be captured in a row. The noise reduction may be difficult to see if shooting RAW and you display the image on the camera or print directly from the camera.

0: **[Standard]**

1: **[Low]**

2: **[Strong]**

3: **[Disable]**

> **Sometimes high ISO settings cannot be avoided. It is best to take precautions to limit noise in such circumstances.**

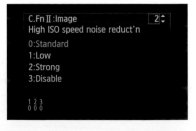

C.Fn Ⅱ :Image 2⏷
High ISO speed noise reduct'n
0:Standard
1:Low
2:Strong
3:Disable

1 2 3
0 0 0

C.FN II-3 HIGHLIGHT TONE PRIORITY

This is one of the EOS 7D's more interesting Custom Functions. Enable this option to expand dynamic range near the bright area of the tone curve. If you are shooting scenes filled with white objects, like bridal gowns or snowy landscapes, this Custom Function will help keep details in the bright areas. When enabled, the ISO speed range available is 200 – 6400. You may see more noise in the dark areas of the image when enabled.

 0: **[Disable]**

 1: **[Enable]**

NOTE: When the 7D has Highlight tone priority enabled, **D+** will be displayed in the viewfinder, on the LCD panel, and on the LCD monitor.

C.FN III: AUTOFOCUS/DRIVE

C.FN III-1 AI SERVO TRACKING SENSITIVITY

When the 7D is set for **AI SERVO** autofocus, this Custom Function allows you to adjust how quickly the focus system reacts to moving objects in the frame. The range goes from slow to fast. When set for **[Slow]**, an object that quickly pops up and then disappears will be ignored. If set for **[Fast]**, the camera will quickly lock on to objects that suddenly appear in the scene.

Essentially what you are doing when you set the sensitivity to **[Slow]** is to add a delay before the AF system reacts to a new object in the scene. It is important to remember that setting this parameter to **[Fast]** does not make the 7D achieve focus any faster.

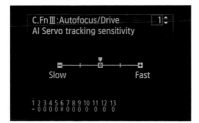

‹ There is no perfect tracking sensitivity setting. Your choice comes down to balancing the need to stay with the original object or move on to a new one.

NOTE: Unlike most Custom Functions, this adjustment doesn't have specific numbers to select. The settings are similar to the following:

-2: [Slow]

-1: [Moderately slow]

 0: [Standard sensitivity]

+1: [Moderately fast]

+2: [Fast]

C.FN III-2 AI SERVO 1ST/2ND IMG PRIORITY

When the 7D is set for a continuous drive mode, and focus is set for **AI SERVO** AF, this Custom Function sets the priority of camera functions for the first image captured and the priority for each successive image. Essentially, you are choosing whether rapid fire is more important than focus tracking. When the first shot of the sequence is set for [AF priority], a set amount of time is given for achieving focus; then the shutter is fired. Focus doesn't necessarily have to be locked to take the shot, but with the fixed time there is a good chance that focus has been achieved. When the first shot is set for [Release] (think "shutter release"), the image is captured as soon as the shutter release button is depressed fully (no delay for focus), regardless of whether the image is in focus.

When the second image of the sequence is set for [Tracking priority], more time is given before the second shot is taken in order to achieve focus. When there is a difficult focus tracking situation, the continuous shooting speed will be slower. When the second shot is set for [Drive speed priority], emphasis is placed on drive shooting speed.

 0: [AF priority/Tracking priority]

 1: [AF priority/Drive speed priority]

 2: [Release/Drive speed priority]

 3: [Release/Tracking priority]

TIP: Use option 0 when you want to shoot fast-moving objects but are concerned that focus will need to be tracked (adjusted) for subsequent shots. Option 1 is great if the first shot will set focus for the subsequent shots. Use Option 2 when you are more concerned about getting the quick shot, even if it is a little out of focus. The last option is good for getting the shot, but also giving the camera a bit more time to track focus on subsequent shots.

C.FN III-3 AI SERVO AF TRACKING METHOD

When the camera is set for **AI SERVO** AF, the 7D can track focus on the closest object that enters the scene [Main focus point priority], or it can ignore the object and continue focus tracking on the first object the focus locks on [Continuous AF track priority].

 0: [Main focus point priority]

 1: [Continuous AF track priority]

When the 7D is set for 19-point AF ⊂ ⊃, or AF point expansion ⋅⊹⋅, the main focus point is the first AF point that begins focus tracking. But with Zone AF | |, the main focus point is the active AF point.

C.FN III-4 LENS DRIVE WHEN AF IMPOSSIBLE

If you are using autofocus and the lens keeps hunting for proper focus, this Custom Function can stop the camera from trying to focus. If you use a long lens and autofocus results in an extremely out-of-focus setting, select [Focus search off] to minimize the problem.

 0: [Focus search on]

 1: [Focus search off]

C.FN III-5 AF MICROADJUSTMENT

The 7D allows you to further refine the focus system. You can store adjustments for up to 20 different lenses or you can adjust focus for all lenses by the same factor. If you exceed 20 lenses, but want to add a new one, mount a previously stored lens and zero out the setting before entering the new lens' setting. To microadjust the focus for the currently mounted lens, highlight [Adjust by lens] and press INFO., then use ◯ to adjust the focus backwards or forwards in 20-step increments in each direction, then press ⊕. The amount that each step represents depends on the maximum aperture of the lens. Once set, take a picture and evaluate focus; repeat the procedure to adjust the focus as necessary.

 0: [Disable]

 1: [Adjust all by same amount]

 2: [Adjust by lens]

Only use this setting if you notice a problem. If not done properly, you could end up with a lens that never achieves sharp focus.

C.FN III-6 SELECT AF AREA SELEC. MODE

Normally the 7D is set for three different AF area selection modes: 19 point AF ⊂ ⊃, Zone AF ⊦ ⊦ and Single point AF □. Use this option to enable two more modes: AF point expansion ⵈⵈ and Spot AF ▣.

[Disable]: Sets the mode choices to the three default options.

[Enable]: Sets the mode choices to the options that have been registered.

[Register]: Enters selection mode so you can add and delete choices.

> Enabling an option doesn't mean you have to use it, just that it is available if you need it.

```
C.Fn Ⅲ :Autofocus/Drive          6 ↕
Select AF area selec. mode
     Disable      Enable      Register
      ✓  ( ⁚ )              ✓   □
      ✓  [  ]              ✓   ▣
      ✓  ⵈⵈ                   Apply

1 2 3 4 5 6 7 8 9 10 11 12 13
– 0 0 0 0 ＊0 0 0  0   0   0   0
```

When you enter the [Register] mode, you can select the choices using ◯. Press ⊛ to place a checkmark next to each mode you want to enable. You must then select [Apply] and press ⊛ to accept the selection. Make sure that [Enable] is selected and press ⊛ again.

C.FN III-7 MANUAL AF PT. SELEC. PATTERN

When you manually select AF points and you get to the last point on the edge of the frame, the 7D can either continue on to the AF point on the opposite edge of the screen, or it can stop at the edge. Stopping at the edge is useful if you often use AF points near the edge of the frame.

0: [Stops at AF area edges]

1: [Continuous]

C.FN III-8 VF DISPLAY ILLUMINATION

The viewfinder can illuminate the AF points and grids in red. This can be done automatically when the 7D senses the light level is low, or it can be set to always illuminate. If you find it distracting you can also disable illumination, even in low light.

0: [Auto]

1: [Enable]

2: [Disable]

C.FN III-9 DISPLAY ALL AF POINTS

When you shoot, you can display all the AF points or just the ones that are active.

 0: **[Disable]**: Displays active AF points.

 1: **[Enable]**: Displays all AF points.

C.FN III-10 FOCUS DISPLAY IN AI SERVO/MF

If the 7D is set for **AI SERVO** AF and you are using either 19-point AF ⊂ ⊃ or Zone AF ⊥ ⊥, set this function to **[Enable]** so you will know which focus point is being used to track the subject. If you are using manual focus, the points will also show up. If this focus confirmation is distracting, you can disable this feature.

 0: **[Enable]**

 1: **[Disable]**

C.FN III-11 AF-ASSIST BEAM FIRING

This controls the AF-assist beam. With the built-in flash and some Canon Speedlites, the AF-assist beam is a series of rapid, low-power flash bursts that are useful when operating autofocus in low-light situations. Some Canon Speedlites like the 580EX II use an infrared (IR) AF-assist beam instead.

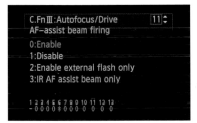

‹ Use Option 3 with an accessory EX flash when you are don't want to drive your subjects crazy with a bright visible AF-assist beam.

 0: **[Enable]**: The AF-assist beam is emitted whenever appropriate.

 1: **[Disable]**: This disables the AF-assist beam.

 2: **[Enable external flash only]**: In low light, an accessory EX flash unit fires its AF-assist beam. The built-in flash's AF-assist feature is disabled.

 3: **[IR AF assist beam only]**: In low light, an accessory EX flash unit that has an IR AF-assist beam fires its beam. This is useful when you don't want even a low-power flash to distract your subject.

C.FN III-12 ORIENTATION LINKED AF POINT

When you manually set the AF point or AF Zone, the 7D normally uses the same point no matter which way you hold the camera. For instance, if you select the last AF point on the left when the camera is horizontal, when you switch to vertical the AF point will be on the bottom or the top, depending on which way you rotated the camera. By selecting option 1, you can explicitly set different AF points for horizontal and both vertical orientations (grip at the top and grip at the bottom).

0: **[Same for both vertic./horiz.]**

1: **[Select different AF points]**

When option 1 is selected, you will need to set the points explicitly for each vertical mode. The 7D does not convert the selected horizontal point to a comparable vertically-oriented point. Remember that there are three orientations: horizontal, vertical with the grip at the top, and vertical with the grip at the bottom.

C.FN III-13 MIRROR LOCKUP

This Custom Function turns Mirror lockup on or off. Mirror lockup is used to minimize camera shake during exposures.

0: **[Disable]** The mirror functions normally.

1: **[Enable]** The mirror moves up and locks in position with the first push of the shutter button (press fully). With the second full pressing of the shutter button, the camera takes the picture and the mirror returns to its original position. After 30 seconds, this setting automatically cancels.

› Locking the mirror up before shooting insures there is no camera vibration, especially during long shutter speeds, as the camera has time to settle down before the shot.
© Kevin Kopp

C.FN IV-1 CUSTOM CONTROLS

Although the 7D offers My Menu and three Camera User Settings, this Custom Function actually allows you to reprogram many of the camera's buttons and controls. This amount of customization is usually found only on professional-level cameras. You can reprogram the following controls, each with a certain array of functions:

‹ The 7D can be customized for individual photographic style in a number of different ways, including use of Custom Function IV-1.

123

O Shutter release button, half-press for following options:
 Metering and AF start
 Metering start
 AE lock

O AF start button options:
 Metering and AF start*
 AE lock
 AF stop
 FE (Flash Exposure) lock
 No function (disabled)

* When selected, press INFO. to choose between a manually selected AF point or a registered (memorized) AF point.

‹ The Custom Control menu presents several different functions that you can assign a specific camera button to control—in this case it is the AF-ON button.

O AE lock button options::

AE lock

Metering and AF start*

AF stop

FE (Flash Exposure) lock

No function (disabled)

* When selected, press **INFO.** to choose between a manually selected AF point or a registered (memorized) AF point.

O Depth-of-Field Preview button options::

Depth-of-Field Preview

AF stop

AE lock

One Shot/AI Servo toggle

IS start

Switch to registered AF func.*

* When selected, press **INFO.** and proceed through the following four screens to explicitly set the AF function:

1. AF area selection mode

2. AI Servo tracking sensitivity

3. AI Servo 1st/2nd img priority

4. Main focus point priority

> This is a powerful tool that allows you to set a number of AF parameters at once. But it can only be used when programmed to the Depth-of-Field Preview button or an AF-stop button on a lens.

Register AF function
AF area selection mode
⊙ Manual select.:Spot AF
O Manual select.:Single point AF
O Man. select.:AF point expansion
O Manual select.:Zone AF
O Auto select.:19 point AF
Cancel OK

O Lens AF stop button options (only available on Canon Super Telephoto lenses):

> AF stop
>
> Metering and AF start
>
> AE lock
>
> One Shot/AI Servo toggle
>
> IS start
>
> Switch to registered AF func.*

* When selected, press **INFO.** and proceed through the four screens to explicitly set the AF function:

> 1. AF area selection mode
>
> 2. AI Servo tracking sensitivity
>
> 3. AI Servo 1st/2nd img priority
>
> 4. Main focus point priority

O Multi-function button **M-Fn** options:

> FE (Flash Exposure) lock
>
> AF lock
>
> One-touch RAW+JPEG
>
> VF electronic level

O Set button ⊛ options:

> No function (disabled)
>
> Image quality
>
> Picture Style
>
> Menu display
>
> Image replay
>
> Quick Control screen

O Main Dial ⌲ options:

> Shutter speed setting in **M** mode
>
> Aperture setting in **M** mode

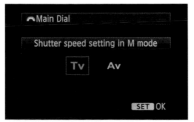

< Use this Custom Function option if you want to swap the controls you use for setting aperture and shutter speed in Manual shooting mode.

O Quick Control Dial ○ options:

Aperture setting in **M** mode

Shutter speed setting in **M** mode

AF point direct selection

O Multi-controller ✛ options:

No function (disabled)

AF point direct selection*

* When selected, press **INFO.** to choose between the center AF point or a registered (memorized) AF point.

While this single Custom Function offers unprecedented control in a camera of this price range, make sure you have a thorough understanding of the operation of the 7D before you start to make changes to these controls.

C.FN IV-2 DIAL DIRECTION DURING TV/AV

When **[Reverse direction]** is selected in Manual mode **M**, both the Main dial ▧ and the Quick Control dial ○ operate in reverse directions. In other words, normally rotating ▧ to the right shortens the shutter speed (1/60...1/250...1/1000) and rotating ○ to the right closes down the aperture (f/4...f/8...f/22). By selecting **[Reverse direction]** you'll need to rotate each control in the opposite direction to achieve the same effect. This option also has the same effect on ▧ when the exposure mode is set for **Av**, **Tv**, and **P**. Since ○ acts as an exposure compensation dial in these exposure modes and is coordinated with the exposure compensation scale on the back of the camera, in the viewfinder, and on the LCD panel, its direction is not changed.

> This simple setting is helpful if you find yourself constantly rotating dials in the wrong direction.

C.Fn Ⅳ:Operation/Others 2 ⌃⌄
Dial direction during Tv/Av
0:Normal
1:Reverse direction

1 2 3 4
⁎ 0 0 0

0: **[Normal]**

1: **[Reverse direction]**

C.FN IV-3 ADD IMAGE VERIFICATION DATA

This function is used with the Original Data Security Kit (OSK-E3), an optional Canon-designed software package. The software is used to authenticate the image data when used in forensic and other specialized applications.

C.Fn IV:Operation/Others 3
Add image verification data
0:Disable
1:Enable

1 2 3 4
0 0 0 0

‹ This function is used primarily by professionals to insure the integrity of digital images.

0: [Disable]

1: [Enable] The captured image is embedded with verification data

C.FN IV-4 ADD ASPECT RATIO INFORMATION

If you shoot for final prints at certain aspect ratios, you can embed aspect ratio information in the EXIF data. When you shoot with Live View, cropping lines are displayed. When images captured with embedded aspect ratio data are reviewed or played back, cropping lines appear on the LCD monitor. When images are opened in Digital Photo Professional, they are displayed with the correct aspect ratio.

C.Fn IV:Operation/Others 4
Add aspect ratio information
0:Off
1:Aspect ratio 6:6
2:Aspect ratio 3:4
3:Aspect ratio 4:5
4:Aspect ratio 6:7

1 2 3 4
0 0 0 0

‹ This function allows you to produce images with an aspect ratio that is different than the 7D's normal 3:2.

0: [Off]

1: [Aspect ratio 6:6]

2: [Aspect ratio 3:4]

3: [Aspect ratio 4:5]

4: [Aspect ratio 6:7]

5: [Aspect ratio 10:12]

6: [Aspect ratio 5:7]

Shooting and Drive Modes

SHOOTING MODES

The EOS 7D offers seven shooting modes ranging from completely automatic to entirely manual. The primary benefit in the two fully-automatic modes (□ or ⒸⒶ) is that the camera can be matched quickly to conditions or to a subject. Fast and easy to manage, the automatic modes permit the camera to predetermine a number of settings.

In these modes, all of the controls are set by the camera and cannot be adjusted by the photographer. Though □ and ⒸⒶ require you to select the file size and compression options, the camera will set color space to sRGB, white balance to 𝗔𝗪𝗕, metering to ⒮, and ISO to Auto. In □ and ⒸⒶ, these settings cannot be changed. Also, the ⚐ᵗ, ⎐ᵗ, ⚑ᵗ, ⚑, and ⚑ menus, as well as various other menu items, are not accessible when you are in either of the fully-automatic shooting modes.

All shooting modes are selected by using the Mode dial, located on top of the camera's left shoulder. Simply rotate the dial to the icon you wish to use. In addition to the fully-automatic modes, there are five exposure shooting modes: Program AE (**P**), Aperture-Priority AE (**Av**), Shutter-Priority AE (**Tv**) (AE stands for autoexposure); also Manual exposure (**M**), and Bulb (**B**). These are more advanced modes, in that you, not the camera, must manage more of the camera settings to control photographic results. The camera only pays attention to the exposure settings, specifically shutter speed, aperture, and sometimes ISO speed. You have to do the rest.

Finally, there are also three Camera User modes that allow you to program, or register, your current settings to the camera's memory: Ⓒ1, Ⓒ2, and Ⓒ3. You can then select the user mode to recall the settings.

> The Mode dial is a key control for setting your method for shooting.

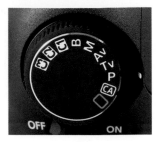

FULLY-AUTOMATIC SHOOTING MODES

□ Full Auto: The green rectangle is used for completely automatic shooting. This mode essentially converts the EOS 7D into a very sophisticated point-and-shoot. The camera chooses everything; you cannot adjust any controls except the file size/format (image quality) and drive mode. This shooting mode is designed for photographers who aren't familiar with D-SLRs. In □, the Picture Style is Standard (⊞⊞S), for crisp, vivid images; the white balance is set for AWB; ISO speed is Auto, and focus method is set for **AI FOCUS**. The flash pops up and fires if needed.

NOTE: Keep in mind that Manual focus can be engaged on the lens, and it overrides the focus setting in any shooting mode.

CA Creative Auto: This mode is similar to □, but offers the opportunity to make more adjustments. Press the Quick Control button (Q) to display the Quick Control screen, then scroll using �֎ to turn the flash on or off, as well as to adjust Background, Exposure, Picture Style, file size/format, and drive mode.

> Though the camera controls the majority of settings in Creative Auto, that mode still lets you gives you the opportunity to make certain decisions, such as how much to blur the background.

The Background and Exposure settings are unique to ⊞. Background is another way of adjusting depth of field. Instead of having to worry about which aperture or shutter speed to use, press ⊡ and then use ✥ as a joystick to navigate to the Background adjustment. This is a slider that allows you to choose whether you want the background in your image to be blurry or sharp. (A blurry background can be useful when you shoot portraits of people standing in front of a busy background.) If you set the Background adjustment towards Sharp, the EOS 7D picks an appropriate aperture (f/stop) so that a greater part of your photo is in focus.

The Exposure setting is accessed in the same manner as Background. This function operates the same way as exposure compensation. The center position on the range represents zero exposure compensation, while the two positions to the right represent overexposure adjustments of +2/3 and +1 1/3 stops, respectively. The two positions to the left indicate -2/3 and -1 1/3 stops of underexposure.

The Picture Style setting is a little more limited than normal, offering just Standard (⊞S), Portrait (⊞P), Landscape (⊞L), and Monochrome (⊞M). Unlike the exposure shooting modes, the fully-automatic shooting modes do not permit you to make further adjustments to the Picture Style parameters. In fact, if you make adjustments to Picture Styles before you enter ⊞ mode, you won't see those adjustments—they will be set to their default values.

The following drive modes are available in ⊞: Single shooting (☐), Low-speed continuous shooting (⊒), and Self-timer:10sec/Remote shooting (◉).

EXPOSURE SHOOTING MODES

Canon hasn't given a specific name to this group of advanced exposure modes for the EOS 7D, but in the past they have commonly been referred to as Creative Zone modes. Although they do offer you more creative control than the fully-automatic shooting modes, they really just control exposure so I will refer to these collectively as the exposure shooting modes.

Once you become familiar with the 7D, you will probably want to use the exposure shooting modes most of the time. They encourage a more creative approach to photography because they provide more control

over camera adjustments. Settings such as white balance, file type (RAW or JPEG), metering method, focus method, Picture Style, ISO, and drive need to be set manually. Control is usually a good thing, but so many possible adjustments can sometimes be confusing at worst, and time consuming at best.

P Program AE: In **P**, the camera chooses the shutter speed and aperture combination. This gives the photographer less direct control over the image because no matter how appropriate, the settings are chosen arbitrarily (by the camera, not by you). However, you can shift the "program" by changing either the selected aperture or the shutter speed, and the system compensates to maintain the same exposure value. Program Shift, however, is not the same as exposure compensation.

To shift the program, simply press the shutter button halfway to turn on the camera's built-in light meter, then turn ⛭ until the desired shutter speed or aperture value is displayed on the LCD monitor or viewfinder.

NOTE: Program Shift only works for one exposure at a time, making it useful for quick-and-easy shooting while providing some control over camera settings.

The flash will not pop up automatically in **P** mode when light levels are low. You must manually activate the flash by pressing the ⚡ button on the front of the camera above the lens release button. Also, when any flash is on, you cannot use Program Shift to change shutter speed or aperture.

P selects shutter speed and aperture values steplessly. This means that any shutter speed or aperture within the range of the camera and lens is selected, not just those that are the standard full steps, such as 1/250 second or f/16. This has been common with most SLRs (both film and digital) for many years, and allows for extremely precise exposure accuracy, thanks to the lens' electromagnetically controlled diaphragm and the camera's electronically timed shutter.

Tv Shutter-Priority AE: **Tv** stands for "time value." In this mode, you set the shutter speed (using ✍) and the camera sets the aperture. If you want a particular shutter speed for artistic reasons—perhaps a high speed to stop action, or a slow speed for a blur effect—this is the mode to use, because even if the light varies, the shutter speed does not. The camera keeps up with changing light by adjusting the aperture automatically.

If the aperture indicated in the viewfinder or the LCD monitor is constantly lit (not blinking), the 7D has picked a useable aperture. If the maximum aperture (lowest number) blinks, it means the photo will be underexposed. Select a slower shutter speed by turning ✍ until the aperture indicator stops blinking. You can also remedy this by increasing the ISO setting. If the minimum aperture (highest number) blinks, this indicates overexposure. In this case, you should set a faster shutter speed until the blinking stops, or choose a lower ISO setting.

The EOS 7D offers a choice of speeds, from 1/8000 second up to 30 seconds, in 1/3-stop increments (1/2-stop increments with C.Fn I-1; see page 114). For flash exposures, the camera syncs at 1/250 second or slower (which is important to know, since slower shutter speeds can be used to record the ambient or existing light in a dimly-lit scene).

Let's examine these shutter speeds by designating them "fast," "moderate," and "slow." (These divisions are arbitrarily chosen, so speeds at either end of a division can really be assigned to the groups on either side of it.)

Fast shutter speeds are 1/500 – 1/8000 second. It wasn't all that long ago that most film cameras could only reach 1/1000 second, so having this range of high speeds on a D-SLR is quite remarkable. The obvious reason to choose these speeds is to stop action. The more the action increases in pace, or the closer it crosses directly in front of you, the higher the speed you need. As mentioned previously, the neat thing about a digital camera is that you can check your results immediately on the LCD monitor to see if the shutter speed has, in fact, frozen the action.

At these fast speeds, camera movement during exposure is rarely significant unless you try to handhold a super telephoto lens of 600mm (not recommended!). This means, with proper handholding technique you can shoot using most normal focal lengths (from wide-angle to telephoto up to about 300mm) without blur resulting from camera movement.

^ Clearly a fast shutter speed was not required to stop the action in this photo. But 1/640 second allowed the picture to be taken using an aperture of f/2.8, emphasizing the hub of the canon's wheel and against the blurred background. © Kevin Kopp

Besides stopping action, high shutter speeds allow you to use your lens at its wide openings (such as f/2.8 or f/4) for selective focus effects (shallow depth of field). This is a useful technique. In bright sun, for example, you might have an exposure of 1/200 second at f/16 with an ISO setting of 200. You can get to f/2.8 by increasing your speed by five whole steps of exposure, to approximately 1/4000 second.

NOTE: Remember the balance between shutter speed and aperture. In **Tv**, the camera takes care of aperture, according to how you set shutter speed. Try this yourself. Go outside and use 🔄 to set the shutter speed to 1/200. Now, look in the viewfinder, ignore the shutter speed and just watch the aperture. Keep changing the shutter speed by rotating 🔄 until the aperture is at the widest setting that the lens will allow. Now look and see how short the shutter speed has become.

Moderate shutter speeds (1/60 – 1/250 second) work for most subjects and allow a reasonable range of f/stops to be used. They are the real workhorse shutter speeds, as long as there's no fast action. You have to be careful when handholding cameras at the lower end of this range—especially with telephoto lenses—or you may notice blur in your pictures from camera movement during the exposure. Many

photographers find that they cannot handhold a camera with moderate focal lengths (50 – 150mm) at shutter speeds less than 1/125 second without some degradation of the image due to camera movement. You can double-check your technique by taking a photograph of a scene while handholding the camera and then comparing it to the same scene shot using a tripod. Be sure to magnify the image to check for image blur caused by camera motion. (Even better, check it on the computer.)

> **NOTE:** Lenses with image stabilization (Canon lenses with this feature are labeled IS) can help you shoot handheld with slower shutter speeds, but they may only give you an extra stop.

Slow shutter speeds (1/60 second or slower) require something to stabilize the camera. Some photographers may discover they can handhold a camera and shoot relatively sharp images at the high end of this range, but most cannot get optimal sharpness from their lenses at these speeds without a tripod or another stabilizing mount. Slow shutter speeds are used mainly for low-light conditions, and to allow the use of smaller f/stops (higher f/numbers—increasing depth of field) under all conditions.

⌃ Always use a tripod when you slow the shutter speed to portray the flowing motion of water.

A fun use of very slow shutter speeds (1/2 – 1/8 second) is to photograph movement, such as a waterfall or runners, or to move the camera during exposure, panning it across a scene. The effects can be unpredictable, but again, Image Review using the LCD monitor helps. You can try different shutter speeds and see what your images look like. This is helpful when you try to choose a slow speed appropriate for the subject because each speed blurs action differently.

You can set slow shutter speeds (up to 30 seconds) for special purposes, such as capturing fireworks or moonlit landscapes. Canon has engineered the sensor and its accompanying circuits to minimize noise (a common problem of long exposures with digital cameras) and the EOS 7D offers remarkable results with these exposures. C.Fn II-1 can be used to reduce noise even more (see page 116).

In contrast to long exposures using film, long digital exposures are not susceptible to reciprocity. The reciprocity effect comes with film because as exposures lengthen beyond approximately one second (depending on the film), the sensitivity of the film declines, resulting in the need to increase exposure to compensate. A metered 30-second film exposure might actually require double or triple that time to achieve the effect that is desired. Digital cameras do not have this problem. A metered exposure of 30 seconds is all that is actually needed.

Av Aperture-Priority: In **Av** (aperture value), you set the aperture (the f/stop or lens opening) and the camera selects the appropriate shutter speed for a proper exposure. This is probably the most popular automatic exposure setting among professional photographers.

One of the most common reasons to use **Av** mode is to control depth of field (the distance in front of and behind a specific plane of focus that is acceptably sharp). While the f/stop, or aperture, affects the amount of light entering the camera, it also has a direct effect on depth of field. The three variables that affect depth of field are lens aperture, focal length, and focused distance.

A small lens opening (higher f/number), such as f/11 or f/16, increases the range of acceptable sharpness in the photograph, as long as the other variables remain fixed. Hence, higher f/numbers are great for landscape photography.

^ Selective focus on the subject of this photo is produced by using a wide aperture so the woman is sharp while the background is softly out of focus. © Rebecca Saltzman

A wide lens opening, such as f/2.8 or f/4, decreases the depth of field. These lower f/numbers work well when you want to take a photo of a sharp subject that creates a contrast with a soft, out-of-focus background.

If the shutter speed blinks in the viewfinder (or on the LCD monitor), it means the shutter speed the camera wants to use is not available on the camera. In other words, good exposure is not possible at the selected aperture, so determine whether you need to change the aperture to let in less light (change it to f/8 or f/11, for example) or to decrease the ISO speed setting to make the 7D less sensitive to light.

You can see the effect of the aperture setting on the depth of field by pushing the camera's Depth-of-Field Preview button, located on front of the camera below the lens release button. This stops the lens down to the taking aperture and reveals sharpness in the resulting darkened viewfinder (the lens otherwise remains wide-open until the next picture is taken). Using Depth-of-Field Preview takes some practice due to the darkened viewfinder, but changes in focus can be seen if you look hard enough. You can also check focus in the LCD monitor after the shot (magnify as needed).

NOTE: When you press the Depth-of-Field Preview button, you are only concerned about evaluating depth of field; don't worry about how dark things look.

SHOOTING AND DRIVE MODES

It may sound counterintuitive, but a sports or wildlife photographer might choose **Av** mode in order to stop action, rather than to capture depth of field. To accomplish this, he or she selects a wide lens opening—perhaps f/2.8 or f/4—to let in the maximum amount of light. The camera automatically selects the fastest shutter speed possible for the conditions. Compare this with **Tv** mode, in which you can set a fast shutter speed, but the camera still may not be able to expose correctly if the light drops and the selected shutter speed requires an opening larger than the particular lens can provide. (The aperture value blinks in the viewfinder if this is the case.) As a result, photographers typically select **Tv** only when they have to use a specific shutter speed. Otherwise they use **Av** both for depth of field and to gain the fastest possible shutter speed for the circumstances.

NOTE: One exception to using **Av** to get a fast shutter speed is to instead use **Tv**, but then use Auto ISO. For example, if you are shooting a certain sporting event and you discover that you need 1/500, you could set that while in **Tv** and then, if the aperture was at the end of its range (widest opening that the lens will go), the Auto ISO function will kick up the camera's sensitivity.

M Manual Exposure: In **M**, you set both the shutter speed (using 🖾) and aperture (using ◯). This option is important for photographers who are used to working in full manual and for anyone who faces certain tricky situations. (However, since this camera is designed to give exceptional fully-automatic exposures, I recommend that everyone try the fully-automatic settings at times to see what they can do.)

You can use the camera's exposure metering system to guide you through Manual exposure settings. The current exposure is visible on the scale at the bottom of the viewfinder information display. "Correct" exposure is at the mid-point, and you can see how much the exposure settings vary from that point by observing the scale. The scale shows up to two f/stops over or under the mid-point, allowing you to quickly compensate for bright or dark subjects (especially when using partial metering). If the pointer on the scale blinks, the exposure is off the scale. Of course, you can also use a handheld meter.

The following examples of complex metering conditions might require you to use **M** mode: Panoramic shooting (you need a

consistent exposure across the multiple shots taken, and the only way to ensure that is with **M**—do not adjust white balance or focus from shot to shot); lighting conditions that change rapidly around a subject with (a theatrical stage, for example); close-up photography where the subject is in one light but slight movement of the camera dramatically changes the light behind it; and any conditions where you need a consistent exposure through varied lighting conditions.

B Bulb Exposure: This mode allows you to control long exposures because the shutter stays open as long as you keep the shutter button depressed. Let go, and the shutter closes. A dedicated remote switch, such as the Canon RS-60E3, is helpful for these long exposures. It allows

∧ Using a wireless remote switch and Bulb shooting mode allowed me to wait until an eruption was occurring before taking this night time picture.

you to keep the shutter open without touching the camera (which can cause movement). It attaches to the camera's remote terminal (on the left side). You can use the RC-1 or RC-5 wireless remote switches for bulb exposures, as well.

When you use **B**, the camera shows the elapsed time (in seconds) for your exposure as long as you keep the shutter release or remote switch depressed, which is a helpful feature. Currently with digital camera technology, exposures beyond a few minutes start to produce excessive noise. Still, the EOS 7D allows longer exposures than most cameras of this type. It is a good idea to use C.Fn II-1, [Long exposure noise reduction], to apply added in-camera noise reduction. Remember that Long exposure noise reduction doubles the apparent exposure time, so make sure you have enough battery power.

Imagine you want to shoot your child's soccer match. You will, no doubt, set your camera differently than if you are going to record an autumn morning landscape. The aperture or shutter speed, plus the ISO setting, white balance, saturation and/or sharpness levels, etc. will be different for each type of photo.

Having set your 7D to record the soccer match, you can have the camera memorize and save those settings so it is ready to shoot soccer action every time there is a match—you don't have to remember the settings and reprogram them each time you get to the field.

```
Register
   Select mode dial position to
            register
 Mode dial : C1
 Mode dial : C2
 Mode dial : C3

                    MENU ↩
```

‹ Once you get familiar with your 7D, the Camera User Settings can be an effective tool to make the camera work for you.

You do this by using the Camera User Settings. Each user setting stores more than just shooting modes; it remembers many menu settings and even Custom Functions. Once you get used to your EOS 7D, you'll find that Camera User Settings are a powerful tool for quickly setting up your camera In different shooting situations. In addition to soccer shooting, for instance, you can have one setting for taking portraits and another one for shooting at night. The possibilities are endless. Make your settings and then point your Mode dial to **C1**, **C2**, or **C3**. Use ♥: to register the Camera User Setting (see page 109). Note that even when you select a Camera User Setting, you are still able to temporarily override any of the camera's settings.

DRIVE MODES AND THE SELF-TIMER

The term "drive mode" is a throwback to film days when a photographer had to advance the film after every shot. Professional photographers would add a "motor drive" to their camera so that they could take photos in rapid succession without having to manually cock the shutter and advance the film. Even though the film is gone, shutter mechanics are still needed in any D-SLR. The EOS 7D offers several different drive modes.

❯ When the action is happening fast, use High-speed continuous drive and a large memory card to increase your chances of getting a great photo.

To select the drive mode, press AF•DRIVE and use ◯ to select from Single shooting (☐), High-speed continuous (⬛H), Low-speed continuous (⬛), Self-timer (10 sec./Remote control Ⓘ☉), and 2 sec/

Remote control (i⟳2). Both of the timer icons also show a remote icon i. When you use one of Canon's optional wireless remote controls (either the RC-1 or RC-5), you must set the drive mode to i⟳ or i⟳2. When you use the RC-1 wireless remote, i⟳2 delays the shutter release for two seconds after you press the button, and i⟳ has no delay. The RC-5 always has a 2-second delay in both i⟳ and i⟳2. It is important to remember that the only way to cancel the self-timer once it has started counting down is to press AF·DRIVE.

NOTE: In ☐, you can only choose between ☐ or i⟳ drive modes. When the camera is set for ⒸⒶ, you also have access to Low-speed continuous ⬚ᵢ.

During adjustment, the AF and drive mode settings can be seen on the LCD panel and on the LCD monitor. There are two continuous shooting speeds because there may be times when you want to fire off multiple frames but need a little more control.

NOTE: You can also set the drive mode using the Quick Control screen (page 53).

☐ SINGLE SHOOTING

This is the standard shooting mode. One image is captured each time you press the shutter release.

⬚ᴴ HIGH-SPEED CONTINUOUS SHOOTING

When the shutter button is held down, the camera captures at a rate of eight images per second for approximately 126 consecutive JPEG images at the highest JPEG resolution and best quality. When the in-camera buffer (or the memory card) fills up, the camera stops capturing images. The 7D resumes taking pictures when the buffer has space again. When you shoot RAW images, a maximum of about 15 consecutive images can be captured before the buffer fills.

⬚ᵢ LOW-SPEED CONTINUOUS SHOOTING

High-speed continuous shooting can fill up a memory card very quickly, and with the image size the 7D records, that can mean a lot of storage on your computer too. Low-speed continuous shooting gives

you the ability to capture multiple images, but at a slower rate. When the shutter button is held down, the camera captures at a rate of three images per second.

> **NOTE:** The speed for both continuous drive modes is dependent on memory card speed, battery charge, and shutter speed.

¡⊙ SELF-TIMER:10SEC/REMOTE CONTROL

There are actually two parts to this setting: (1) self-timer and (2) remote control. When you want to be in the picture, the 10-second self-timer is the function to use. Press the shutter button halfway and make sure you have achieved focus. Then, press the shutter release button the rest of the way down. A self-timer lamp (located on the front of the camera, built into the camera grip) flashes once per second to count down the remaining time. By default, a beep is enabled and sounds during the countdown. Two seconds before the picture is taken, the lamp lights continuously on and the camera beeps more frequently to let you know the shutter is about to be released. To cancel the countdown, press AF·DRIVE.

☺ SELF-TIMER:2SEC/REMOTE CONTROL

The 2-second self-timer operates similarly to the 10-second timer in that it takes the picture after a set time. When you shoot with a tripod and have longer shutter speeds, 1/60 and slower, use this quick timer, along with C.Fn. III-13, [Mirror lockup], to reduce camera shake.

> For the sharpest pictures, especially in light that is a bit low, take the time to engage Mirror lockup and use the 2-second self-timer with a remote control when shooting from tripod. © Kevin Kopp

Focus and Exposure

Canon spoke with photographers from around the world to determine their wishes and develop a camera that would exceed expectations. The 7D's newly designed autofocus system and color-sensitive metering system are unlike any other. The innovation, thought, and technology that have gone into the 7D become evident as soon as you begin to operate the camera's various systems and utilize its many functions. From finding focus on moving subjects, to capturing great exposures in low light, the EOS 7D offers a number of options that enhance your ability to take excellent photographs.

AUTOFOCUS

Of course the EOS 7D offers the option to focus manually. But the newly designed AI (artificial intelligence) AF (autofocus) system based on a special CMOS sensor is a marvel dedicated to autofocus. The camera smartly handles various functions of autofocus through the use of a high-performance microcomputer, along with improvements in AF system design. The 19 AF points give the camera 19 distinct spots where it can measure focus. They are arranged in a diamond pattern around the center, which improves focus tracking of moving subjects.

All of the AF points are "cross-type." Since AF sensors work based on identifying edges in a scene, cross-type points are equally adept at detecting vertical or horizontal edges. In short, a cross-type sensor is more accurate than a vertical-only or horizontal-only sensor. Some previous EOS cameras only had a few cross-type AF points.

All 19 AF points work with lenses with maximum apertures of f/5.6 or wider. The center AF point adds a separate diagonal cross-point sensor when you use lenses with a maximum aperture of f/2.8 or wider. This offers enhanced AF accuracy.

When light levels are low, the camera activates AF-assist with the built-in flash and produces a series of quick flashes to help autofocus. (External dedicated flashes can also do this. See Custom Function (C.Fn) III-11 on page 121.) The range is up to approximately 13.1 feet (4 m). The 580EX II Speedlite includes a more powerful AF-assist beam, effective up to 32.8 feet (10 m).

AF MODES

The camera has three AF modes: **ONE SHOT**, **AI SERVO**, and **AI FOCUS**. Each is used for a different purpose, as described below. With the exception of the fully-automatic shooting modes (□ and 🆑), where the AF mode is set automatically, you can choose among all three settings. They are accessed by pressing AF·DRIVE, which displays the AF mode menu on the LCD monitor. Use 🖎 to select the mode you want. Once selected, press 🔘 to accept the selection. The selected AF mode is indicated on the camera settings display on the LCD monitor.

NOTE: You can also set the AF mode using the Quick Control screen (page 53).

ONE SHOT: This is perfect for recording stationary subjects because it finds and locks focus on the important part of a subject when you aim and press the shutter button halfway. If the camera doesn't focus on the right spot, simply change the framing slightly and again press the shutter button halfway to lock focus. Once you have found and locked focus, you can move the camera to set the proper composition. The focus confirmation light ● glows steadily in the viewfinder when you have locked focus. It blinks when the camera can't achieve focus. Since this camera focuses very quickly, a blinking light is a reminder that you need to change something (you may need to focus manually).

AI SERVO: Great for action photography where subjects are in motion, **AI SERVO** becomes active when you press the shutter button halfway, but it does not lock focus. It continually looks for the best focus as you

^ This tree wasn't going anywhere, so I could lock focus on the trunk. One Shot AF mode is great for recording landscape elements and other non-moving subjects.

move the camera or as the subject travels through the frame, with both the focus and exposure becoming set only at the moment the shutter opens. This can be a problem when used for motionless subjects, because the focus continually changes, especially if you are handholding the camera. However, if you use **AI SERVO** on a moving subject, it is a good idea to start the camera focusing (depress the shutter button halfway) before you actually need to take the shot, so the system can find the subject.

AI FOCUS: This mode allows the camera to choose between **ONE SHOT** and **AI SERVO**. It can be used as the standard setting for the camera because it switches automatically from **ONE SHOT** to **AI SERVO** if your subject should start to move. Note, however, that if the subject is still (like a landscape), this mode might detect other movement (such as a blowing tree), so it may not lock on the non-moving subject.

NOTE: Focus during Live View shooting and Movie shooting is handled differently. See page 181.

> Since I knew this butterfly could take off at any moment, I selected AI Focus mode so the camera would switch automatically from One Shot to IA Servo.

AF POINT SELECTION MODES

The 7D utilizes several new methods to select the AF points used for measuring focus. Previous EOS models gave you a choice between auto selection and manual selection. Now you can choose from among auto selection and four different manual selection modes. To pick which one to use, press ⊞/⊕ (on the back of the camera in the upper right corner). Use the new Multi-function button (M-Fn), located in front of ⌂, to cycle through all of the AF point selection modes.

NOTE: By default, two of the modes, Spot AF (⊡) and AF point expansion (⸬), are disabled. Use C.Fn III-6 to enable them (see page 120).

Once you've settled on the selection mode you want, use either ○ and 🖾, or ✛ to identify the initial AF point. ○ moves the selection vertically, while 🖾 moves it horizontally. ✛ is the most flexible because it acts like a joystick to select any point. Pressing ✛ straight down selects the center point.

> **NOTE:** If you want to select an initial AF point, but the AF point selection screen is no longer displayed, press ⊞/🔍.

You can also use the Quick Control screen to gain access to the AF point selection mode. Press 🔲 and use ✛ to highlight the AF point selection mode area. Then use 🖾 or ○ to cycle through the modes.

〈 〉 19-point AF (Auto select): Use this mode if you want the 7D to have complete control over which point or points to use to set focus. Also, this point selection mode is used when the 7D is in either □ or CA. It does a good job of automatically selecting an AF point. When the AF mode is set for **ONE SHOT**, the viewfinder shows 〈 〉, indicating that the camera will pick the AF point that it deems correct for the scene. This is usually based on the closest item that has enough detail to engage the AF points.

After the 7D achieves focus, the viewfinder shows the AF point or points that were used for the task. The camera also beeps and shows the focus confirmation indicator ● in the viewfinder. This has been the normal operation within Canon's EOS line for quite a while.

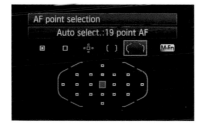

〈 When the 7D is in AI Servo AF mode, and the AF point selection is set for 19-point AF, you still need to select which point you want to use to start focus tracking.

In **AI SERVO**, when you are usually trying to track (lock focus on) a moving object, this mode operates quite differently from previous EOS cameras. With those, the object you were tracking had to be in the center of the frame. With the 7D, you can now select any AF point (in **AI SERVO**). This means an AF point at an edge of the frame can

be the first point the camera picks to achieve focus. The AF overlay in the viewfinder shows ⊂ ⊃ as well as the AF point that you designate as the starting point for focus tracking. As the object moves across the scene, the 7D automatically uses other AF points to track the object. As different AF points are used, the viewfinder overlay updates to identify those new AF points. Any AF points that are used will display in the viewfinder when they are engaged in achieving focus.

Remember that you are only selecting the AF point with which to start tracking. You are not limiting how many AF points the 7D uses for AF.

NOTE: It may seem counterintuitive to select an AF point when the 7D is in 19-point AF (auto select), but you are just choosing the starting AF point—the 7D selects the AF points from there. Select the point you want to use with either ⊚ and ⌂, or ✵.

☐ Single-point AF (Manual select): This selection is useful when you have a specific composition in mind, but the camera won't focus consistently where you want it to. Once you have gained access to ☐ mode, the bottom half of the LCD monitor and the viewfinder show a graphic representation of the 19 AF points. Select the point you want using either ○ and ⌂, or ✵.

NOTE: By default, the selection process stops at the edges. In other words, if you rotate ○ until the selection reaches the top, it stops there. If you set C.Fn III-7 to **[Continuous]**, the selection jumps to the bottom.

Once the AF point has been selected, it is displayed in the viewfinder. The 7D then uses that point to set focus. When focus is achieved, the camera beeps and the focus confirmation indicator appears in the viewfinder. If the camera is in **ONE SHOT** mode, focus isn't locked until the picture is taken—and there is no indicator or beep.

NOTE: The size of the AF point is smaller than the overlay displayed in the viewfinder.

⊏ ⊐ Zone AF (Manual select): This mode is a hybrid. The 7D automatically selects the AF point, but you tell it which "zone" to look in. Use when you want the 7D to do the bulk of the work selecting the best AF point to use for focus, but when you also want to limit the search range.

^ Naturally this hummingbird was moving quickly and unpredictably, but I knew it would most likely remain above and to the right in relation to the yellow blossom. The Zone autofocus mode was ideal for this situation.

The 19-point AF system is divided into five zones. With this mode, you select the zone that is used to measure and set focus. The zones are: center, top, bottom, left, and right. The center zone contains nine AF points, while the other four zones (top, bottom, left, and right) are each made up of four AF points.

With [] selected, press ⊞/⊕ and use ⌂, ○, or ⁙ to select the zone. Once a zone is selected, the 7D decides which AF point (or points) to use to achieve focus. You cannot select a focus tracking point, even in **ONE SHOT** focus mode.

▣ Spot AF (Manual select): This mode is similar to [], but it narrows the area of the AF point. When ▣ is selected, the viewfinder displays a "spot" within the regular AF point. In reality, this AF point is larger than the spot you'll see in the viewfinder, but smaller than the regular AF point. Use this mode when you need pinpoint accuracy in choosing the part of the scene you want the 7D to focus on.

> The LCD monitor
shows at a glance
which AF-point
selection mode and
which point has been
selected.

□ must first be enabled in C.Fn III-6 before it may be selected (see page 120). Once enabled, selecting AF points is accomplished in exactly the same manner as with □.

◌ AF point expansion (Manual select): You might consider this the opposite of □. Use this mode when you want to select the AF point but don't want the point to be too narrow to miss focus. ◌ must also be enabled in C.Fn III-6 before it may be selected. Choose the AF point using the same method as the □ and □ selection modes. However, instead of just one active AF point, the 7D surrounds your chosen point with additional ones. The expanded points are determined by the 7D and are dependent on the location of the selected AF point. They are indicated by the smaller "spots" within the normal AF point overlay. These spots are the same indicators used during □ selection mode.

When the 7D attempts to lock focus using this method, it first uses the selected AF point. If it has difficulty, it starts using the expanded AF points. If the focus is locked via one of the expanded points, that point changes to a normal AF point overlay—it appears as a larger rectangle, rather than a small spot.

REGISTERING AN AF POINT

Canon EOS cameras have provided for manual AF point selection for some time. Now the 7D allows you to register ("memorize") an AF point. This is like having a manually selected focus point along with an extra AF point in your back pocket if you need it. This mode only works when the camera is not in the 19-point AF ⊂ ⊃ mode. It is also only available when you change the function of either ✶ or **AF-ON** to [Metering and AF Start] using C.Fn IV-1 (see page 123).

To register the AF point, press ⊞/🔍 and use either ○ and 🎛, or ✣ to make your selection, just as you would when manually selecting an AF point. Once the point is highlighted, press and hold ⊞/🔍, then press ✵, on the top right shoulder, behind 🎛. (Normally ✵ is used to light up the LCD panel, but in this case it registers an AF point.) The registered AF point is shown in the viewfinder overlay as a blinking point, smaller than a normally-sized AF rectangle.

Now that the AF point has been registered, you can re-select a manual AF point that is different than the registered one. When you want to use the registered AF point, merely press the button you have programmed for **[Metering and AF start]**—either ✱ or **AF-ON**. Remember, as the function name says, that both autofocus and metering occurwhen the programmed button is pressed.

When the 7D is set for | | , the registered point isn't necessarily used as the focus point. It is simply used to select a zone, and the camera then automatically selects the appropriate AF point within that zone. In □ AF point selection, the registered point becomes the new AF point. Similarly, in ▣, the registered AF point is converted to a Spot AF point. Finally, in ·✥·, the registered AF point is treated as an AF expansion point.

C.Fn III-12 takes the process one step further (see page 122). It allows the 7D to remember three different registered AF points, depending on camera orientation: one for horizontal, one for vertical with the grip on top, and one for vertical with the grip on the bottom. To un-register the AF point, press and hold ⊞/🔍 and then press ISO·🔳.

This new method of registering an AF point can take some getting used to, but once learned, it is a powerful tool to help you achieve focus. The 7D is the first digital SLR to have this feature.

Because AF point registration is tied to metering, it is important to understand how it works. I recommend that you try it out. First program **AF-ON** to **[Metering and AF Start]** using C.Fn IV-1. (Remember to use INFO. to selected **[Registered AF point]**.) Next, set the 7D to □ and select an AF point toward the edge of the frame. Register the point by pressing and

holding ⊞/⊕ as you press ☼. Now you are ready to test: Move the manually-selected AF point to the other side of the frame (in selection mode, the registered point continues to blink) and compose your shot. Compare the difference between pressing the shutter half way (it uses the manual AF point for focus) and pressing **AF·ON** (which uses the registered point for both metering and focus). If the camera is also set to evaluative metering ⊛, notice how the metering changes if the light levels are different at the two different AF point locations.

Switch to Registered AF Function: Clearly, Canon has given a lot of thought to autofocus in the 7D. As previously mentioned, there are five different AF point selection methods. In addition, when you use **AI SERVO**, there are several Custom Functions that can be adjusted to tweak how fast the camera tracks focus.

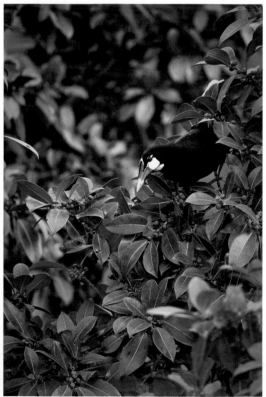

> **By programming the Depth-of-Field Preview button to pick the AF point selection mode, you can quickly control where to focus in a scene, even at one of the edges of the frame.**

Obviously, in situations where things happen fast, it is unrealistic to think you're going to jump into the Custom Functions menu and start making changes. Fortunately C.Fn IV-1 lets you re-program the Depth-of-field Preview button so you have easy access to AF functions when you're in the heat of action. When you select **[Switch to registered AF function]**, you can choose whether the Depth-of-Field Preview button will temporarily switch to one of the five AF point selection methods, change the AI Servo tracking sensitivity, change the AI Servo 1st/2nd image priority, or select the AI Servo AF tracking method.

This advanced tool offers a great way to rapidly set your 7D to optimize focus tracking for fast moving objects, while still being able to return quickly to other focusing methods. You can also use it to compare two different focusing methods. For example, you could set the tracking sensitivity to Fast on the Depth-of-Field Preview button, but Medium Slow without the Depth-of-Field Preview button. Then you can take two pictures in rapid succession and compare them. But beware: The programmed button is not a press-and-release control. You must continue to hold down the button to engage this feature.

> **NOTE:** You can also program this feature on Canon lenses that offer an AF stop button. This is typically found only on their super telephoto lenses.

AUTOFOCUS LIMITATIONS

With its impressive AF sensitivity, the 7D is able to autofocus in conditions that are quite challenging for other cameras. Still, as the maximum aperture of lenses decreases, or tele-extenders are used, the camera's AF capabilities change. AF works best with f/2.8 and wider lenses. This is normal, and not a problem with the camera.

It is possible for AF to fail in certain situations, requiring you to focus manually. This is most common when the scene is low-contrast or has a continuous tone (such as sky), in conditions of extreme low light, with subjects that are strongly backlit, and with compositions that contain repetitive patterns. A quick way to deal with these situations is to focus on something else at the same distance, lock focus on it (keep the shutter button pressed halfway), then move the framing back to the original composition. This only works while the camera is in **ONE SHOT** Mode.

No matter what technology is used to create a photo, it is always preferable to have the best possible exposure. Digital photography is no exception. A properly exposed digital file is one in which the right amount of light has reached the camera's sensor and produces an image that corresponds to the scene, or to the photographer's interpretation of the scene. This applies to color reproduction, as well as tonal values and subject contrast.

ISO

ISO (sensitivity) is one control worth knowing so well that its use becomes intuitive. The first step in getting the best exposure is to provide the camera's meter with information on how it should respond to light. The meter can then determine how much exposure is required to properly record the image. Digital cameras adjust the sensitivity of the sensor's circuits to settings that can be compared to film ISO speeds. (This apparent change in sensitivity actually involves amplifying the electronic sensor data that creates the images.)

The EOS 7D offers ISO speed settings of 100 – 6400. This range can be expanded to 100 – 12800 by using C.Fn I-3 (see page 114). The full ISO range (expanded or not) is only available in **P**, **Tv**, **Av**, and **M** shooting modes. In the ☐ and ⒸⒶ modes, ISO is set automatically from 100 – 3200 and you cannot override it. There is also an Auto ISO (A) setting that lets the 7D select which ISO setting to use. (see next page).

When the ISO range is expanded, there is an additional speed, labeled "H" (ISO 12800). The H setting is not a free ride, however, as additional noise is present in the image. (To counteract this, extra noise reduction can be applied by using C.Fn II-2, see page 116.)

Setting the ISO: To set the ISO speed, use the ISO·⚡ button located on the top right shoulder of the camera. The ISO speed menu displays on the LCD monitor, LCD panel, and in the viewfinder. Use 🔆 to choose the sensitivity that you want, and confirm by pressing Ⓔ⒯, ISO·⚡, or the shutter button. The selected ISO setting appears on the camera settings display on the LCD monitor.

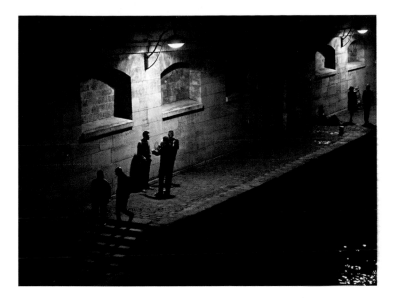

‹ When you don't have a tripod in low light, increase ISO to produce a shutter speed fast enough to avoid the effects of camera shake. The 7D image quality is excellent even at high ISO settings. © Frank Gallaugher

By default, the ISO settings occur in 1/3-stop increments (100, 125, 160, 200 etc.). You can change the steps to 1-stop increments by using C.Fn I-2 (see page 114). Most of the time you will want to choose among several key ISO settings: 100 to capture detail in images of nature, landscape, and architecture; 400 when more speed is needed, such as handholding for portraits when shooting with a long lens; 800 and 1600 when you really need the extra speed under low-light conditions.

Auto ISO: You can also let the 7D select the ISO. One of the options in the ISO menu is **[AUTO]**. When selected, the camera chooses an ISO from 100 to 3200. When you use **B** bulb, the ISO is set to 400. When you use flash, Auto ISO uses 400 unless the 7D determines there will be overexposure, and then a lower ISO is selected. With a Speedlite set for bounce, the ISO is set in the range of 400 – 1600.

Auto ISO can be used in combination with **Av** and **Tv** modes to give you enhanced control of exposure settings. For example, if you want to shoot with a high shutter speed, set the mode to **Av**, open the aperture to its widest setting, and turn on Auto ISO. The 7D will set both shutter speed and ISO speed, with emphasis on high shutter speed.

ISO speed can be set quickly from shot to shot in the **P**, **Tv**, **Av**, and **M** modes. Since sensitivity to light is easily adjusted using a D-SLR, and since the EOS 7D offers clean images with minimal noise at any standard setting, ISO is a control you can use freely to rapidly adapt to changing light conditions.

Low ISO settings give the least amount of noise and the best color, while high ISO settings can lead to noise in your pictures. Traditionally, film would increase in grain and decrease in sharpness with increased ISO. This is not entirely true with the EOS 7D because its image is extremely clean. Noise is virtually nonexistent at ISO settings of less than 800. Some increase in noise (the digital equivalent of grain) may be noticed as settings of 800 or 1600 are used, but there will be little change in sharpness. (Check the image on a computer to see if the noise is acceptable.) If you use speeds beyond 1600, the noise level in the image can be significant, but it may be the only way to get the shot.

You can also set the ISO speed using the Quick Control screen. Press ⓠ and use ✺ to highlight the current ISO setting. Then use 🖰 or ◯ to scroll through the ISO options, or press ⊛ to bring up the ISO options and then use 🖰 or ◯ to make your selection. Next, tap the shutter release or press ⊛ to exit.

NOTE: If you use Highlight Tone Priority (Custom Function II-3, see page 117) to expand the dynamic range of the 7D, the ISO range is 200 – 6400 and **D+** displays by the ISO number.

METERING

The 7D is the first camera to use Canon's new iFCL (intelligent Focus Color Luminance) system. This new technology works in conjunction with the 19-point AF system to produce well-exposed images even in difficult lighting situations. The 63-zone iFCL sensor is made up of two layers, one that is sensitive to blue and green light, the other that is sensitive to red and green light. The two layers are compared to minimize

errors due to color. Together, they evaluate the color and luminosity (brightness) of light surrounding the active AF point. In addition, the AF points transmit distance information to the metering system to help achieve accurate exposures.

To choose a metering mode, press ⊡·WB and use ⚙ to select the mode you want. Once selected, press ⊛ or the shutter button. The symbol or icon for the type of metering in use appears in the camera settings display on the LCD monitor. The camera offers four user-selectable methods for measuring light (metering modes):

o ⊡ evaluative (linked to any desired AF point)

o ⊡ partial

o ⊡ spot

o ⊡ center-weighted average

NOTE: Use the Quick Control screen for a faster method of setting the metering mode. With the shooting settings displayed on the LCD monitor, press ⊡ and use ✧ to highlight the current metering method. Then use ⚙ or ○ to scroll through the metering options, or you can press ⊛ to bring up the metering mode screen and then use ⚙ or ○ to make your selection. Tap the shutter release or press ⊛ to exit.

⊡ Evaluative Metering: The EOS 7D's evaluative metering system divides the image area into 63 zones, "intelligently" compares them in conjunction with the AF system, and then uses advanced algorithms to determine exposure. The zones come from a grid of carefully designed metering areas that cover the frame and complement the 19 AF points. Basically, the system evaluates and compares all of the metering zones across the image, noting things like the subject's position in the viewfinder (based on focus points and contrast), brightness of the subject compared to the rest of the image, backlighting, and much more.

As mentioned above, the EOS 7D's evaluative metering system is linked to autofocus. The camera actually notes which autofocus point is active and emphasizes the corresponding metering zones in its evaluation of the overall exposure. If the system detects a significant difference between the main point of focus and the different areas that surround this point, the camera automatically applies exposure compensation. (It assumes the scene includes a backlit or spot-lit subject.) However, if the area around the focus point is very bright or

dark, the metering can be thrown off and the camera may underexpose or overexpose the image. When your lens is set to manual focus, evaluative metering uses the center autofocus point.

NOTE: With evaluative metering, after autofocus has been achieved, exposure values are locked as long as the shutter button is partially depressed. However, meter readings cannot be locked in this manner if the lens is set for manual focus. In this case, use the AE lock button ✱, located on the back of the camera toward the upper right corner, to lock exposure (see page 164).

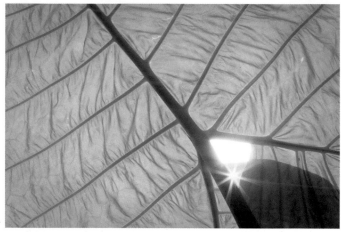

⌃ AE lock came to the rescue in this photo. Using evaluative metering, I first composed the scene without the sun showing through the hole in the leaf. I then pressed ✱ to lock exposure, and reframed to include the sunlight shining through.

It is difficult to capture perfect exposures when shooting subjects that are extremely dark or light, that are backlit, or have unusual reflectance. Because the meter theoretically bases its analysis of light on an average gray scene, it tends to overexpose or underexpose when subjects or the scene differ greatly from that average. Luckily, you can check exposure information in the viewfinder, or check the image itself—and its histogram—on the LCD monitor, and make adjustments as needed.

The main advantage of evaluative metering over the other methods is that the exposure is biased toward the active AF point, rather than the center of the picture. Plus, evaluative metering is the only metering mode that automatically applies exposure compensation based on comparative analysis of the scene.

⊡ Partial Metering: Partial metering covers about 9.4% of the frame, utilizing the exposure zones at the center of the viewfinder. It allows the photographer to selectively meter portions of a scene so they can evaluate the readings in order to select the right overall exposure. To compare exposures, fill the viewfinder with the area you want to meter and press ✱ to lock exposure, then reframe and press ✱ again and compare exposure settings. This can be an extremely accurate way of metering, but it requires some experience to do well. When you shoot with a telephoto lens, partial metering acts like spot metering.

⊡ Spot Metering: Use this mode to further reduce the area covered for metering. The metering is weighted to the center area (about 2.3%) of the viewfinder. This can give you an extremely accurate meter reading of a single object in your scene.

NOTE: Just because spot metering only measures the center of the frame, it doesn't mean your subject has to stay in the center. Use ✱ to lock exposure and then reframe.

⊏⊐ Center-Weighted Average Metering: This method averages the readings taken across the entire scene. In computing the average exposure, however, the camera puts extra emphasis on the reading taken from the center of the horizontal frame. Since most early traditional SLR cameras used this method exclusively, some photographers have used center-weighted average metering for such a long time that it is second nature and they prefer sticking with it. It can be very useful with quickly changing scenes that have an important central subject, such as an outdoor portrait.

TIP: Be aware of the effect the viewfinder eyepiece can have on exposure! The EOS 7D's metering system is sensitive to light coming through an open eyepiece. If you shoot a long exposure on a tripod and do not have your eye to the eyepiece, there is a good possibility that your photo will be underexposed. To prevent this, Canon has included an eyepiece cover on the camera strap. It can be slipped over the viewfinder to block the opening in these conditions. It is necessary to remove the rubber eyecup on the viewfinder to attach the cover. You can quickly check the effect by watching the camera settings on the LCD monitor as you cover and uncover the eyepiece—you'll see how much the exposure can change.

✱ AE LOCK

AE lock is a useful tool for the **P**, **Tv**, **Av** shooting modes. Under normal operation, the camera continually updates exposure as you move it across the scene or as the subject moves. This can be a problem if there is strong light in the scene that may cause the camera meter to underexpose the shot. For example, if you want to take a photo of a person standing next to a bright window, the meter will overcompensate for the window light, causing the person to be underexposed. In this case, point the camera at the subject, so the window is not in the frame, press ✱, then reframe the shot so both the person and window are in it. (If you have a zoom lens mounted, you could zoom in to a particular area of the scene, as well.)

AE lock on the EOS 7D is similar to that used for most EOS cameras. The ✱ button is located on the back of the camera to the upper right, easily accessed with your thumb. Aim the camera where needed for the proper exposure, then push ✱. The exposure is locked or secured, and it won't change, even if you move the camera. ✱ appears in the viewfinder on the left of the information display until the lock is released.

The exposure stays locked until you take a picture or the camera's metering system shuts down—about four seconds. You can tell that the metering system has shut down when the information display turns off in the viewfinder. If you want to keep the exposure locked longer—even through multiple shots—press and hold ✱. The meter stays on and the exposure stays locked until about four seconds after you let go.

NOTE: You can program other buttons on the 7D for AE lock using C.Fn IV-1 (see page 123).

EXPOSURE COMPENSATION

The existence of exposure compensation, along with the ability to review images in the LCD monitor, means you can quickly override exposures without using **M** shooting mode. Exposure compensation cannot be used in **M** mode; however, it makes the **P**, **Tv**, and **Av** modes much more versatile. Compensation is added (for brighter exposure) or subtracted (for darker exposure) in f/stop increments of 1/3 for up to +/– three stops (1/2-stop increments with C. Fn I-1; see page 114).

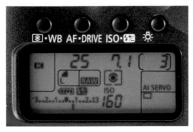

< In addition to the LCD monitor, the exposure compensation scale can be found along the lower left portion of the LCD panel as illustrated here..

To use the exposure compensation feature, make sure that the Quick Control dial switch, on the back of the camera below ○, is not locked, but set to ∕. Then press the shutter button halfway to turn on the metering system. Rotate ○ to change the compensation amount. The exact exposure compensation appears on the scale at the bottom of the viewfinder information display, as well as on the LCD monitor and the LCD panel.

You can also adjust exposure compensation using the Quick Control screen. Adjusting exposure compensation via this method allows access to exposure bracketing, too.

It is important to remember that once you set your exposure compensation control, it stays set even if you shut off the camera. Check your exposure setting (by looking at the bottom scale in the viewfinder information display) as a regular habit when you turn on your camera to be sure the compensation is not inadvertently set for a scene that doesn't need it. Turn exposure compensation off (set it to zero) by turning ○ to set the scale in the LCD monitor or viewfinder back to zero.

If you want to use the same exposure compensation for a group of shots and are concerned about accidentally changing the setting, you can set the Quick Control dial switch to lock. In lock mode, ○ is disabled.

With experience, you may find that you use exposure compensation routinely with certain subjects. Since the meter wants to increase exposure on dark subjects and decrease exposure on light subjects to make them both closer to middle gray, exposure compensation may be necessary.

For example, say you are photographing a football game with the sun behind the players. The camera wants to underexpose in reaction to the bright backlight, but the shaded sides of the players' bodies may be too dark. So you add exposure with the exposure compensation feature. Or maybe the game is in front of densely shaded bleachers. In this case,

the players would be overexposed because the camera wants to react to the darkness. Here, you subtract exposure. In both cases, the camera consistently maintains the exposure you have selected until you readjust the exposure settings.

The LCD monitor can come in handy when you experiment with exposure compensation. Take a test shot, and then check the photo and its histogram (see page 169). If it looks good, go with it. If the scene is too bright, subtract exposure; if it's too dark, add it. Again, remember that if you want to return to making exposures without using compensation, you must move the setting back to zero!

Autoexposure Bracketing (AEB): This control offers another way to apply exposure compensation: AEB tells the camera to make three consecutive exposures that are different: (1) A standard exposure or "base-line" shot (even a shot that already has exposure compensation applied); (2) An image with less exposure; and (3) One with more exposure. The last two shots are said to "bracket" the "normal" exposure.

> The center indicator shows the "baseline" exposure, in this case +1 1/3 stops above normal due to exposure compensation. The two short indicators show bracketed settings.

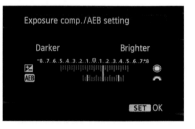

The difference between exposures can be set up to +/- three stops in 1/3-stop increments. (C. Fn I-1 allows you to change this to 1/2-stop increments—see page 114.) While using AEB, the EOS 7D changes the shutter speed in **Av** mode and aperture in **Tv** mode.

NOTE: If the 7D is in Auto ISO mode and AEB needs to use an exposure setting beyond the range of the camera, the ISO speed is adjusted. So you could pick a shutter speed where the aperture doesn't change through the bracketed shots, but the ISO speed does.

AEB is set using ◻️⁞. Scroll to **[Expo.comp./AEB]** and press ⑤. The submenu gives you to the ability to adjust both exposure compensation and bracketing. Use ○ to adjust exposure compensation on the center shot (between the under and overexposed images), then use ⌂ to set the bracketing amount. The short outer lines show the exposure setting for "under" and "over" shots, and the long line is the "center" exposure. Make sure you press ⑤ to accept the changes.

NOTE: If C. Fn I-1 is set for 1/2-stop increments, the bracket amount will also use 1/2-stop increments.

TIP: Put the Quick Control screen to work for you. It is the quickest way to access AEB. Press ◫ and use ✢ to highlight the exposure compensation scale. Use ○ to set exposure compensation and ⌂ to set the bracket amount. If you forget which control affects which parameter, press ⑤ to bring up a more intuitive display.

When in ◻ drive, you must press the shutter button for each of the three shots. The three indicators on the exposure scale will blink as long as there are shots left to be taken for the bracketing sequence. When you turn on the meter by pressing the shutter release button, a single point appears that indicates which shot in the bracket sequence will be captured next. In ▱ or ▱ᴴ drive modes, when you press and hold the shutter release button, the camera takes the three shots and stops. When you use ⏱ or ⏱₂, all three shots are taken.

NOTE: When set to AEB, the camera continues to bracket exposures until you reset the control to zero or turn the camera off. You can also use C.Fn I-4 (see page 114) to keep AEB active, even when the camera is powered off. With this Custom Function set to **[Off]**, AEB is turned off for flash, but when you stop using flash, the AEB setting is restored.

AEB can help ensure that you get the best possible image files for later adjustment using image-processing software. A dark original file always has the potential for increased noise as it is adjusted, and a light image may lose important detail in the highlights. AEB can help you determine the best exposure for the situation. You won't use it all the time, but it can be very useful when the light in the scene varies in contrast or is complex in its dark and light values.

AEB is also important for a special digital editing technique called High Dynamic Range (HDR) photography. This allows you to put multiple exposures together in the computer to gain more tonal range from a scene. You can take the well-exposed highlights of one exposure and combine them with the better-detailed shadows of another. (This works best with 1/2-stop bracketing.) If you carefully shoot the exposures with your camera on a tripod, you can put the images on top of one another as layers using image-processing software so that they line up exactly, making the different exposures easy to combine. (You may even want to set the camera to ⬚ or ⬚H—in these modes it takes the three photos for the AEB sequence and then stops.)

NOTE: There are software applications that can merge these files and help you choose which parts of which image to use. In order for HDR to be successful, a tripod is a necessity. You'll also need to shoot in **Av** (so depth of field doesn't change) or **M**; use a preset white balance—not ▨▨▨ (so color doesn't change); and use manual focus or a locked focus (so that focus doesn't change). HDR works best with images that have little or no movement.

You can combine exposure compensation with AEB to handle a variety of difficult situations. But remember, although AEB resets when you turn off the camera, exposure compensation does not.

JUDGING EXPOSURE

Examine your recorded images on the LCD monitor during playback. Though it is possible to be fooled, with a little practice you will soon be able to use this small image to evaluate your exposure. Recognize that because of the LCD monitor's calibration, size, and resolution, it only gives an indication of what you will actually see when the images are downloaded into your computer.

The EOS 7D includes two features—Highlight alert and the histogram—that give you a better indication of whether or not each exposure is correct. These features can be seen on the LCD monitor once an image is displayed there. Push **INFO.** repeatedly to cycle through a series of four displays: (1) Both the image and its exposure information; (2) The image with exposure, recording quality, and number of images; (3) A small image with a histogram (brightness or RGB depending on

the histogram setting in ▤⁺) and extended image information; and (4) A small image with the Brightness histogram, the RGB histogram, and reduced image information.

Highlight Alert: The camera's Highlight alert is straightforward: Overexposed highlight areas blink when an image is displayed on the LCD monitor. These areas have so much exposure that only white is recorded, no detail. To turn on Highlight alert, go to ▤⁺ and use ○ to select **[Highlight alert]**, then press ⊛. Use ○ to select **[Enable]** and press ⊛.

TIP: Although it is helpful to immediately see what highlights are getting blown out, some photographers are distracted by the blinking. But blinking highlights are simply information, and not necessarily bad. Sometimes have less important areas of the frame become washed out when the most important parts of the scene are exposed correctly. However, if you discover that significant areas of your subject are blinking, the image is likely overexposed and you need to reduce exposure in some way.

The Histogram: The EOS 7D's histogram, though small, is an extremely important tool. It is the graph that appears on the LCD monitor next to the image when selected with **INFO.** during Image Review or Playback. The 7D can display two different kinds of histograms: Brightness and RGB. The Brightness histogram allows you to judge the overall exposure of the image, while the RGB histogram focuses on the individual color channels.

 The horizontal axis of the Brightness histogram represents the level of brightness—dark areas are at the left, bright areas are at the right. The vertical axis indicates the pixel quantity of the different levels of brightness. If the graph rises as a slope from the bottom left corner of the histogram and then descends towards the bottom right corner, all the tones of the scene are captured.

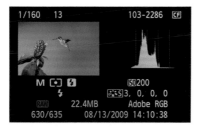

< The Brightness histogram shows the distribution of tones in the image, indicating no clipping of information on the left (dark) or right (bright).

Consider the graph from left to right (dark to bright). If the graph starts too high on either end, i.e., so the slope looks like it is abruptly cut off at either side, then the exposure data is also cut off at the ends clipped, because the sensor is incapable of handling the areas darker or brighter than those points. An example would be a dark, shadowed subject on a bright, sunny day.

Or, the histogram may be weighted towards either the dark or bright side of the graph (wider, higher "hills" appear on one side or the other). This is okay if the scene is naturally dark or bright, as long as detail is not lost. However, be careful of dark scenes that have all the data in the left half of the histogram. Such underexposure tends to overemphasize any sensor noise that may be present. You are better off increasing the exposure, even if that makes the LCD image look too bright. You can always darken the image in the computer, which will not affect grain; however, lightening a very dark image usually has an adverse effect and results in added noise.

If highlights are important, be sure that the slope on the right reaches the bottom of the graph before it hits the right axis. If darker areas are important, be sure the slope on the left reaches the bottom before it hits the left axis.

If the scene is low in contrast, the histogram appears as a rather narrow hill in the middle of the graph, leaving gaps with no data toward both left and right axes. To help this situation, check the EOS 7D's Picture Styles. Boosting contrast expands the histogram—and you can create a customized Picture Style with contrast change and tonal curve adjustment that addresses such a situation. This means better information is captured—it is spread out more evenly across the tones—before bringing the image into your computer to use image-processing software. You could also experiment with the Auto Lighting Optimizer in ◘ (see page 91). Or, you could record using RAW, since results are best in RAW when the data has been stretched to make better use of the tonal range from black to white.

> **NOTE:** When shooting RAW, the effects of the Auto Lighting Optimizer will only be apparent if the RAW file is processed through Canon's Digital Photo Professional software.

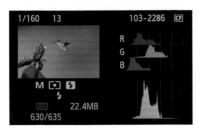

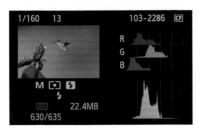

1/160 13 103-2286 CF

M ⬚ 🗲
 🗲
RAW 22.4MB
630/635

R
G
B

< You must select which
histogram you want to
view in Playback mode,
either Brightness or
RGB, in the Playback 2
menu.

RGB Histogram: You can check to see if any of the individual color channels is over-saturated when you use the RGB histogram. Similar to the brightness histogram, the horizontal scale represents each color channel's Brightness level—if more pixels are to the left, the color is less prominent and darker; to the right, the color is brighter and denser. If the histogram shows an abrupt cut-off on either end of the histogram, your color information is either missing or over-saturated. In short, by checking the RGB histogram, you evaluate the color saturation and white balance bias.

Live View and Movie Shooting

LIVE VIEW

It wasn't long ago that people who were stepping up to a D-SLR from a point-and-shoot camera were asking, "Why can't I see the image on the LCD before I take the shot? My little camera that is one-fourth of the price can do it!" Live View in D-SLRs has changed all that.

Canon was one of the first manufacturers to offer Live View shooting in a D-SLR. This technology, which displays an image on the LCD monitor before you shoot, allows you to frame shots when it is difficult to look through the viewfinder. It also permits you to check exposure, composition, color, and focus on a computer display; When you connect the EOS 7D to a computer and run Canon EOS Utility software, you view images live on the computer.

> **NOTE:** Since Live View and Movie shooting share the same technology and some of the same camera settings, this chapter deals with both in tandem. But keep in mind that when I refer to Live View shooting, I am talking about capturing stills; Movie shooting refers to the EOS 7D's operations when the Live View shooting/Movie shooting switch, which surrounds the START/STOP button to the right of the viewfinder, is set for '🎥.

To enable Live View shooting, set the Live View shooting/Movie shooting switch to ⬛, then press ⓢⓣⓐⓡⓣ/ⓢⓣⓞⓟ to turn on the Live View display on the LCD monitor.

To shoot movies, set the Live View shooting/Movie shooting switch to �. Once the switch is set, the image displays immediately on the LCD monitor. ⓢⓣⓐⓡⓣ/ⓢⓣⓞⓟ is used to start and stop recordings.

> Live View is a great option for many types of photography. It is especially useful when you need to hold the camera in a low or high position, or at an odd angle to record still life, landscape, or architecture photos. © Kevin Kopp

LIVE VIEW AND MOVIE MENUS

The menu items for Live View ⬛ are found in ⬛⁞. When the EOS 7D is set for ☐ or ㉄, the ⬛⁞ menu becomes ⬛ː, and menu options for ⬛ː and ▸switch change.

AF MODE

You can select from three different focusing methods. You can also use the Live View Quick Control screen to set AF method (see page 53).

○ [AFⓆⓤⓘⓒⓚ]

○ [AFⓁⓘⓥⓔ]

○ [AF ☺]

GRID DISPLAY

Grids can be used to assist in leveling the camera and for help in composition. Grids are only displayed on the LCD monitor and are not embedded in the image.

- O **[Grid 1]**: This option looks like a tic-tac-toe pattern and is useful as a guide for rule-of-thirds shooting. The rule of thirds divides the frame into nine areas, based on three equal horizontal spaces and three vertical spaces. You should place the main focus of your scene at one of the four intersections of the grid. Not all pictures have to follow the rule of thirds; it is just a starting point. This is also a good grid overlay that reminds you not to put horizons smack dab in the middle of the frame.

- O **[Grid 2]**: This is a denser pattern of five vertical lines and three horizontal lines. This is a good tool when you need to make sure that the EOS 7D is level and square to the scene you are photographing. For example, you might use it when you photograph a building.

∧ Silent shooting is a useful feature when photographing subjects that might be easily startled by noise.

SILENT SHOOTING

One of the advantages of Live View is that camera noise is reduced because the reflex mirror is already in the up position. In addition, during Live View, you can further reduce noise by controlling how the 7D's shutter operates. The camera has a mechanical focal plane shutter that has two "curtains." The first curtain opens the shutter and the second curtain closes it. After each exposure, the shutter curtains need

to be reset. Since the curtains are mechanical, they make noise when they move. The loudest noise is made when the curtains are reset. This menu item lets you reduce the first curtain noise and control when the shutter reset happens. There are three options as outlined on the following page:

O **[Mode 1]**: The first shutter curtain is done electronically on the image sensor, so there is less noise than normal. This selection resets the shutter right after taking the picture and allows for continuous shooting.

O **[Mode 2]**: The first curtain is done electronically. Also, the shutter reset happens only after you take your finger off the shutter. For example, if you were taking a picture of someone hitting a golf ball, you would set **[Mode 2]** so that the shutter noise would not disturb the golfer's concentration. When you take the picture at the moment the club hits the ball, you would press the shutter release button and keep holding it down. When the gallery starts cheering, you can release the button to reset the shutter. Continuous shooting is not available in this mode.

O **[Disable]**: This setting is required for accurate exposures when you use tilt-shift lenses or close-up tubes. When you use the built-in flash or a Canon Speedlite, silent shooting is set automatically for **[Disable]**. When you use a third-party flash, it will not fire unless you set silent shooting to **[Disable]**.

METERING TIMER

The EOS 7D offers an extended AE lock timer when you shoot with Live View. The metering timer ranges from four seconds to 30 minutes, so you can now hold an exposure setting for half an hour, compared to the four seconds that occurs with non-Live View shooting.

NOTE: Although the Live View and Movie shooting menus appear in two different places, they share the same settings. In other words, if you set the metering timer for one minute in Live View, it will be one minute in the Movie shooting menu, as well.

In Live View shooting, the menu has four additional items to enable the ᴿᵀᴬᴿᵀ/ₛₜₒₚ button and control of the LCD display. They are:

LIVE VIEW SHOOT

O **[Enable]**: (Default) Unless you shoot movies, the Live View/Movie shooting button will be set to 🞐, whether you are actively using Live View shooting or not. This menu option enables the ᴿᵀᴬᴿᵀ/ₛₜₒₚ button so that when you press it, you turn on Live View shooting.

o **[Disable]**: When the Live View/Movie shooting button is set to ▢, the START/STOP button is disabled and you cannot start Live View. However, if you change the Live View shooting/Movie shooting button to '🎥 you can still shoot movies.

EXPO. SIMULATION

When you shoot in Live View, normally the 7D tries to simulate on the LCD monitor what the final captured image looks like. There might be instances, such as low light shooting, when you want to be able to see more detail in the image for focusing or judging composition.

o **[Enable]**: (Default) As described above, the image in the LCD display is close in terms of brightness to the actual scene.

o **[Disable]**: When this option is selected, a bright image is displayed on the LCD monitor, no matter if the exposure setting is under or overexposed. If you normally run with the exposure simulation setting disabled, you can always use the Depth-of-Field Preview button to quickly simulate exposure.

Movie shooting also has some additional menu options for resolution and sound:

MOVIE RFC. SIZE

o **[1920 x 1080]**: The higher of two High-Definition resolution options, there are additional choices to record at 30 frames per second (default) and at 24 frames per second.

o **[1280 x 720]**: The second High-Definition selection available for recording movies. This offers the option of high quality while consuming less memory than the choice above.

o **[640 x 480]**: Standard definition.

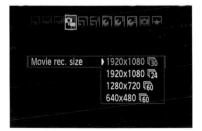

‹ There are several different settings for recording movies; three of which are High-Definition, while one is Standard definition.

See page 191 to learn more about video resolution.

SOUND RECORDING

You can record sound by enabling the default for this option **[On]**. The audio is recorded with the built-in microphone on the front of the EOS 7D (the four holes above the EOS logo). The audio is mono. Since the microphone is built into the body of the camera, it picks up any handling noises as you adjust the lens or press buttons. Set **[Off]** to record silently.

Live View and Movie shooting use a lot of power, so make sure you have fully charged batteries on hand. The EOS 7D is good for about 230 shots using Live View (220 when flash is used about half the time). When you record movies, the batteries last about one hour and 20 minutes. (Battery runtime figures assume a temperature of 73°F or 23°C.)

LCD MONITOR

The LCD monitor is the key to Live View and Movie shooting. It doubles as a viewfinder for composing your scene, yet it still acts as a status display to show you many of the 7D's settings.

STATUS DISPLAYS

Depending on your camera's settings, you can cycle through up to five display modes, or up to four when shooting movies, by pressing **INFO.** The first display is just the image with the AF point. (The AF point might not be displayed if the AF mode is set for **AF** ∵.)

Press **INFO.** to add a status display at the bottom of the LCD that will show exposure information (shutter speed and aperture when the meter is on), an exposure level indicator (including compensation and bracketing indicators if engaged), flash exposure compensation, shots remaining, ISO speed, Highlight tone priority indicator, and battery level. In Movie shooting, this status display is similar except there is no flash exposure compensation or Highlight tone priority.

Press **INFO.** again in Live View shooting to add information about white balance, Picture Style, Auto Lighting Optimizer, image recording

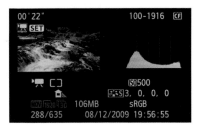

< The histogram is also available with movies.

quality, autoexposure lock ✱, flash-ready, drive mode, AF mode, AEB, flash exposure bracketing (FEB), and exposure simulation. In Movie shooting, this display is slightly different. Beneath the image recording quality is the movie recording size and the remaining recording time. The available recording time switches to elapsed time when you are recording. Also missing from this display in Movie shooting is flash-ready, AEB, and FEB, since flash cannot be used while shooting movies and bracketing is disabled.

NOTE: If there is no CF card in the camera or the card is full, the remaining recording time appears in red.

Press INFO. again to display a histogram. This histogram displays brightness or RGB, depending on the [Histogram] setting in ⵣ. When recording movies, this status screen in not available—there is no histogram.

The final screen brings up the level display. When you shoot movies, the level display disappears once recording starts. It will not return—even after recording stops—until you press INFO. again.

QUICK CONTROL SCREEN

Depending on the status screen display in Live View and Movie shooting, you may see a special Quick Control screen on the left side of the LCD. If it is not displayed, press �Q.

With Live View shooting, the Quick Control screen allows you to adjust Auto Lighting Optimizer and Image-recording quality. Use ✥ to highlight the parameter you want to change. Then use 🔆 to change the value. Note that Auto Lighting Optimizer is disabled if C.Fn II-3, [Highlight tone priority], is enabled.

> During Live View
Quick mode AF, you
still have access to AF
point selection modes.

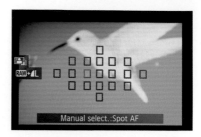

Manual select.:Spot AF

Since ⊞/Q is used to magnify the image on the LCD monitor, the Quick Control screen is also used to pick AF points when the 7D is set for AFᴏᵘᶦᶜᵏ. While in the Quick Control screen, push ⁜ to the right and the highlight will move to the AF point overlay. Use ⌂ to move the selection horizontally and ○ to move it vertically. Press the Multi-function button M-Fn to cycle through the five AF point selection modes. (See page 150 for information on AF point selection modes.)

When the 7D is in Movie shooting mode, the Quick Control screen adds one more control: The movie recording size. Use ⌂ to cycle through the four options.

CAMERA SETTINGS

While in Live View shooting, you still have access to many of the same settings that are used for non-Live View shooting, with a few exceptions. The biggest change is that metering is always evaluative ▣. Otherwise you still have access to white balance, autofocus, drive mode, ISO, flash exposure compensation, Picture Styles, and exposure compensation. Since the Quick Control screen has fewer options in Live View, a number of settings (i.e., autoexposure bracketing) are accomplished via menus.

When you shoot movies, you have access to white balance, autofocus, and exposure compensation. However, drive mode relates only to taking still images. Metering is center-weighted average ⊏⊐ and ISO can only be set when the exposure mode is set to **M**.

FOCUS DURING LIVE VIEW SHOOTING

As mentioned previously, when Live View shooting is turned on, the reflex mirror pops up, rendering the viewfinder unusable. Since the autofocus sensors are part of the viewfinder, and the mirror is blocking the viewfinder, the EOS 7D's traditional autofocus method is not immediately functional. Autofocus is accomplished either by flipping the mirror back down or by evaluating the image coming from the sensor. You choose the AF mode via the Live View function settings screen in ▣⁝ or by pressing AF·DRIVE and using ⌂. There are three autofocus options:

AF⒬ *QUICK MODE AF*

You might wonder why this is called Quick mode since it takes a bit of time to achieve focus. In reality, this is often the fastest and most accurate way to achieve focus. The method uses the same autofocus sensors that are used during non-Live View still photography. Remember that during Live View, the reflex mirror— -reflex is the "R" in SLR—is in the up position, so that light lands on the image sensor and creates an image. But because the AF sensors are located in the viewfinder, the reflex mirror must be in the down position so that the light hits the AF sensors. In other words, if you use AF⒬, the Live View image is temporarily interrupted while the camera sets focus.

When you use AF⒬, you must select an AF point selection mode, just as you would if you were not using Live View shooting; however, you use the Live View Quick Control screen. Press ⒬ to activate the Quick Control screen. Push ✛ to the right to highlight the currently selected AF point(s). Use ⌂ to move horizontally through the AF points and ○ to move vertically. Use M-Fn to change the AF point selection mode. Once you have highlighted the AF point(s) you want to use, press ⒬ or tap the shutter to exit AF point selection. The AF point(s) selected are overlaid on the LCD monitor as gray points.

The AF point selection mode and selected AF point carry over from non-Live View shooting. For example, if you have selected both **[Manual select.: Spot AF]** and the center AF point during normal shooting, the selected AF point is still the center point when you switch to Live View with AF⒬, until you change it.

> Select the AF point(s) in Live View and magnify the image in the LCD to check sharpness before shooting.
© Kevin Kopp

Once the AF point is selected, press and hold **AF-ON** to start autofocus or press the shutter release button half way. The mirror flips down, interrupting the Live View image on the LCD monitor. The camera then sets focus and confirms the focus with a beep (unless the beep was disabled in ◘˙). Once focus is set, the mirror flips back up and you can see the Live View image again. The AF point used to set focus is highlighted in red.

To check the focus, a white rectangular magnifying frame can be moved anywhere in the scene with ✥. Once in place, press ⊕ to magnify the image in that frame. Press once to magnify 5x, press again to magnify 10x, and press a third time to return to normal view. Use ✥ to scroll around the magnified image or press ✥ to reset the frame to the center of the screen.

> **NOTE:** While you can't register an AF point in Live View shooting, you can use a registered point by using **AF-ON** instead of the shutter release button to start focus. (See page 154 to learn more about registered AF points.)

Once focus has been set, press the shutter to take the picture. It is critical that you make sure the 7D has set focus before you take the picture. If you let go of the button you used to achieve focus before you take the picture, the 7D attempts focus again when you press the shutter release button.

In this mode, the EOS 7D sets focus by evaluating the image coming from the sensor. The camera uses contrast detection to examine edges in the scene, continually measuring the image while focus is adjusted. This feedback loop takes a bit longer to set focus, but it does not interrupt the Live View image.

When you use AF⬛Live, first set the Live Mode focus point. When the EOS 7D is in AF⬛Live, a white frame overlay becomes the AF point. Use ✴ to move the AF point to the area of the image you want in focus. For quicker and more accurate results, pick an area with high contrast images. You can move the AF point around more than 60% of the image with ✴. If you press ✴ straight down you can reset the AF point to the center of the screen.

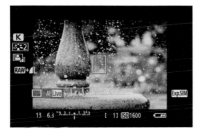

< Unlike AF Quick, which must interrupt the live image on the LCD, AF Live displays a continuous image but takes longer to set focus.

NOTE: You can tell the difference between the magnifying frame in AF⬛Quick and the AF point in AF⬛Live even though they are both white rectangular boxes. The magnifying frame is larger and has a horizontal aspect ratio. The AF point is smaller and vertical.

Once the AF point is selected, press and hold **AF·ON** or press the shutter release button halfway to start autofocus. The camera indicates that focus is achieved by beeping and turning the AF point green. If the camera fails to find focus, the AF point turns red and there is no beep. You can magnify the image using ⊕ to check the focus. Press ⊕ once to magnify 5x, twice for 10x, and a third time to return to normal view.

Once AF is set, the picture can be taken. It is critical that you make sure the 7D has set focus before you take the picture. If you let go of the button you used to achieve focus before you take the picture, the 7D attempts focus again when you press the shutter release button.

AF ⚇ *FACE DETECTION AF*

The last Live View AF mode uses face detection technology built into the DIGIC 4 chip. The EOS 7D can detect up to 35 different faces in the scene. Once detected, the camera chooses either the largest or the closest face in the scene and sets the AF point at that location.

> Face detection AF lets you easily select which face in the frame you want to focus on.

When AF ⚇ is selected, simply frame the scene and the camera detects the faces in it. A special face detection AF point ⌈ ⌉ appears over the largest or the closest face on the LCD monitor. If there are multiple faces in the scene, the face detection AF point changes to ❴ ❵. Use ✢ if you want to move the AF point to a different face. Once a face has been selected, press and hold **AF-ON** to engage the autofocus. When focus is achieved, the face detection AF point turns green and the camera beeps. If focus cannot be achieved, the AF point turns red. Once focus has been set, you can take the picture. You cannot magnify the live image to evaluate the focus.

If a face cannot be detected in the scene, the AFᴸⁱᵛᵉ point appears in the center of the screen and is used for focus. You will not be able to move this point. To temporarily leave AF ⚇ so that you can have more control of the AF point, press straight down on ✢. This toggles the AF mode to AFᴸⁱᵛᵉ. Then you can use ✢ to move the AF point. Press straight down on ✢ again to return to AF ⚇. This is a useful technique to remember if you want to quickly switch between AFᴸⁱᵛᵉ and AF ⚇.

Face detection is an impressive technology, but it is not perfect. Faces that are at an angle to the camera, that are tilted, that are too dark or too bright, and those that are too small, will be difficult to detect. Don't expect the face detection AF point to completely overlay the face

< Face detection technology helps you take sharp photos of family and friends.
© Rebecca Saltzman

all the time. Also, if the lens is way out of focus to begin with, the camera will have difficulty detecting faces. If the lens supports manual focusing (via turning the focus ring), manually set the focus while the lens is in AF mode. Once the Live View image is in better focus, the EOS 7D may detect faces.

AF in Live View only occurs near the center area of an image. If the camera detects a face near the edge of the frame, the face detection AF point turns gray. If you attempt autofocus at that time, the center Live View AF point is used instead.

TIP: For best results with any autofocus mode, get in the habit of pressing down the AF-lock button. Otherwise, pressing the shutter release button can cause the camera to refocus, possibly on the wrong area of the image.

MF *MANUAL FOCUS*

Manual focus is still a good option for Live View shooting. When you switch the manual focus switch on the lens, the camera displays a magnification frame. One of the best ways to ensure accurate focus is to use ✵ to position the frame over the area of your scene that you want in focus. Then press ⌕ to magnify the image either 5x or 10x. Use the lens' focus ring to set focus; then press ⌕ once or twice to restore the normal image size.

> **HINT:** You can center the magnification frame by pressing straight down on ✵.

FOCUS DURING MOVIE RECORDING

Since Movie shooting uses the same technology as Live View, the AF modes are the same. You can use AFQuick before you start shooting movies, but once recording starts, AFQuick is no longer accessible. Pressing **AF-ON** attempts focus using AFLive. AFLive can be used during movie shooting just like with Live View shooting: Use ✵ to move the AF point, then press and hold **AF-ON** to set focus. AF ☺ also works for recording movies the same way it does for still shooting.

Don't expect AFLive or AF ☺ to be as smooth as if you had a Hollywood-style focus puller—the person whose sole job on a movie set is to adjust lens focus when the camera moves. The EOS 7D is designed to achieve focus as quickly as possible. Since there is a feedback loop, the focus setting "hunts" a little when it gets close to the right setting. Also, the brightness level of the scene may temporarily change while focus is set.

If you are used to the autofocus of camcorders, it will take some time to adjust to the autofocus of the EOS 7D. In short, I don't recommend that you try to autofocus while the 7D is recording, unless you don't mind if the video image is disturbed (focus and exposure) while the camera sets focus. For best results, consider using manual focus when recording movies. It may be the fastest method to achieve focus. And, with a gentle touch, it can be done while recording.

> **NOTE:** The built-in microphone may pick up the sound of the focus motors in the lens when the camera adjusts focus.

ISO IN LIVE VIEW AND MOVIE SHOOTING

Live View: During Live View still shooting, the ISO speed setting operates the same way as during normal still shooting: Press ISO·🔅 and use 🔆 to select the ISO speed from the display on the LCD monitor.

> **NOTE:** When Highlight tone priority has been activated (C.Fn II-3), it is indicated by **D+** next to the ISO speed display at the bottom of the LCD monitor during Live View still shooting.

Movie Shooting: There is no direct control over the ISO setting when shooting movies, except in **M** mode. When in **M** mode, press ISO·🔅 and use 🔆 to select the ISO speed from the display on the LCD monitor. If you set ISO to Auto the 7D automatically fixes the aperture and adjusts the ISO for the best exposure while shooting.

EXPOSURE MODES IN LIVE VIEW AND MOVIE SHOOTING

Live View: When you capture stills during Live View shooting, the **P**, **Tv**, **Av**, and **M**, modes operate the same way as during non-Live View shooting. Exposure compensation is accessed using ○, as with normal shooting. Apply AEB through ◘⋮.

> **NOTE:** Exposure compensation as currently set for non-Live View shooting carries over into Live View shooting

Movie Shooting: In '🎥 the EOS 7D automatically sets ISO speed, aperture, and shutter speed in every exposure mode but **M**. The shutter speed is set in a range from 1/30 – 1/125. The exposure settings change as needed—even during recording—to maintain a good movie image. Exposure compensation is available and exposure can be locked with ✶. But if you lock exposure, it stays locked even if the scene gets darker or lighter. In that case you'll need to press ✶ to lock a new exposure. If the change is drastic you may need to press ✶ twice.

> **NOTE:** If you adjust the zoom while recording, the image may flicker as the EOS 7D adjusts the exposure.

The 7D offers manual exposure control when shooting movies in **M** mode. Just as in still shooting, use 🕸 to set shutter speed and ○ to set aperture. ISO is set using ISO·⚡. The shutter speed must be equal to or faster than the frame rate that you are using to record. For example, if the 7D is set for 1920 x 1080 at 30 frames per second, the shutter speed must be set for 1/30 of a second or faster. If you use 1280 x 720 at 60 frames per second, the shutter speed must be 1/60 or faster.

The EOS 7D displays an aperture and shutter speed when the meter is turned on in '🎥. This shows the settings that will be used if the shutter release button is pressed to take a still picture. When the camera is in shooting modes other than **M**, the display is not necessarily representative of the values that will be used for movie recording.

METERING IN LIVE VIEW AND MOVIE SHOOTING

Metering during Live View shooting is preset to ▣ because it is linked to the Live View AF point and cannot be changed. You can still use all of the exposure and drive modes, however. Adjust ISO, aperture, shutter speed, and exposure compensation just as you would when shooting normally. When you use a Speedlite external flash unit, E-TTL II metering uses the normal meter in the viewfinder, so the mirror must pop down briefly. When you take a picture with flash, the EOS 7D sounds like it is taking two pictures. Flash units other than Canon do not fire.

NOTE: If you use one of the continuous drive modes, the exposure for all of the images shot is locked to the first image captured.

Movie shooting exposure metering is automatically set for center-weighted average metering ⊏⊐. The one exception is if you use **AF ⠶**. When a face is detected, the metering is ▣, and it is linked to the face detection AF point.

< This shows where you will see the Exp. SIM icon when this feature is turned on in Live View, giving you a good idea of the image's exposure.

EXPOSURE SIMULATION INDICATOR

When exposure simulation is enabled in ▣ during Live View shooting, the Exp.SIM icon is shown at the lower right of the LCD monitor when the full status screen is displayed. If the 7D is able to simulate what the image will look like when recorded, Exp.SIM will be displayed in white.

If the 7D is not able to simulate the exposure (usually if the camera is set for an extremely overexposed shot), the icon blinks. If the camera temporarily disables exposure simulation (for example, when it is performing autofocus, when a flash is used, or when the camera is set for **B** exposure), Exp.SIM will be grayed out. If exposure simulation is disabled in ▣, ●DISP will be displayed instead.

When the 7D is shooting movies, the camera is always in exposure simulation mode. The icon displayed is ↵DISP. If the image displayed on the LCD monitor is a fair representation of what will be recorded, ↵DISP is displayed in white; otherwise it blinks.

> **NOTE:** Heat can be a problem when you use Live View and Movie shooting. Thermal build-up on and near the image sensor causes the function to shut down. This is particularly true when you shoot under hot studio lights or outdoors in direct sun. If heat becomes a problem, the temperature icon 🌡 is displayed. While you can keep shooting, image quality may suffer, so it is best to turn off Live View shooting for a while.

One EOS 7D feature that is improved with Live View shooting is Depth-of-Field Preview. Depth-of-Field Preview produces an image that is dim in the viewfinder, making it difficult to see the image. With Live View shooting, the Depth-of-Field Preview has a brighter display that allows you to better check depth of field, as long as a reasonably correct exposure is set.

There are ten things you should do to record movies successfully with your EOS 7D. These steps are important because the process of recording movies can be very different than that of shooting stills. These are just a starting point. As you get used to the camera, you'll develop your own steps.

1. Make sure you have plenty of power: If you use batteries, make sure they are charged and make sure you have spares. Running Live View and recording movies can use up battery power quickly. Better yet, use the optional AC adapter (ACK-E6).

2. Use a large UDMA CompactFlash (CF) memory card with a write speed greater than 8MB per second: For optimum performance when recording High-Definition movies, make sure that you format the card in the EOS 7D. If you shoot stills and record movies, consider using different cards for each scenario. This also helps organize files when you download to the computer.

3. Pick the movie resolution: Press ⬚, highlight the Movie-shooting size parameter on the Quick Control screen, and use ⬚ to make your choice. The options are **[1920 x 1080 30 fps]**; **[1920 x 1080 24 fps]**; **[1280 x 720 60 fps]**; or **[640 x 480 60 fps]**.

4. Enable audio recording: To reduce camera handling noise picked up by the microphone, make sure that you make all camera adjustments before you start recording, or use an external microphone.

5. Select a Picture Style: Press ⬚, use ⬚ to choose from ⬚, ⬚, ⬚, ⬚, ⬚, ⬚, or one of the three User-defined Picture Styles ⬚. Use ⬚ to make adjustments—Sharpness, Contrast, Saturation, and Color tone—to the selected Picture Style.

6. Make a white balance (WB) selection: The Live View display on the LCD monitor can help you choose the best white balance setting. To set, press ⬚·WB, use ⬚ to scroll through the white balance options: ⬚, ⬚, ⬚, ⬚, ⬚, ⬚, ⬚, ⬚, and ⬚. If in doubt, choose ⬚.

7. Choose a focus mode: Decide if you want to set focus manually or via one of the three special Live View AF modes. If you opt for an AF mode, first make sure your lens is not in manual focus mode, and then press AF•DRIVE. Use 🖾 to select the AF options: AF⬛, AF⬛, or AF ⬛.

8. Set focus: Press and hold **AF•ON** until you receive a confirmation that focus has been achieved. Depending on the AF mode you have set, this might involve momentary loss of the Live View display on the LCD monitor.

9. Adjust exposure: If you are not happy with the exposure that is automatically set in Movie shooting, use exposure compensation. Rotate ○ to set exposure compensation. For more control, use **M** shooting mode and manually set aperture with ○, shutter speed with 🖾, and ISO with ISO•⬛.

10. Make a test recording: Press ⬛ to start recording. Since you can't monitor audio from the EOS 7D's audio video out terminal while you record movies, make sure that you do a test recording. Listen to the recorded audio to make sure it sounds good and look at the movie to check exposure. Exposure can be adjusted by using ○ before and during recording.

MOVIE RECORDING QUALITY

There are four parameters that are important in any digital movie specification: resolution, frame rate, scanning type, and compression. The first two you can control; the last two cannot be changed.

Resolution: Much like still photography, digital video is captured in pixel form. Unlike stills, however, movies cannot "print" at various sizes and resolutions. Instead, movies are locked into displays that have fixed pixel counts. Rather than talking about how many megapixels a camera has, you specify exactly how many pixels there are in the horizontal and vertical direction.

The EOS 7D has three digital movie resolution options: **[1920 x 1080]**, **[1280 x 720]**, and **[640 x 480]**. **[1920 x 1080]** and **[1280 x 720]** are the two resolutions that comprise High-Definition video. **[640 x 480]** is close to the standard definition digital video specification (which is typically 720 x 486). It is typical to refer to the resolution by its vertical dimension, so the EOS 7D is considered a "1080" or "720" camera.

The EOS 7D is a true 1080 camera. Some camcorders (including high-level professional cameras costing thousands more) use pixels that are rectangular. The actual count of their pixels is 1440 x 1080, which is later stretched out to create a 1920-wide image. The EOS 7D uses square pixels.

TIP: While it is easy to print a vertical (portrait format) still image and hang it on the wall vertically, you don't see many televisions mounted on a wall vertically. Avoid shooting movies when the camera is in a vertical position.

Frame Rate: The second parameter is frame rate, the number of frames that the camera can capture per second. This should not be confused with shutter speed or maximum burst rate. In the case of the EOS 7D, the camera records 30 or 24 frames per second (fps) in 1080, and 60 fps in 720 and standard definition. 24 fps is the standard frame rate for movies and it is used in video cameras to approximate a "film look." In reality, more than just frame rate is involved in creating a film look (i.e., lighting, depth of field, and camera movement) but the 7D can produce some great film-like moving images.

NOTE: The frame rates given are rounded up. The true frame rates are 29.97, 23.976 and 59.94. These are the actual frame rates for HD video.

TIP: If you live outside of North America, the frame rates may be changed. In ♈⁺, set **[Video system]** to PAL. This changes your recording options to **[1920 x 1080 25fps]**, **[1920 x 1080 24fps]**, **[1280 x 720 50fps]**, and **[640 x 480 50fps]**.

Scanning Type: Another parameter important in movies is the scanning type. There is nothing similar to it in still cameras. In the early days of television, bandwidth was a big problem. Transmitting lines of video (think of a line of video as a row of pixels) every 1/30 second required a great deal of bandwidth. Using lots of bandwidth meant fewer television channels, so a system was devised to transmit every other line of video at 1/60 second. This "interlace" scanning scheme has been used for decades and it fit in very nicely with televisions based on CRTs (cathode ray tubes). With the advent of computers and computer displays like LCDs, the concept of interlace scanning became problematic. LCDs are more efficient if they get each line sequentially, rather than every other

line. LCDs use a type of scanning that is called progressive. The EOS 7D is a progressive scanning capture device so the High-Definition output is sometimes referred to as 1080p or 720p—"p" for "progressive." There are other movie recorders that are 1080i ("i" for "interlace").

Compression: Lastly, because movies—particularly High-Definition movies—take up a lot of space on memory cards and hard drives, they are usually compressed. Just like the JPEG compression that is used for still images, the video compression is high quality—don't think web movie compression. In video parlance, the compression is referred to as a codec, which stands for compressor/decompressor. The EOS 7D uses an MPEG4 compression scheme that is most commonly referred to as h.264. There are a variety of quality levels of h.264, from very low file size and low image quality, to large file size and high image quality. This camera uses a very high quality version of h.264 for all resolutions.

SHUTTER

When recording video, the 7D does not use the mechanical shutter that is used for taking still photos. Instead, it uses an electronic shutter on the image sensor. This type of shutter is sometimes referred to as a "rolling shutter." A rolling shutter does not capture the entire image at one time. This can lead to motion artifacts where fast-moving objects become skewed. If you move the camera quickly—for example, a rapid pan—the image can appear to wobble.

To minimize these effects, be careful with panning speed and use a faster shutter speed if it is available. It should be noted that cinematographers face similar challenges with panning speeds when shooting motion picture film at 24 fps.

AUDIO

Audio is recorded simultaneously with the video. The 7D records two digital audio channels (stereo) at a sampling rate of 44.1 kHz, which is the same rate used for audio CDs. It uses a linear PCM audio format, which is uncompressed. The audio can be recorded via the built-in microphone (located on the front of the camera above the 7D logo) or from an external audio source plugged into the external microphone jack. You can also turn off audio recording if it is not needed.

The built-in microphone is mono and picks up a lot of the camera noise, i.e., focus motors, stabilization, lens zooming, and any adjustments you make to a camera control. So, the built-in microphone isn't the answer for good audio recording. It is more for background recording, where audio isn't that important. The external microphone connection (located on the left side of the camera) is a stereo mini jack (3.5mm). It is important that a stereo plug is used; otherwise you may end up with a noisy recording or no audio at all. The microphone input supports condenser or dynamic microphones, but it does not supply power for microphones that require phantom power (+48v).

NOTE: There is an automatic audio gain control (AGC) built into the 7D. Think of AGC as "autoexposure" for audio. The AGC is used for both the on-board and external microphone inputs. It cannot be turned off.

RECORDING LENGTH

As mentioned before, a large high-speed UDMA CompactFlash card with a write speed of 8MB per second or greater should be used for recording movies.

MOVIE REC. SIZE	FILE SIZE	4GB CARD	16GB CARD
1920 x 1080	330MB/min.	12 minutes	49 minutes
1280 x 720	222MB/min.	12 minutes	49 minutes
640 x 480	165MB/min.	24 minutes	99 minutes

The maximum size for a single file is 4GB. If you have installed, say, a 16GB card, the camera will stop recording when the file size of the current recording reaches 4GB. Even though the 16GB card has a 49-minute capacity (see the chart above), those 49 minutes must be in several files. The LCD monitor displays movie recording size information and the amount of time left on the memory card. During recording, it indicates the elapsed shooting time.

If the card you are using is slow, a buffer capacity indicator appears on the LCD monitor. As the buffer fills up, waiting to write to the card, the icon indicates when the buffer is close to reaching capacity. When the memory card is full (or not present) the file recording size on the LCD appears in red.

MOVIE PLAYBACK

To access recorded movies, press ▶. Movies are indicated in the upper right corner of the LCD by 🎬SET; the movie's duration in minutes and seconds is displayed as well. Once a movie is selected via ○, press ⊛ to enter movie playback mode. A set of "VCR-style" movie controls appears at the bottom of the screen:

‹ Using the camera's controls, you can play back at normal speed, in slow motion, or frame by frame, while also being able to quickly go to the start or end of the movie.

O Play: This button is highlighted by default. Press ⊛ to begin Playback; press it again to pause Playback.

O Slow motion: Once engaged, use ○ to change the playback speed.

O First frame: Returns to first frame of the recorded movie.

O Previous frame: Highlight this button and press ⊛ to move back one frame. If you keep holding down ⊛, the rate increases until you reach "rewind" speed.

O Next frame: Operates exactly like "Previous frame" except it advances through frames rather than going backwards.

O Last frame: Moves to the last frame of the movie.

O Edit: Allows you to trim the beginning or end of the movie.

While movies are playing back, rotate 🎛 to adjust the volume of the audio coming out of the camera's speaker. The control will not affect the volume when the EOS 7D is connected to a TV. In that case, use the volume control on the TV.

MOVIE TRIMMING

While you would normally transfer your movie to a computer to edit, there is a tool built into the 7D that allows you to remove (trim) some footage at the beginning or end of the movie. To trim your movie:

> In the movie trimming screen, you can play back the movie and trim the start and end of it, saving the result as a new file or overwriting the original file.

1. Select the movie you want to edit.
2. Press ⊛ to bring up the Playback controller.
3. Highlight ✂ and press ⊛. A timeline appears at the top of the display and the trimming controls appear.
4. Use ❖ or ◯ to select whether you want **[Cut beginning]** or **[Cut end]**, and press ⊛.
5. Use ◯ to move the trimming pointer a frame at a time, or use ❖ to shuttle through the movie.
6. Press ⊛ to stop moving the pointer. If you want to trim the other end of your movie, repeat steps 4 and 5.
7. Highlight the play button and press ⊛ to preview your edit.
8. Highlight the save icon and press ⊛. You can overwrite the original movie or save it as a new file. If there is not enough room on the memory card, the only option is to overwrite the original file.

STILL CAPTURE WHILE RECORDING MOVIES

If you press the shutter release button while recording movies, you can capture an image. The image quality/size, white balance, and Picture Style will be whatever has been set on the Live View Quick Control screen. You can use any drive mode except the self-timers and the flash. (The built-in flash and external Speedlites will not fire.)

When the image is being captured, the movie records a still frame until the high resolution still image has been written to the memory card. Typically this takes about one second.

^ You can capture a high resolution still photo while recording a movie, but the camera will temporarily pause recording while it captures the still image for transfer to the memory card. The 7D will then resume recording the movie (as the same file). However, this means there will a gap in the action when you look at the movie in Playback.

© Rebecca Saltzman

Flash

Electronic flash is not just a supplement for low light; it can also be a wonderful tool for creative photography. Flash is highly controllable, its color is precise, and the results are repeatable. However, the challenge is getting the right look. Many photographers shy away from using flash because they aren't happy with the results. This is because on-camera flash can be harsh and unflattering, and taking the flash off the camera used to be a complicated procedure with less than sure results.

The Canon EOS 7D's sophisticated flash system eliminates many of these concerns and, of course, the LCD monitor gives instantaneous feedback, alleviating the guesswork. With digital, you take a picture and you know immediately whether or not the lighting is right. You can then adjust the light level higher or lower, change the angle, soften the light, color it, and more. Just think of the possibilities:

Fill Flash: Fill in harsh shadows in all sorts of conditions and use the LCD monitor to see exactly how well the fill flash works. Often, you'll want to dial down the output of an accessory flash to make sure the fill looks natural.

Off-Camera Flash: Putting a flash on a dedicated flash cord allows you to move the flash away from the camera, yet still have it work automatically. Using the LCD monitor, you can see exactly what the effects are so you can move the flash up or down, left or right, for the best light and shadows on your subject.

Close-Up Flash: This used to be a real problem, except for those willing to spend some time experimenting. Now you can see exactly what the flash does to the subject. This works fantastically well with off-camera flash, as you can "feather" the light (aim it so it doesn't hit the subject directly) to gain control over its strength and how it lights the area around the subject.

Multiple Flash Set-ups: Modern flash systems have made exposure with multiple flash units easier and more accurate. However, since the flash units are not providing continuous light, they can be hard to place so that they light the subject properly. Not anymore. With the EOS 7D, it is easy to set up the various flash units, and then take a test shot. Does it look good, or not? Make changes if you need to. In addition, certain EX-series flash units (and independent brands with the same capabilities) offer wireless exposure control with the 7D. This is a good way to learn how to master multiple-flash setups.

Colored Light: Many flash photos look better with a slight warming filter. With multiple light sources, you can attach colored filters (also called gels) to the various flashes so that different colors light different parts of the photo. (This can be a very trendy look.)

Balancing Mixed Lighting: Architectural and corporate photographers have long used flash to fill in dark areas of a scene so it looks less harsh. Now you can double-check the light balance on your subject using the LCD monitor. You can even be sure the added light is the right color by attaching filters to these units to mimic or match lights (such as a green filter to match fluorescents).

FLASH SYNCHRONIZATION

The EOS 7D is equipped with an electromagnetically timed, vertically traveling focal-plane shutter that exposes the sensor. The shutter works via two "curtains." The first curtain opens at the start of the exposure. The second curtain closes at the end of the exposure. With shorter shutter speeds (those shorter than the camera's "flash sync" rating) the second curtain starts to close before the first curtain has finished

opening. This means that the entire surface of the image sensor is never completely exposed by the flash.

When using a flash to illuminate the scene, the extremely short duration of the flash only reaches the sensor when it is entirely exposed. The fastest shutter speed where the entire image sensor is exposed at once—when the second curtain doesn't start closing until the first curtain is completely open—is called the maximum flash sync speed.

The EOS 7D's maximum flash sync speed is 1/250 second. If you use a flash and set the exposure to a speed faster than that in **Tv** or **M** mode, the camera automatically resets the speed to 1/250. In **Av**, the 7D won't let you go above 1/250. Instead, the shutter speed flashes 1/250 if the aperture setting will cause overexposure.

⚡ʜ *HIGH-SPEED SYNC*

If you want to use flash beyond the maximum sync speed, you can use Canon EX-series flash units that allow flash at all shutter speeds up to 1/8000. This mode is called High-speed sync—instead of one burst of flash illumination, the Speedlite emits light in several short bursts as the shutter slit moves across the sensor. High-speed synchronization must be activated on the flash unit itself or by using **[Flash control]** in the Shooting 1 menu 📷 (see page 90). It is indicated by the ⚡ʜ symbol on the flash unit's LCD panel and in the 7D's viewfinder. The 7D's built-in flash does not offer High-speed sync.

FIRST AND SECOND CURTAIN SYNC

When you use flash with longer shutter speeds mixed with ambient light, the timing of the firing of the flash can lead to unnatural effects with moving subjects. Imagine a baseball pitcher throwing a ball during a night game. The sequence for a flash picture is: first curtain opens, flash fires, shutter remains open for rest of exposure, second curtain closes. While the shutter remains open, the image sensor still records ambient light in the scene.

^ As with the example of a baseball pitcher, consider a hammer coming down on an object. When the curtain opens and the flash fires, the blur is between the hammer and the object, making it appear that the hammer is traveling up, away from the object that is to be hit (1st Curtain sync). Setting the 7D to 2nd Curtain sync will make the trail follow the hammer downward.

When you look at the picture, it will look as though the ball player is pulling the ball back towards himself. This is because the flash fires at the beginning of the exposure, "freezing" the action of his arm. Then the pitcher's arm travels forward, lit by ambient light. So the final image has a blurry trail preceding the moving arm. This is the opposite of what we are used to seeing—motion expressed as trails following a moving object.

To correct this anomaly, the 7D can be set to fire the flash just before the second curtain closes. This is called second curtain sync. It can be used with the built-in flash and external Speedlites. Use ◘˙, and select [Flash control] and press ⊛. Select either [Built-in flash func. setting] or [External flash func. setting] and press ⊛. Select [Shutter sync.] and press ⊛. Select [2ⁿᵈ curtain] and press ⊛.

NOTE: Second curtain sync is only necessary at slow shutter speeds (1/30 and below) and only when there is lighting in the scene in addition to the flash. If the 7D uses a shutter speed faster than 1/30, first curtain sync is used.

GUIDE NUMBERS

It is helpful to compare guide numbers (GN) when you shop for a flash unit because the GN is a simple way to state the power of the flash. It is computed as the product of aperture value and subject distance, and is usually included in the manufacturer's specifications for the unit. High numbers indicate more power; however, this is not a linear relationship. Guide numbers act a little like f/stops (because they are directly related to f/stops!). For example, 56 is half the power of 80, and 110 is twice the power of 80 (see the relationship with f/5.6, f/8, and f/11?).

‹ You can use flash to add a little bit of fill light to dark areas on an image. This is particularly useful with scenes with strong background lighting.

FLASH

Since distance is part of the formula, guide numbers are in feet and/ or meters. Also, guide numbers are usually based on ISO 100 (film or sensor sensitivity), but this can vary, so check the ISO speed reference (and determine whether the GN was calculated using feet or meters) when you compare different flash units. If you compare units that have zoom heads (special diffusers built into the flash units to match flash angle of view with lens in use), make sure you compare the guide numbers for similar zoom-head settings.

Built-In Flash Guide Number Chart in Feet (Meters):

ISO SPEED	100	200	400	800
APERTURE				
f/3.5	12 (3.5)	16 (5)	23 (7)	31 (9.5)
f/4	10 (3)	13 (4)	20 (6)	28 (8.5)
f/5.6	7 (2)	10 (3)	15 (4.5)	20 (6)

ISO SPEED	1600	3200	6400	12800
APERTURE				
f/3.5	46 (14)	62 (19)	89 (27)	128 (39)
f/4	39 (12)	56 (17)	79 (24)	112 (34)
f/5.6	28 (8.5)	39 (12)	56 (17)	79 (24)

To use the GN chart, set ISO and aperture on the 7D. Read the distance in feet (meters) for flash range. For example, at ISO 400 using f/4 the built-in flash is able to illuminate objects up to 20 feet (6 m) from the camera.

BUILT-IN FLASH

The EOS 7D's built-in flash pops open to a higher position than the flash on many other cameras. This reduces the chance of getting red-eye and minimizes problems with large lenses blocking the flash. The flash supports E-TTL II (an evaluative autoexposure system), covers a field of view up to a 15mm focal length, and has a guide number of 39 feet (12 m) (ISO 100). Like most built-in flashes, it is not particularly high-powered, but its advantage is that it is always available and is

useful as fill-flash to modify ambient light. This flash, as well as many Canon Speedlites, has the ability to send color temperature data to the camera's processor each time it fires. As flash light output changes due to exposure needs, the color temperature of the flash can change. By communicating color temperature information to the camera, the 7D can better maintain consistent color.

‹ The built-in flash pops up high so that it is far away from the level (or axis) of the lens. Even this small distance can help reduce red-eye.

The flash pops up automatically in low-light or backlit situations in the fully-automatic exposure modes, ▢ and Ⓒ. In Ⓒ, you can force the flash mode to always be off ⊕ or always be on ⚡ using the Quick Control screen. In **P**, **Tv**, **Av**, **M**, and **B**, you can choose to use the flash (or not) at any time. Just press the ⚡ button (located on the front of the camera, on the upper left of the lens mount housing) and the flash pops up. To turn it off, simply push the flash down.

> **NOTE:** You cannot use the built-in flash while an external flash is mounted in the hot shoe of the 7D.

The **P**, **Tv**, **Av**, **M**, and **B** exposure shooting modes do not all use the same approach with the built-in flash. In **P** mode, the flash is fully automatic, setting both an appropriate shutter speed and the aperture. In **Tv**, it can be used when you need a specific shutter speed up to the maximum sync speed. In **Av**, if you set an aperture that the flash uses for its exposure, the shutter speed controls how much of the ambient (or natural) light appears in the image. In **M**, you set the aperture to control flash exposure, then choose a shutter speed that is appropriate for the ambient light in the scene (see flash metering on the next page). Remember, you can use any shutter speed of 1/250 second and slower.

The EOS 7D uses a flash autoexposure system that measures light coming through the lens (TTL). Canon's first evaluative flash metering system was called E-TTL; the latest version used on the 7D is called E-TTL II. The system has improved algorithms and, compared to earlier technology, can better use distance information obtained from the lens to improve control over flash exposure. It is important to understand that E-TTL II is a system—it won't work unless you are using both a Canon Speedlite that supports E-TTL II and a Canon EOS camera that supports E-TTL II.

To understand the EOS 7D's flash metering, it is helpful to know how a flash works with a digital camera on automatic with evaluative metering. When you press the shutter release button, the camera causes the flash to fire a pre-flash. During the pre-flash, the camera's evaluative metering system measures the preflash and the ambient (existing) light reflected back from the subject.

After the pre-flash, the camera also measures the light level in the scene without flash illumination. Any dramatic changes in light level are given less weight in the overall exposure calculation since they are likely to come from highly reflective surfaces that may skew the reading

^ The flash metering system is very sophisticated, able to correctly expose subjects that are quite close to the camera, or much farther away. You can also control the flash output by manually setting its power level on the camera.

and cause underexposure. Also during this measurement, lens distance information is added to the exposure calculation in order to determine the location of the subject in the scene.

Once the exposure has been calculated, the shutter is triggered and the Speedlite is fired. The amount of flash that hits the subject is based on how long the flash fires; close subjects receive shorter flash bursts than more distant subjects. The E-TTL II can produce some remarkably accurate flash exposures.

NOTE: You can control the built-in flash manually by setting its specific output from full power (1/1) to 1/128 power. Press MENU, select **[Flash control]** and press ⊛. Make sure **[Flash firing]** is set to **[Enable]**, then select **[Built-in flash func. setting]** and press ⊛. Change **[Flash mode]** to **[Manual flash]**. Then use **[⬆ flash output]** to set the output power.

SETTING FLASH EXPOSURE

Flash can be confusing when you are trying to set exposure. Key concepts will help you understand how to adjust exposure when using flash. First, shutter speed has no effect on flash exposure other than determining flash sync. The flash burst only occurs for a fraction of a second. Keeping the shutter open longer won't let in any more light from the Speedlite because it has already finished lighting up the scene. Thus, shutter speed only affects exposure for ambient light in the scene.

Second, aside from controlling the Speedlite power output on the unit itself, the only way to control the amount of flash illumination is to change the aperture. If you open up the aperture, you let more flash light onto the sensor. You will also allow more ambient light in, but since the ambient light is generally at a much lower level, the change may not be as noticeable.

So remember: adjust the shutter speed to control the amount of ambient light, especially in areas not lit by flash, and adjust the aperture to control the amount of flash illumination. Try it out yourself. Photograph a scene with some ambient light. Use **M** exposure mode and adjust only the shutter speed (in both directions). What changes do you see in your image? Now repeat the exercise but only adjust the aperture.

You have no control over flash when the camera is set to ☐. This means you have no say in whether the flash is used for an exposure or how the exposure is controlled. The camera determines it all, depending on how it senses the scene's light values. When the light is dim or there is a strong backlight, the built-in flash automatically pops up and fires. In ⒸⒶ, you have a little more control because you have several flash options available—you can have the flash operate like it does in ☐, you can have the flash always fire, or you can make sure that the flash never fires (a useful setting when in a museum).

In the other shooting modes, you either pop up the built-in flash by pushing the ⚡ button, or you attach an EX Speedlite accessory flash unit and simply switch it to the ON position. The flash operates in the various shooting modes as detailed below:

P Program AE: Flash photography can be used for any photo where supplementary light is needed. All you have to do is turn on the flash unit—the camera does the rest automatically. Canon Speedlite EX flash units should be switched to E-TTL II and the ready light should be on, indicating that the flash is ready to fire. When you are ready to take your picture, you must pay attention to make sure the flash symbol ⚡ is visible in the viewfinder, indicating that the flash is charged. The EOS 7D picks a shutter speed in the range of 1/60 – 1/250 second automatically in **P** mode and also selects the correct aperture.

Tv Shutter-Priority AE: This mode is a good choice in situations when you are using flash and want to control the shutter speed, which affects how ambient light is recorded. In **Tv** mode, you set the shutter speed before or after a dedicated accessory flash is turned on. All shutter speeds between 30 – 1/250 second synchronize with the flash. With E-TTL II flash in **Tv** mode, synchronization with longer shutter speeds is a creative choice that allows you to control the ambient-light background exposure. A portrait of a person at dusk that is shot with conventional TTL flash in front of a building with its lights on would illuminate the person correctly, but would cause the background to go dark. However, using **Tv** mode, you can control the exposure of the background by changing the shutter speed. (A tripod is recommended to keep the camera stable during long exposures.)

^ When shooting with flash in combination with ambient light, the shutter speed controls the ambient light exposure while the aperture setting controls the flash exposure.

If the aperture value flashes on the LCD or in the viewfinder, the current shutter speed is forcing an aperture value beyond what the lens can produce, indicating that the flash exposure will not be adequate for the focused distance. Adjust the shutter speed until the aperture value stops blinking.

Av Aperture-Priority AE: Using this mode allows you to balance the flash with existing light and control the distance that the flash can reach. The aperture is selected by turning and watching the external flash's LCD panel until the desired range appears. The camera calculates the lighting conditions and automatically sets the correct shutter speed for the ambient light. If the shutter speed value flashes on the LCD or in the viewfinder, the camera wants to choose a shutter speed beyond the sync speed of the flash. Either set the flash for High-speed sync (see page 201) or close down the aperture.

M Manual Exposure: Using Manual gives you the greatest number of choices in modifying exposure. The photographer who prefers to adjust everything manually can determine the relationship of ambient light and electronic flash by setting both the aperture, which affects the flash

exposure range, and shutter speed. Any aperture on the lens and all shutter speeds between 30 – 1/250 second can be used. If a shutter speed above the normal flash sync speed is set, the EOS 7D switches automatically to 1/250 second to prevent partial exposure of the sensor, unless the flash is set to High-speed sync.

M mode also offers a number of creative possibilities for using flash in connection with long shutter speeds. You can use zooming effects with a smeared background and a sharply rendered main subject, or take photographs of objects in motion with a sharp "flash core" and indistinct outlines.

↯* FE (FLASH EXPOSURE) LOCK

Autoexposure lock (AE lock, see page 164) on the 7D is a useful tool for controlling exposure in difficult natural light situations. Flash exposure (FE) lock offers the same control in difficult flash situations. When either the built-in flash or an attached flash is turned on, you can lock the flash exposure by pressing the M-Fn button.

With a charged external or built-in flash active, pressing M-Fn causes the camera to emit a preflash, and the 7D calculates the exposure without taking the shot. **FEL** appears briefly in the viewfinder (replacing the shutter speed) during the pre-flash. The ↯ changes to ↯*, indicating the flash exposure has been locked. You can press M-Fn repeatedly as you change framing. If the subject is beyond the illumination of the flash, ↯ blinks.

NOTE: FE lock can also be used to reduce people's reactions to the pre-flash. They may keep their eyes open during the actual exposure for a change!

To use the FE lock, pop up the flash (or turn on an external flash unit), and then lock focus on your subject by pressing the shutter button halfway. Next, aim the center of the viewfinder at the important part of the subject and press M-Fn (↯* appears in the viewfinder). Now, reframe your composition and take the picture. FE lock produces quite accurate flash exposures.

Using the same principle, you can make the flash weaker or stronger. Instead of pointing the viewfinder at the subject to set flash exposure, point it at something light in tone or a subject closer to the camera. This causes the flash to provide less exposure. For more light, aim the

camera at something black or far away. With a little experimenting, and by reviewing the LCD monitor, you can very quickly establish appropriate flash control for particular situations.

⚡ *FLASH EXPOSURE COMPENSATION*

You can also use the EOS 7D's flash exposure compensation feature to adjust flash exposure by up to +/- three stops in 1/3-stop increments (or 1/2-stop increments if selected in C.Fn I-1). Flash exposure is accessed via ◘: First highlight **[Flash control]** and press ⓢ. Next, highlight **[Built-in flash func. setting]** for the built-in flash, or **[External flash func. setting]** for an external flash, and press ⓢ again. Finally, select **[⚹ exp. comp]** for the built-in flash or **[⚹ exp. comp]** for an external flash, and press ⓢ yet again. A flash exposure compensation scale is displayed that operates similarly to the exposure compensation scale. The viewfinder displays ⚡ to let you know flash exposure compensation is enabled.

NOTE: A quick method to access flash exposure compensation is to press ISO·⚡ and use ◯ to adjust compensation. The menu method described immediately above comes in handy when using multiple flashes.

∧ Photographing dark animals against a high contrast background is a difficult task. Using a flash extender—a third-party lens attached to the flash—can extend the distance of the flash and offer some fill light.

NOTE: If you have learned to use the Quick Control screen (see page 53), you can quickly set flash exposure compensation. With the shooting settings displayed on the LCD, press ⊡. Use ☼ to highlight the flash exposure compensation display. Then use 🗝 to adjust the setting. If you want to have a little guidance for the setting, after it is highlighted, press ☯ to bring up a more intuitive adjustment screen.

For the most control over flash, use the camera's **M** exposure setting. Set an exposure that is correct overall for the scene, and then turn on the flash. (The flash exposure is still E-TTL II automatic.) The shutter speed (as long as it is 1/250 second or slower) controls the overall light from the scene (and the total exposure). The f/stop controls the exposure by the flash. So, to a degree, you can make the overall ambient exposure of the scene lighter or darker by changing shutter speed (up to 1/250 second), with no direct effect on the flash exposure. (Note, however, that this does not work with High-speed sync.)

RED-EYE REDUCTION

In low-light conditions, when the flash is close to the axis of the lens—which is typical for built-in flashes—the flash reflects back from the retina of people's eyes because their pupils are wide. This appears as "red-eye" in the photo. You can reduce the chances of red-eye appearing by using an off-camera flash or by having the person look at a bright light before you shoot (to cause their pupils to constrict). In addition, many cameras offer a red-eye reduction feature that causes the flash to fire a burst of light before the actual exposure, resulting in contraction of the subject's pupils. Unfortunately, this may also result in less than flattering expressions from your subject.

Although the EOS 7D's flash pops up higher than most, red eye may still be a problem. The EOS 7D offers a red-eye reduction feature for flash exposures, but the feature works differently than red-eye reduction on many other cameras. The EOS 7D uses a continuous light from a lamp next to the handgrip, just below the shutter button—be careful not to block it with your fingers.

This continuous, lower power light (versus a brief bright flash) closes the subject's iris somewhat and helps your subject pose with

better expressions. Red-eye reduction is set in the ◻˙ menu under [Red-eye On/Off]. Since the lamp is lower power, it takes a little longer to do the job. The 7D provides a visual countdown in the viewfinder, where the exposure compensation scale would normally display. Once the indicator decrements to nothing and the exposure compensation scale reappears, you can take the picture. In reality, you can take the picture at any time, but you should wait for the countdown for best results.

NOTE: Don't confuse red-eye reduction with the AF-assist beam (see page 121). The AF-assist beam uses a series of brief flashes to help the 7D achieve focus. This function is turned on/off via the Custom Function menu, not the red-eye reduction setting. However, the 7D is smart enough that if the AF-assist beam is fired, it knows that the red-eye reduction lamp doesn't have to be used.

CANON SPEEDLITE EX FLASH UNITS

Canon offers a range of accessory flash units in the EOS system, called Speedlites. While Canon Speedlites don't have the power of studio strobes, they are remarkably versatile. These highly portable flash units can be mounted in the camera's hot shoe, used off-camera with a dedicated cord, or used wirelessly via Canon's wireless Speedlite system.

The EOS 7D is compatible with the EX-series of Speedlites. Units in the EX-series range in power from the Speedlite 580EX II, which has a maximum ISO 100 GN of 190 feet (58 m), to the small and compact Speedlite 220EX, which has an ISO 100 GN of 72 feet (22 m).

Speedlite EX-series flash units offer a wide range of features to expand your creativity. They are designed to work with the camera's microprocessor to take advantage of E-TTL II exposure control, extending the abilities of the EOS 7D considerably.

I strongly recommend Canon's off-camera OC-E3 shoe-mounted extension cord for your Speedlite. When you use the off-camera cord, the Speedlite can be moved away from the camera for more interesting light and shadows. You can aim light toward the side or top of a close-up subject for variations in contrast and color. If you find that your subject is overexposed, rather than dialing down the light output (which can be done on certain flash units), just aim the Speedlite a little farther away from the subject so it doesn't get hit so directly by the light.

Introduced with the EOS 1D Mark III professional camera, the 580EX II replaces the popular 580EX. This top-of-the-line flash unit offers outstanding range and features adapted to digital cameras. Improvements over the 580EX include a stronger quick-locking hot shoe connection, stronger battery door, better dust and water resistance, a shorter and quieter recycling time, and an external metering sensor. The tilt/swivel zoom head on the 580EX II covers focal lengths from 14mm to 105mm, and it swivels a full 180° in either direction. The zoom positions (which correspond to the focal lengths 24, 28, 35, 50, 70, 80, and 105mm) can be set manually or automatically (the flash reflector zooms with the lens). In addition, this flash "knows" what size sensor is used with a D-SLR and it varies its zoom accordingly. With the built-in retractable diffuser in place, the flash coverage is wide enough for a 14mm lens. It provides a high flash output with an ISO 100 GN of 190 feet (58 m) when the zoom head is positioned at 105mm. The guide number decreases as the angular coverage increases for shorter focal lengths, but is still quite high with an ISO 100 GN of 145 feet (44 m) at 50mm, or an ISO 100 GN of 103 feet (32 m) at 28mm.When used with other flashes, the 580EX II can function as either a master flash or a slave unit (see page 219).

Also new to the 580EX II is a PC terminal for use with PC cords. PC cords were the way external flashes were connected to cameras before the hot shoe was developed. The 7D does not have a PC connector, but PC terminals are still used for flash accessories like wireless remotes. For external power, a new power pack, LP-E4, has been developed for the 580EX II that is dust- and water-resistant.

The large, illuminated LCD panel on the 580EX II provides clear information on all settings: flash function, reflector position,

© Canon Inc.

working aperture, and flash range in feet or meters. The flash also includes a Select dial for easier selection of these settings. When you press the 7D's Depth-of-Field Preview button (front of camera, on lower right of the lens mount housing), a one-second burst of light is emitted.

This modeling flash allows you to judge the effect of the flash. The 580EX II also has 14 user-defined custom settings that are totally independent of the camera's Custom Functions; for more information, see the flash manual.

```
External flash func. setting
Flash mode          E–TTL II          ▮
Shutter sync.       1st curtain
FEB                 ⁻3..2..1..0..1..2⁺3
📷exp. comp.        ⁻3..2..1..0..1..2⁺3
E–TTL II            Evaluative
Zoom                Auto
INFO Clear flash settings
```

‹ The advanced menu system eases the flash set-up process. Depending on the accessory Speedlite, the only control on the unit that you need to touch is the power switch.

Although the LCD panel on the 580EX II provides a lot of information, it can be a little complicated if you try to adjust the various settings and Custom Functions when you don't use the flash every day. Canon came up with a great solution: You can use the 7D's menu system to access the 580EX II's controls. The Custom Functions appear as numeric codes on the Speedlite's LCD, but within the 7D's external flash control system, those Custom Functions have names and descriptions, just like the 7D's own Custom Functions. The same is true when you adjust other flash functions such as flash exposure mode, flash exposure compensation, shutter sync, flash exposure bracketing, and many more. You can also adjust the flash zoom head setting and wireless E-TTL II setting from the camera. With this new intelligence, it has never been easier to learn how to use Canon Speedlites to capture great images.

CANON SPEEDLITE 430EX II

Much as the 580EX II improved on the 580EX, the 430EX II, introduced in June 2008, improves on the 430EX. While the ISO 100 GN stays the same—141 feet (43 m), the recycle time has increased by 20%. It is also quieter than the 430EX and can be controlled from the 7D, just like the 580EX II. It offers E-TTL II flash control, wireless E-TTL operation, flash exposure compensation, and High-speed synchronization. It does not offer flash exposure bracketing.

The tilt/swivel zoom reflector covers focal lengths from 24mm to 105mm and swivels 180° to the left and 90° to the right. The zoom head operates automatically for focal lengths of 24, 28, 35, 50, 70, 80, and 105mm. A built-in, wide-angle pull-down reflector makes flash coverage wide enough for a 14mm lens.

An LCD panel on the rear of the unit makes adjusting settings easy, and there are six Custom Functions. Just like the 580EX II, you can control most of the settings and Custom Functions from the 7D's menus. Since the 430EX II supports wireless E-TTL, it can be used as a remote (slave) unit. A new quick-release mounting system makes it easy to securely attach the 430EX II to the 7D.

© Canon Inc.

CANON SPEEDLITE 270EX

If you are looking for a simple, small flash that fits into just about every camera bag or even your pocket, the 270EX is it. It is a compact basic flash unit that offers a lot of features despite its size. Rather than have a zoom reflector, it has a 2-step selection of 28mm and 50mm. At the 28mm setting it has an ISO 100 GN of 72 feet (22 m). At the 50mm position the ISO 100 GN is 89 feet (27 m).

Unlike its predecessor (220EX), the 270EX has a bounce feature, so the flash head can rotate to point straight up. It can also be controlled from the 7D's menu system.

© Canon Inc.

OTHER SPEEDLITES

The Speedlite 220EX is an economy alternative EX-series flash. It offers E-TTL flash and High-speed sync, but does not offer E-TTL II, wireless E-TTL flash, or bounce, and it can't be controlled by the camera's menu.

There are also two specialized flash units for close-up photography that work well with the EOS 7D. Both provide direct light on the subject.

Macro Twin Lite MT-24EX: The MT-24EX uses two small flashes affixed to a ring that attaches to the lens. These can be adjusted to different positions to alter the light and can be used at different strengths so one can be used as a main light and the other as a fill light. If both flash tubes are switched on, they produce an ISO 100 GN of 72 feet (22 m), and when used individually, the ISO 100 GN is 36 feet (11 m). The MT-24EX does an exceptional job with directional lighting in macro shooting.

Macro Ring Lite MR-14EX: Like the MT-24EX, the MR-14EX uses two small flashes affixed to a ring. It has an ISO 100 GN of 46 feet (14 m), and both flash tubes can be independently adjusted in 13 steps from 1:8 to 8:1. It is a flash that encircles the lens and provides illumination on axis with it. This results in nearly shadowless photos because the shadow falls behind the subject compared to the lens position, though there will be shadow effects along curved edges. The MR-14EX is often used to show fine detail and color in a subject, but it cannot be used for varied light and shadow effects. This flash is commonly used in medical and dental photography so that important details are not obscured by shadows.

The power pack for both of these specialized flash units fits into the hot shoe of the camera. In addition, both macro flash units offer some of the same technical features as the 580EX II, including E-TTL operation, wireless E-TTL flash, and High-speed synchronization.

NOTE. When the EOS 7D is used with older system flash units (such as the EZ series), the flash unit must be set to manual, and TTL does not function. For this reason, Canon EX Speedlite system flash units are recommended for use with the camera.

217

BOUNCE FLASH

Direct flash can often be harsh and unflattering, causing heavy shadows behind the subject or underneath features such as eyebrows and bangs. Bouncing the flash softens the light and creates a more natural-looking light effect. The Canon Speedlite 580EX II, 580EX, 430EX II, 430EX and 270EX accessory flash units feature heads that are designed to tilt so that a shoe-mounted flash can be aimed at the ceiling to produce soft, even lighting. The 580EX II also swivels 180° in both directions, so the light can be bounced off something to the side of the camera, like a wall or reflector. However, the ceiling or wall must be white or neutral gray, or it may cause an undesirable colorcast in the finished photo.

> Flash can be bounced off of a neutral ceiling or wall. In this case, a card-type accessory was attached to an external flash to create a bounce effect. Compared to direct flash, this set-up produced more diffuse light, softening the shadows that can appear beneath the eyes, nose, and chin.
© Kevin Kopp

Canon's Speedlite system allows the Speedlites to communicate with each other via light. A single main controller called the master sends out pulses of light to transmit information on light output (including ratio between multiple Speedlites) and also triggers the remote Speedlites to fire when the shutter is tripped. You can use up to three groups of Speedlite 580EX IIs, 430EX IIs, 430EXs, or the now discontinued 580EXs, 550EXs and 420EXs, for more natural lighting or emphasis. (The number of flash groups is limited to three, but the number of actual flash units is unlimited.) When set for E-TTL, the master unit and the camera control the exposure.

^ This shot was done with four Speedlites and the ST-E2 transmitter. All communication was wireless.

The 7D is the first EOS camera with a built-in flash that can perform the duties of a master controller. Previously, an EOS camera required you to attach either a 580EX II, 580EX or 550EX to control remote or slave Speedlites. Canon even has a master controller, the ST-E2, that doesn't illuminate a scene but simply controls the remote Speedlites. With the 7D, you can operate the built-in flash as a master controller and also illuminate the scene. Other master controllers are the Macro Twin Lite MT-24EX and the Macro Ring Lite MR-14EX. The 430EX II and 430EX can only be used as a remote (slave) unit.

CHANNELS

In the event that you are shooting with other Canon photographers and with multiple Speedlites, the wireless Speedlite system runs on transmission channels. There are four channels (1 – 4) to choose from, which is helpful when others around you are also shooting with flash. All of your Speedlites must be on the same channel in order to operate. Channels can be set via the control buttons on the back of each Speedlite. If you forget how to set the channels, an easy method to set up a newer Speedlite is to mount it on the 7D. Then use the 7D's menu system to set the channel.

To set the channel on the built-in flash, use ◻️. Select [Flash control] and press ⊛. Select [Built-in flash func. setting] and press ⊛. Select [Wireless func.] and press ⊛. Choose a wireless setting other than [Disable] and press ⊛. Then select [Channel] and press ⊛. Choose a channel using ◯ and press ⊛.

To set the channel on a Speedlite mounted on the hot shoe, select [Flash control] and press ⊛. Select [External flash func. setting] and press ⊛. Select [Wireless func.] and press ⊛. Select [Enable] and press ⊛. Then select [Channel] and press ⊛. Choose a channel using ◯ and press ⊛.

GROUPS

The wireless system divides the Speedlites into groups. Groups can be used to set up ratios between Speedlites. This enables you to have brighter light on one side of your subject and weaker fill light on the other. With E-TTL II, you don't have to worry about setting specific power output. The 7D's metering system handles all the calculations; you just set up how much brighter one flash group should be, compared to the other.

Groups can also be used when you want to control the power output of the Speedlites manually. By setting each Speedlite to a different group, you can dial in each one's output from the camera, rather than from each unit. This makes it easy to take a quick shot, evaluate the exposure, make adjustments from the back of the camera, and quickly make another shot.

Configure external Speedlites in up to three groups, labeled A, B and C. The built-in flash, or an external Speedlite connected to the hot shoe, is always in group A. When you first start to use wireless

Speedlites (particularly when using ratios) it is helpful to consider group A as your main light, group B as the fill, and group C as the background light.

WIRELESS E-TTL FLASH VIA BUILT-IN FLASH

Since the built-in flash on the 7D can act as a master controller, it has some special groupings. To change the function, use ◌', [Flash control], and press ⊕. Make sure [Flash firing] is set to [Enable]. Choose [Built-in flash func. setting] and press ⊕. Set [Flash mode] to [E-TTL II]. Using [Wireless func.] you can then choose between [Disable] and three wireless functions.

NOTE: You must manually pop up the built-in flash. Also, if you want the 7D to control the remote flashes via E-TTL II, make sure that each remote flash is set to E-TTL and not to Manual or Multi.

ᵃ🔦:ᵃ📸 (Built-in and Single-Group Mode): This wireless function sets up a ratio between any external Speedlite (ᵃ🔦) and the built-in flash (📸). In this case there are no additional groups, so any slave Speedlite will be controlled no matter what "group" the slave is set for. For example, if you are using two 580EX II Speedlites, and one is set for slave group A and the other is set for group B, the two flashes will be controlled as one group.

In this mode you can control the ratio of light via the [ᵃ🔦:📸] selection. The ratio can be from 8:1 to 1:1, with the external group always being the left number. This represents a three-stop difference. Because the GN of the built-in flash is weaker than the external Speedlites, this mode is most useful when the camera is close to the subject. In addition, the [Flash exp. comp] adjustment in this menu can control the flash exposure compensation for the overall flash illumination. It is important that you press ⊕ to accept both ratio and exposure compensation settings.

ᵃ🔦 (Controller Only Mode): This mode is similar to mounting an ST-E2 to your 7D. The built-in flash simply becomes a wireless controller for the slave flashes. Although light comes from the built-in flash, it is at a level that is too low to illuminate the scene. The built-in flash is used strictly for communicating to the slave flashes. One benefit of the built-in flash vs. the ST-E2 is that the built-in flash can control three groups (A, B, and C) but the ST-E2 can only control two (A, B).

> Ratios and groups
can be adjusted from
the back of the camera
when setting up
wireless Speedlites.

```
Built-in flash func. setting

Firing group      ▸🔦(A+B+C)
                   🔦(A:B)
                   🔦(A:B C)

[INFO] Clear flash settings
[⊞] Test flash firing
```

There are three firing group options when the 7D is set to ³🔦.
🔦 (A+B+C) treats all the external Speedlites as one group. It doesn't matter
which group the individual Speedlites are set for; as long as they are set for
slave mode, they will be controlled. You can also control the flash exposure
compensation for the entire group with the [🔦 exp. comp.] selection.

With 🔦 (A:B) firing group, the built-in flash controls two groups of
slave flashes: A and B. This allows you to set up light ratios from 8:1 to
1:8 using the [A:B fire ratio]. When set to 8:1, the A group produces three
stops more light than the B group. Just like 🔦 (A+B+C), there is control of
the entire flash exposure compensation with the [🔦 exp. comp.] selection.

The third firing group, 🔦 (A:B C), adds a C group. Notice the icon
doesn't say that the C group has the same ratio setting as A and B.
The C group should be used for backgrounds or accent lights. If the C
group is used to light the main subject, the E-TTL system may cause
overexposure. The ratio between A and B is set using the same function
mentioned previously: [A:B fire ratio].

The C group is adjusted using a special control called [Grp C. exp.
comp.] which allows a +/- three-stop adjustment. The A and B groups,
together, have their own exposure compensation setting.

³🔦+³➘ (Built-in and Multi-Group Mode): This is probably the most
flexible wireless E-TTL mode. It operates similarly to ³🔦 but it also adds
the built-in flash as part of the illumination of the scene. Keep in mind
when setting ratios and flash exposure compensation, that the light
output of the built-in flash is significantly lower than an external flash.

Just like ³🔦, ³🔦+³➘ has three firing group options. 🔦 (A+B+C) ➘ treats
all the external Speedlites as one group. It doesn't matter which group the
remote slaves are set for. The built-in flash is a second group. You can
control the flash exposure compensation of the remote group with the
[🔦 exp. comp.] selection. The built-in flash is controlled by [➘ exp. comp.].

With the ☑ (A:B) ☑ firing group option, the built-in flash controls two groups of slave flashes—A and B—and is itself a third group. This allows you to set up light ratios from 8:1 to 1:8 using the [A:B fire ratio] and exposure compensation for the built-in flash. When set to 8:1 the A group produces three stops more light than the B group. Just like ☑ (A+B+C) ☑, there is control of the entire remote flash exposure compensation with the [☑ exp. comp.] selection and there is control of the built-in flash via [☑ exp. comp.].

NOTE: Do not use this mode or the next if you only have one remote Speedlite. The meter expects group B to provide illumination and won't expose properly.

The third firing group option, ☑ (A:B C) ☑, adds the C group. As before, the icon doesn't say that the C group has the same ratio setting as A and B. The C group should be used for backgrounds or accent lights. If the C group is used to light the main subject, the E-TTL system may cause overexposure. The ratio between A and B is set using the same function mentioned previously: [A:B fire ratio].

The C group is adjusted using a special control called [Grp C. exp. comp.] which allows a +/- three-stop adjustment. The A and B group (together) have their own exposure compensation setting. Lastly, the built-in flash has its own compensation [☑ exp. comp.].

While the built-in flash doesn't have the power of a 580EX II mounted on the 7D, it offers a little more flexibility, i.e., the built-in flash has its own group, but a mounted 580EX II is automatically part of group A.

WIRELESS MANUAL FLASH VIA BUILT-IN FLASH

There are times when E-TTL doesn't offer consistent performance. Sometimes you'll end up with underexposures and overexposures. Manual control of Speedlite power output can offer incredible control, particularly in situations where levels don't need to change once they have been set.

Instead of running around to each Speedlite, you control all of the units wirelessly from the 7D. To run in manual use ☐, [Flash control] and press ⊛. Make sure [Flash firing] is set to [Enable]. Choose [Built-in flash func. setting] and press ⊛. Change [Flash mode] to [Manual flash]. The [Wireless func.] now offers [Disable] and four options.

³◼: When the manual mode is set for ³◼, all of the remote slaves are adjusted to the same manual output setting, from 1/128 to 1/1 (full power). The built-in flash is only used to control the slave Speedlites. The slaves are controlled no matter what group they are set for—A, B or C. Remember that this is manual mode: you set the output level. The 7D does not control the output of the flash via any type of metering.

³◼ (A,B,C): If you want to control the remote slaves in individual groups, set **[Wireless func.]** to ³◼ (A,B,C). This gives you three groups, each individually controlled from 1/128 to 1/1 output. The built-in flash is only used to control the remote slaves and is not used to illuminate the scene.

³◼+³◣: With this setting, the built-in flash now participates in lighting the scene. Two groups are created, the remote slaves and the built-in flash. The remote slaves are set via **[◼ flash output]**, with a range of output from 1/128 power to full power (1/1). The built-in flash is adjusted by **[◣ flash output]**. Since part of the built-in flash output is being used to communicate with the remote units, the power level range is from 1/128 to 1/4.

NOTE: While the remote slaves are considered a group, you set the output value for each individual Speedlite in the group. You do not set the output value for all the Speedlites combined.

³◼ (A,B,C) ³◣: The last manual mode is ³◼ (A,B,C) ³◣. This gives you four distinct groups of Speedlite control: three remote groups and the built-in flash. The remote units are controlled by **[Group A output]**, **[Group B output]** and **[Group C]**. The built-in flash is adjusted with **[◣ flash output]**. Once again, the built-in flash power range goes from 1/128 to 1/4.

Lenses and Accessories

Clearly the EOS 7D is capable of capturing great images right out of the box. But it also belongs to an extensive family of Canon EOS-compatible equipment, including lenses, flashes, and other accessories. With this wide range of available options, you can expand the capabilities of your camera quite easily. Canon has long had an excellent reputation for its optics, and offers over 60 different lenses to choose from. Several independent manufacturers offer quality Canon-compatible lenses as well.

LENSES FOR CANON D-SLRS

The EOS 7D can use both Canon EF and EF-S lenses, ranging from wide-angle to telephoto. The lens lineup includes zoom lenses that can change focal length, and prime lenses that offer a single focal length and high performance. All of these lens types are available in focal lengths from very wide to extreme telephoto. Keep in mind, however, that standard 35mm focal lengths act differently on many D-SLRs than they did with film. This is because many digital sensors are smaller than a frame of 35mm film, so they crop the area seen by the lens, essentially creating a different format. Effectively, this makes the subject appear comparatively larger within the frame. As a result, the lens acts as if it has been multiplied by a factor of 1.6 compared to how it would look on a 35mm film camera or a full frame digital camera.

So, both the widest angle and the farthest zoom focal lengths are multiplied by the EOS 7D's 1.6x focal length conversion factor. The EF 14mm f/2.8 L lens, for example, is a super-wide lens when used with a 35mm film camera or a full-framed sensor like that found in the EOS 5D Mark II, but it offers the 35mm-format equivalent of a 22mm wide-angle lens (14 multiplied by 1.6) when attached to the EOS 7D—wide, but not super-wide. On the other hand, put a 400mm lens on the EOS 7D and you get the equivalent of a 640mm telephoto—a big boost with no change in aperture. (Be sure to use a tripod for these focal lengths!)

It is interesting to note that this is exactly the same thing that happens when one focal length is used with different sized film formats. For example, a 50mm lens is considered a mid-range focal length for 35mm, but it is a wide-angle lens for medium format cameras. The focal length of the lens doesn't really change, but the field of view that the camera captures changes. In other words, this isn't an artifact of digital photography, it's just physics!

> **NOTE:** Unless stated otherwise, I refer to the actual focal length of a lens throughout the rest of the chapter, not its 35mm equivalent.

CHOOSING LENSES

The focal length and design of a lens have a huge effect on how you photograph. The correct lens makes photography a joy; the wrong one makes you leave the camera at home. One approach for choosing a lens is to determine if you are frustrated with your current lens. Do you constantly want to see more of the scene than the lens allows? Then consider a wider-angle lens. Is the subject too small in your photos? Then look into acquiring a zoom or telephoto lens. Do you need more light-gathering ability? Maybe a fixed-focal-length (prime) lens is needed.

Certain subjects lend themselves to specific focal lengths. Wildlife and sports action are best photographed using focal lengths of 200mm or more, although nearby action can be managed with focal lengths as short as 125mm. Portraits look great when shot with focal lengths of 50-65mm. Interiors often demand wide-angle lenses, such as 12mm. Many people also like wide-angles for landscapes, but telephotos can come in handy for distant scenes. Close-ups can be shot with nearly any focal length, though skittish subjects such as butterflies or birds might need a rather long lens.

^ Telephoto lenses can be used with extenders to increase their reach, handy when you photograph subjects that are difficult to get close to.

The inherent magnification factor is great news for the photographer who needs long focal lengths for wildlife or sports. A standard 300mm lens for 35mm film now seems like a 480mm lens on the EOS 7D. It feels like you get a long focal length in a smaller lens, often with a wider maximum f/stop, and with a much lower price tag. But this news is tough for people who need wide-angles, since the width of what the digital camera sees is significantly cropped in comparison to what a 35mm camera would see using the same lens. You need lenses with shorter focal lengths to see the same field of view you may have been used to with film.

ZOOM VS. PRIME LENSES

Though you can get superb image quality from either zoom or prime lenses, there are some important differences. The biggest is maximum f/stop. Zoom lenses are rarely as fast (e.g., rarely have as big a maximum aperture) as single-focal-length (prime) lenses. A 28-200mm zoom lens, for example, might have a maximum aperture at 200mm of f/5.6, yet a prime lens might be f/4 or even f/2.8. When zoom lenses come close to a prime lens in f/stops, they are usually considerably bigger and more expensive

than the prime lens. Of course, they also offer a whole range of focal lengths, which a prime lens cannot do.

Also, the aperture is not constant with many zoom lenses as you move through focal lengths. A lens that is rated f/3.5-5.6 means that its maximum aperture will be f/3.5 at its widest-angle focal length, compared to f5.6 when at full telephoto range.

EF-SERIES LENSES

Canon EF lenses include some unique technologies. Canon pioneered the use of miniature autofocus motors in its lenses. In order to focus swiftly, the focusing elements within the lens need to move with quick precision. Canon developed the lens-based ultrasonic motor for this purpose. This technology makes the lens motor spin with ultrasonic oscillations, instead of using the conventional drive-train system (which tends to be noisy). This allows lenses to autofocus nearly instantly with no noise, and it uses less battery power than traditional systems. Canon lenses that use this motor are labeled USM. (Lower-priced Canon lenses have small motors in the lenses too, but they don't use USM technology, and can be slower and noisier.)

Canon was also a pioneer in the use of image-stabilizing technologies. IS (Image Stabilizer) lenses utilize sophisticated motors and sensors to adapt to slight movement during exposure. It's pretty amazing— the lens actually has vibration-detecting gyrostabilizers that move a special image-stabilizing lens group in response to lens movement. This dampens movement that occurs from handholding a camera and allows much slower shutter speeds to be used. IS also allows big telephoto lenses (such as the EF 500mm IS lens) to be used on tripods that are lighter than would normally be used with non-IS telephoto lenses.

The IS technology is part of many zoom lenses, and does a great job overall. However, IS zoom lenses in the mid-focal length range have tended to be slower than single-focal-length lenses. For example, compare the EF 28-135mm f/3.5-5.6 IS lens to the EF 85mm f/1.8 lens. The former has a great zoom range, but allows less light at maximum aperture. At 85mm (a good focal length for people), the EF 28-135mm is an f/4 lens, more than two stops slower than the f/1.8 single-focal-length lens, when both are shot "wide-open" (typical of low-light situations). While you could make up the two stops in "hand-holdability" due to the IS technology, that also means you must shoot two full shutter speeds slower, which can be a real problem in stopping subject movement.

EF-S SERIES LENSES

EF lenses are the standard lenses for all Canon EOS cameras. EF-S lenses are small, compact lenses designed for use on digital SLRs with smaller-type sensors—such as the Digital Rebel series, the 50D, and now the EOS 7D. EF-S lenses were introduced with the EF-S 18-55mm lens packaged with the original EOS Digital Rebel. They cannot be used with film EOS cameras, with any of the EOS-1D cameras, or with the 5D cameras because the image area for each of those cameras' sensors is larger than what EF-S lenses were designed for.

‹ The EF-S series lenses offer affordable options at many different focal lengths.
© Canon Inc.

NOTE: While these EF-S lenses are designed specifically for EOS cameras with smaller image sensors, focal length is still focal length. It is incorrect to assume that the focal length labeled on the lens has been adjusted for smaller image sensors.

Currently Canon has eight EF-S lenses; all but one are zoom lenses. The EF-S 15-85mm f/3.5-5.6 IS USM is a recent addition to the EF-S line, introduced at the same time as the 7D. It is an image-stabilized zoom in a compact package with a fairly wide angle. The EF-S 17-55 f/2.8 IS USM offers an image-stabilized zoom with a wide aperture. The EF-S 18-55mm f/3.5-5.6 IS is the kit lens that is often sold with the 7D.

For those looking for a bit more range, there is the brand-new EF-S 18-135mm f/3.5-5.6 IS, which is a popular zoom range with image stabilization. The EF-S 18-200mm f3.5-5.6 IS lens offers even more telephoto range.

The EF-S 10-22mm f/3.5-4.5 USM zoom brings an excellent wide-angle range to the EOS 7D. For macro shooting, Canon offers the EF-S 60mm f/2.8 Macro USM that focuses down to life-size magnification. On the opposite end of the lens spectrum is the EF-S 55-250mm f/4-5.6 IS, which offers a very useful telephoto range.

> **NOTE:** The EF-S series offers good value and great performance. The lenses make a great match for the 7D. Remember though, that if you see yourself stepping up to a full-frame sensor EOS camera, you will have to replace an EF-S lens—it will not work on a full-frame camera.

L-SERIES LENSES

Canon's L-series lenses use special optical technologies for high-quality lens correction, including low-dispersion glass, fluorite elements, and aspherical designs. UD (ultra-low dispersion) glass is used in telephoto lenses to minimize chromatic aberration, which occurs when the lens cannot focus all colors equally at the same point on the sensor (or on the film in a traditional camera), resulting in less sharpness and contrast. Low-dispersion glass focuses colors more equally for sharper, crisper images.

> You can identify an "L" series lens at a glance by the red color ring near the front of the lens.
> © Canon Inc.

Fluorite elements are even more effective (though more expensive) and have the corrective power of two UD lens elements. Aspherical designs are used with wide-angle and mid-focal length lenses to correct the challenges of spherical aberration in such focal lengths. Spherical aberration is a problem caused by lens elements with extreme curvature (usually found in wide-angle and wide-angle zoom lenses). Glass tends to focus light differently through different parts of such a lens, causing a slight, overall softening of the image even though the lens is focused sharply. Aspherical lenses use a special design that compensates for this optical defect.

DO-SERIES LENSES

Another Canon optical design is DO (diffractive optic). This technology significantly reduces the size and weight of a lens, and is therefore useful for big telephotos and zooms. Yet, the lens quality is unchanged. The lenses produced by Canon in this series are an EF 400mm f/4 DO IS USM pro lens that is only two-thirds the size and weight of the equivalent standard lens, and an EF 70-300mm f/4.5-5.6 DO IS USM lens that offers a great focal length range; both lenses include image stabilization.

MACRO LENSES

Canon also makes a wide variety of macro lenses for close-up photography. Macro lenses are single-focal-length, or prime, lenses optimized for high sharpness throughout their focus range, from very close (1:1 or 1:2)

magnifications to infinity. They also provide even resolution and contrast across the entire area of the image. The EF 100mm f/2.8L Macro IS USM lens was introduced at the same time as the 7D. While Canon already had a great quality 100mm macro in their lens lineup, this new lens is the first L-series macro lens, and also the first macro to offer image stabilization (IS).

‹ A macro lens offers close focusing and sharpness across the whole image. © Canon Inc.

NOTE: This new macro lens requires an adapter—the Macrolite Adapter 67—to use it with Canon's two macro Speedlites: the Macro Twin Lite MT-24EX and the Macro Ring Lite MR-14-EX.

In addition to the lens mentioned above, the full line of macro lenses ranges from 50mm to 180mm. The macro line up includes the EF 50mm f/2.5 Compact Macro, the EF-S 60mm f/2.8 Macro USM, the MP-E 65mm f/2.8 Macro 1-5x Macro Photo, the EF 100mm f/2.8 Macro USM, and the EF 180mm f/3.5L Macro USM.

TILT-SHIFT LENSES

Tilt-shift lenses are unique lenses that shift up and down or tilt toward or away from the subject. They mimic the controls of a view camera. Shift lets the photographer keep the back of the camera parallel to the scene and move the lens to get a tall subject into the composition. This keeps vertical lines vertical and is extremely valuable for architectural photographers. Tilt changes the plane of focus so that sharpness can be changed without changing the f/stop. Focus can be extended from near to far by tilting the lens toward the subject, or sharpness can be limited by tilting the lens away from the subject (which has been a trendy advertising photographic technique lately).

Canon has recently updated their tilt-shift offerings. New to the lineup is their first wide-angle tilt-shift, the TS-E 17mm f/4L. They have also enhanced their TS-E 24mm f/3.5L II model by improving optical performance with updated coatings, a wider range of tilt and shift, and new optical elements. The TS-E 45mm f/2.8 and TS-E 90mm f/2.8 complete the tilt-shift line.

> Tilt-shift lenses are highly specialized optical systems that require a good deal of practice to learn how to operate.
© Canon Inc.

INDEPENDENT LENS BRANDS

Independent lens manufacturers also make some excellent lenses that fit the EOS 7D. I've seen quite a range in capabilities from these lenses. Some include low-dispersion glass and are stunningly sharp. Others may not match the best Canon lenses, but offer features (such as focal length range or a great price) that make them worth considering. To a degree, you get what you pay for. A low-priced Canon lens probably won't be much different than a low-priced independent lens. On the other hand, the high level of engineering and construction found on a Canon L-series lens can be difficult to match.

^ A zoom lens with close-focusing capability was used to get within a foot or so of these mushrooms. © Kevin Kopp

CLOSE-UP PHOTOGRAPHY

Close-up photography is a striking and unique way to capture a scene. Most of the photographs we see on a day-to-day basis are not close-ups, making those that do make their way to our eyes all the more noticeable. But how do you create pictures with that special close-up look?

CLOSE-UP LENSES AND ACCESSORIES

It is surprising to me that many photographers think the only way to shoot close-ups is with a macro lens. There are, however, several options for close-up photography. The following are four of the most common:

Zoom Lenses with a Macro or Close-focus Feature: Most zoom lenses allow you to focus up-close without accessories, although focal-length choices may become limited when using the close-focus feature. These lenses are an easy and effective way to start shooting close-ups. Keep in mind, however, that even though these may say they have a macro setting, it is really just a close-focus setting and not a true macro lens.

Close-up Accessory Lenses: You can buy lenses, sometimes called filters, that screw onto the front of your lens to allow it to focus even closer. The advantage is that you now have the whole range of zoom focal lengths available and there are no exposure corrections. Close-up filters can do this, but the image quality is not great. More expensive achromatic accessory lenses (highly-corrected, multi-element lenses) do a superb job with close-up work, but their quality is limited by the original lens.

Extension Tubes: Extension tubes fit in between the lens and the camera body of an SLR. This allows the lens to focus much closer than it could normally do so. While extension tubes are designed to work with many of the lenses for your camera, there may be some combinations that might not have the optical performance you would expect. Read any instructions that came with the extension tube, and experiment. Also, older extension tubes won't always match some of the new lenses made specifically for digital cameras. Be aware that extension tubes cause a loss of light.

Macro Lenses: Though relatively expensive, macro lenses are designed for superb sharpness at all distances, across the entire field of view, and focus from mere inches to infinity. In addition, they are typically very sharp at all f/stops.

CLOSE-UP SHARPNESS

Sharpness is a big issue with close-ups, and this is not simply a matter of buying a well-designed macro lens. The other close-up options can also give superbly sharp images. Sharpness problems usually result from three factors: limited depth of field, incorrect focus placement, and camera movement.

The closer you get to a subject, the shallower depth of field becomes. You can stop your lens down as far as it will go for more depth of field. Because of this, it is critical to be sure focus is placed correctly on the subject. If the back of an insect is sharp but its eyes aren't, the photo appears to have a focus problem. At these close distances, every detail counts. If only half of the flower petals are in focus, the overall photo does not look sharp. Using autofocus up close can also cause a real problem with critical focus placement because the camera often focuses on the wrong part of the photo.

^ It was easy to determine the point of critical focus for this close-up picture: The blueberry, of course. But it is not always so easy to get your entire subject sharp when you are shooting very close. © Kevin Kopp

Of course, you can review your photo on the LCD monitor to be sure the focus is correct before leaving your subject. You can also try manual focus. One technique is to focus the lens at a reasonable distance, then move the camera toward and away from the subject as you watch it go in and out of focus. This can really help, but still, you may find that taking multiple photos is the best way to guarantee proper focus at these close distances. Another good technique is to shoot using 🖵 drive mode and fire multiple photos. You may find at least one shot with the critical part of your subject in focus. This is a great technique when you are handholding and when you want to capture moving subjects.

When you are focusing close, even slight movement can shift the camera dramatically in relationship to the subject. The way to help correct this is to use a high shutter speed or put the camera on a tripod. Two advantages to using a digital camera during close-up work are the ability to check the image to see if you are having camera movement problems, and the ability to change ISO settings from picture to picture (enabling a faster shutter speed if you deem it necessary).

CLOSE-UP CONTRAST

The best looking close-up images are often ones that allow the subject to contrast with its background, making it stand out, and adding some drama to the photo. Although maximizing contrast is important in any photograph where you want to emphasize the subject, it is particularly critical for close-up subjects where a slight movement of the camera can totally change the background. There are three important contrast options to keep in mind:

Tonal or Brightness Contrasts: Look for a background that is darker or lighter than your close-up subject. This may mean a small adjustment in camera position. Backlight is excellent for this since it offers bright edges on your subject with lots of dark shadows behind it.

∧ Colors, size, or degrees of relative focus can create contrast as well as bright versus light tones. Here the backlit sky contrasts with the dark green leaves, but there are also layers of leaves that create contrasting patterns of dark and light green.

Color Contrasts: Color contrast is a great way to make your subject stand out from the background. Flowers are popular close-up subjects and, with their bright colors, they are perfect candidates for this type of contrast. Just look for a background that is either a completely different color (such as green grass behind red flowers) or a different saturation of color (such as a bright green bug against dark green grass).

Sharpness Contrast: One of the best close-up techniques is to work with the inherent limit in depth of field and deliberately set a sharp subject against an out-of-focus background or foreground. Look at the distance between your subject and its surroundings. How close are other objects to your subject? Move to a different angle so that distractions do not conflict with the edges of your subject. Try different f/stops to change the look of an out-of-focus background or foreground.

FILTERS

Many people assume that filters aren't needed for digital photography because adjustments for color and light can be made in the computer. But by no means are filters obsolete! They actually save a substantial amount of work in the digital darkroom by allowing you to capture the desired color and tonalities for your image right from the start. Even if you can do certain things in the computer, why take the time if you can do them more efficiently while shooting?

Of course, the LCD monitor comes in handy once again. By using it, you can assist yourself in getting the best from your filters. If you aren't sure how a filter works, simply try it and see the results immediately on the monitor. This is like using a Polaroid, only better, because you need no extra gear. Just take the shot, review it, and make adjustments to the exposure or white balance to help the filter do its job. If a picture doesn't come out the way you would like, discard it and take another right away.

Attaching filters to the camera depends entirely on your lenses. Usually, a properly sized filter can either be screwed directly onto a lens or fitted into a holder that screws onto the front of the lens. There are adapters to make a given size filter fit several lenses, but the filter must cover the lens from edge to edge or it will cause dark corners in the photo (vignetting). A photographer may even hold a filter over the lens with his or her hand. There are a number of different types of filters that perform different tasks.

POLARIZING FILTERS
This important outdoor filter should be in every camera bag. Its effects cannot be duplicated with software because it actually affects the way light is perceived by the sensor.

The filter rotates in its mount, and as you move it, the strength of the effect changes. One primary use is to darken skies. This effect is greatest when used at an angle that is 90° to the sun. As you move off this angle, the effect diminishes. If your back is to the sun or you are shooting towards the direction of the sun, the polarizer will have no effect. A polarizer can also reduce glare (which often makes colors look more saturated), and remove reflections. While you can darken skies on the computer, the polarizer reduces the amount of work you have to perform in the digital darkroom.

There are two types of polarizing filters, linear and circular. While linear polarizers often have the strongest effect, they can cause problems with exposure, and often prevent the camera from autofocusing. Consequently, you are safer using a circular polarizer with the EOS 7D.

NEUTRAL DENSITY (GRAY) FILTERS

Called ND filters, this type of filter is a helpful accessory. ND filters simply reduce the light coming through the lens. They are called neutral because they do not add any color tint to the scene. They come in different strengths, each reducing different quantities of light. They give additional exposure options under bright conditions, such as a beach or snow (where a filter with a strength of 4x is often appropriate). If you like the effect when slow shutter speeds are used with moving subjects like waterfalls, a strong neutral density filter (such as 8x) usually works well, allowing you to use long shutter speeds without overexposing the image. Of course, the great advantage of the digital camera, again, is that you can see the result immediately on the LCD monitor, and modify your exposure for the best possible effect.

GRADUATED NEUTRAL DENSITY FILTERS

Many photographers consider this filter an essential tool. It is half clear and half dark (gray). It is used to reduce bright areas (such as sky) in tone, while not affecting darker areas (such as the ground). The computer can mimic its effects, but you may not be able to recreate the scene you wanted. A digital camera's sensor can only respond to a certain range of brightness at any given exposure. If a part of the scene is too bright compared to the overall exposure, detail is washed out and no amount of work in the computer will bring it back. While you could try to

capture two shots of the same scene at different exposure settings and then combine them on the computer, a graduated ND might be quicker.

UV AND SKYLIGHT FILTERS

Most people use UV or skylight filters as protection for the front of their lens. Whether or not to use a "protective" filter on your lens is a never-ending debate. A lens hood/shade usually offers more protection than a glass filter and should be used at all times, even when the sun isn't out. Still, UV or skylight filters can be useful when photographing under such conditions as strong wind, rain, blowing sand, or going through brush.

If you use a filter for lens protection, a high-quality filter is best, as a cheap filter can degrade the optical quality of the lens. Remember that the manufacturer made the lens/sensor combination with very strict tolerances. A protective filter needs to be invisible, literally, and only high-quality filters can guarantee that.

TRIPODS AND CAMERA SUPPORT

A successful approach to getting the most from a digital camera is to be aware that camera movement can affect sharpness and tonal brilliance in an image. Even slight movement during the exposure can cause the loss of fine details and the blurring of highlights. These effects are especially glaring when you compare an affected image to a photo that has no motion problems. In addition, affected images do not enlarge well.

‹ The surest way to capture a sharp, good-quality image is to use a tripod. A good tripod can last a lifetime.
© Jeff Wignall

You must minimize camera movement in order to maximize the capabilities of your lens and sensor. A steady hold on the camera is a start. Fast shutter speeds, as well as the use of flash, help to ensure sharp photos, although you can get away with slower shutter speeds when using wider-angle lenses. When shutter speeds go down, however, it is advisable to use a camera-stabilizing device. Tripods, beanbags, monopods, mini-tripods, shoulder stocks, clamps, and more, all help. Many photographers carry a small beanbag or a clamp pod with their camera equipment for those situations where the camera needs support but a tripod isn't available.

Check your local camera store for a variety of stabilizing equipment. A good tripod is an excellent investment and it will last through many different camera upgrades. When buying one, extend it all the way to see how easy it is to open, then lean on it to see how stiff it is. Both aluminum and carbon fiber tripods offer great rigidity. Carbon fiber is much lighter, but also more expensive. Another option that is in the middle in price/performance between aluminum and carbon fiber is basalt. Basalt tripods are stronger than aluminum but not quite as light as carbon fiber.

The tripod head is a very important part of the tripod and may be sold separately. There are two basic types for still photography: the ballhead and the pan-and-tilt head. Both designs are capable of solid support and both have their passionate advocates. The biggest difference between them is how you loosen the controls and adjust the camera. Try both and see which seems to work better for you. Be sure to do this with a camera on the tripod because that added weight changes how the head works. Make sure that the tripod and head you choose can properly support the weight of the 7D and all the lenses you will be using.

When shooting video, it is often necessary to pan the camera left or right, or tilt the camera up and down to follow action. Some "photo" heads allowing panning, but many may not have a panning handle that allows you to operate the head while looking at the LCD monitor. If your tripod head allows panning, it may not have the ability to tilt smoothly while recording video. Consider adding a video head to your tripod. Look for a "fluid" video head that offers smooth movement in all directions. Once again, make sure that the head is the right size for the 7D and the lenses and lens accessories that you plan to use.

Output

FROM CAMERA TO COMPUTER

Once you have captured your images and movies, you need to move them to your computer. There are two main ways of transferring digital files from the memory card. One way is to use a media card reader. Many computers have a built-in card reader where you can insert the memory card for instant download. Card readers are also available as accessories that connect to your computer. They can remain plugged in and ready to download your images or videos. The second way to transfer your images is to download them directly from the 7D using a USB interface cable (included with the camera at the time of purchase).

If you use an accessory card reader, you can connect it to your computer via a FireWire or USB port. FireWire (also called iLink or 1394) is faster than USB, but might not be standard on your computer. There are several types of USB: USB 1.0, 2.0, and 2.0 Hi-Speed. Older computers and card readers will have the 1.0 version, but new devices are most likely 2.0 Hi-Speed. This new version of USB is much faster than the old. However, if you have both versions of USB devices plugged into the same bus, the older devices will slow down the faster devices.

The advantage of downloading directly from the camera is that you don't need to buy a card reader. However, there are some distinct disadvantages. For one, cameras generally download much more slowly than card readers (given the same connections). Plus, a camera has to be unplugged from the computer after each use, while accessory card readers can be left attached. In addition to these drawbacks, downloading directly from a camera uses its battery power (and shortens battery life by using up charge cycles), or requires you to plug it into AC power.

THE CARD READER

Accessory card readers can be purchased at most camera or electronics stores. There are several different types, including single-card readers that read only one particular type of memory card, or multi-readers that are able to utilize several different kinds of cards. (The latter are important with the EOS 7D only if you have several cameras using different memory card types.)

> The 7D uses only CompactFlash memory, so make sure your card reader is compatible.
© SanDisk Corporation

NOTE: The 7D supports a special type of CompactFlash card called UDMA. This card is designed for high-speed data reading and writing. If you are going to use UDMA memory cards (as I recommend), you should use a card reader that supports UDMA if you want to take advantage of increased download speeds. A non-UDMA reader will work; it just won't be as fast.

After your card reader is connected to your computer, remove the memory card from your camera and put it into the appropriate slot in your card reader.

The card usually appears as an additional drive on your computer (on Windows and Mac operating systems—for other versions you may have to install the drivers that come with the card reader). When the computer recognizes the card, it may also give instructions for downloading. Follow these instructions if you are unsure about opening and moving the files yourself, or simply select your files and drag them to the folder or drive where you want them (a much faster approach). Make sure you "eject" the card before removing it from the reader. On Windows you right click on the drive and select eject; on a Mac, you drag the memory card icon to the trash.

Card readers can also be used with laptops, though PC card adapters may be more convenient when you're on the move. As long as your laptop has a PC card slot, all you need is a PC card adapter for CompactFlash (CF) memory cards. Insert the memory card into the PC adapter, and then insert the PC adapter into your laptop's PC card slot. Once the

computer recognizes this as a new drive, drag and drop images from the card to the hard drive. The latest PC card adapter models tend to be faster—but are also more expensive—than card readers.

ARCHIVING

Without proper care, your digital images and movies can be lost or destroyed. Many photographers back up their files with a second drive, either added to the inside of the computer or as an external USB or FireWire drive. This is a popular and somewhat cost-effective method of safeguarding your data.

^ When you go to the trouble of waiting all night to capture a nocturnal animal as she feeds, be sure you also go to the trouble of archiving your images properly.

Hard drives and memory cards do a great job of recording image files and movie clips for processing, transmitting, and sharing, but are not great for long-term storage. Hard drives are designed to spin; just sitting on a shelf can cause problems. This type of media has been known to lose data within ten years. And since drives and cards are getting progressively larger, the chance that a failure will wipe out thousands of images and movies rather than "just one roll of shots or tape" is

always increasing. Computer viruses or power surges can also wipe out files from a hard drive. Even the best drives can crash, rendering them unusable. Plus, we are all capable of accidentally erasing or saving over an important photo or movie. Consider using redundant drives for critical data backup.

For more permanent backup, burn your files to optical discs: CD or DVD (recommended). A CD-writer (or "burner") used to be the standard for the digital photographer, but image files are getting too big and high-definition movie files are just about out of the question for CDs. DVDs can handle about seven times the data that can be saved on a CD, but even standard DVDs are becoming inconvenient for larger filed sizes. Blu-ray discs (see below) may be the solution.

There are two types of DVDs (and CDs) that can be used for recording data: R-designated (i.e., DVD-R) recordable discs; and RW-designated (i.e., DVD-RW) rewritable discs. DVD-R discs can only be recorded once—they cannot be erased. DVD-RWs, on the other hand, can be recorded on, erased, and then reused later. If you want long-term storage of your images, use R discs rather than RWs. (The latter is best used for temporary storage, such as transporting images to a new location.) The storage medium used for R discs is more stable than that of RWs (which makes sense since the DVD-RWs are designed to be erasable).

As mentioned above, a new format, Blu-ray, is starting to be an option. This system uses a different colored laser (blue-violet) to read data. The use of a higher frequency light source means more data can be written to the disc. A single-layer Blu-ray disc can hold about 25GB of data, which is more than five times as much data as a single-layer DVD. A dual-layer Blu-ray disc can hold 50GB. This technology is quite new, however, so be aware that there may be some growing pains. As with DVDs and CDs, there are write-once (BD-R) and erasable (BD-RE) discs. Stick to BD-R for archive reliability. Blu-ray discs require a Blu-ray writer.

Optical discs take the place of negatives in the digital world. Set up a DVD binder for your digital "negatives." You may want to keep your original and edited images on separate discs (or separate folders on the same disc).

As previously mentioned, stay away from optical media that is rewriteable like DVD-RW or, for Blu-ray, BD-RE. You want the most reliable archive. At this point rewritable discs, while convenient, are

not as reliable for archiving. Also avoid any options that let you create multiple "sessions" on the disc. This feature allows you to add more data to the disc until it is full. For the highest reliability, write all of the data to the disc at once.

Buy quality media. Inexpensive discs may not preserve your image files as long as you would like them to. Read the box. Look for information about the life of the disc. Most long-lived discs are labeled as such and cost a little more. And once you have written to the disc, store and handle it properly according to manufacturer's directions.

WORKING WITH STILL IMAGES

How do you edit and file your digital photos so they are accessible and easy to use? To start, it helps to create folders specific to groups of images (i.e., Outdoors, Sports, State Fair, Furniture Displays, etc.). You can organize your folders alphabetically or by date inside a "parent" folder. The organization and processing of images is called workflow. (If you want to start a heated conversation among digital photographers, ask them about workflow!)

> **NOTE:** Even though the 7D puts both image and movie files into the same folder on the memory card, it is a good idea to divide the files by type and put them in separate folders. This will help when you use the separate image editing and video editing applications.

Be sure to edit your stills to remove extraneous shots. Unwanted files stored on your computer waste storage space on your hard drive. They also increase the time you must spend when you browse through your images, so store only the ones you intend to keep. Take a moment to review your files while the card is still in the camera. Erase the ones you don't want, and download the rest. You can also delete files once they are downloaded to the computer by using a browser program (described below).

Here's how I deal with digital still files. (Later in this chapter I cover movies.) First, I set up an image filing system. I use a folder called Digital Images. Inside Digital Images, I have folders by year, and within those, the individual shoots (you could use locations, clients, whatever works for you). This is really no different than setting up an office filing cabinet

^ Canon's Digital Photo Professional not only allows you to process CR2 files, but is also useful as a browser.

with hanging folders or envelopes to hold photos. Consider the Digital Images folder to be the file cabinet, and the individual folders inside to be the equivalent of the file cabinet's hanging folders.

Next, I use a memory card reader that shows up as a drive on my computer. Using the computer's file system, I open the memory card as a window or open folder (this is the same basic view on both Windows and Mac computers) showing the images in the appropriate folder. I then open another window or folder on the computer's hard drive and navigate to the Digital Images folder, then to the year folder. I create a new subfolder labeled to signify the photographs on the memory card, such as Place, Topic, Date.

Then, I select all the images (no movies) in the memory card folder and drag them to the new folder on my hard drive. This copies all the images onto the hard drive and into my "filing cabinet." It is actually better than using a physical filing cabinet because, for example, I can use browser software to rename all the photos in the new folder, giving information about each photo; for example, using the title DeathValleyMay10.

I also set up a group of folders in a separate "filing cabinet" (a new folder at the level of Digital Images) for edited photos. In this second filing cabinet, I include subfolders specific to types of photography, such as landscapes, close-ups, people, etc. Within these subfolders, I can break down categories even further when that helps to organize my photos. Inside the subfolders I place copies of original images that I have examined and decided are definite keepers, both unprocessed (direct from the camera) and processed images (keeping such files separate). Make sure these are copies (don't just move the files here), as it is important to keep all "original" photo files in the original folder that they went to when first downloaded.

IMAGE BROWSER PROGRAMS

Image browser programs allow you to quickly look at photos on your computer, rename them one at a time or all at once, read all major files, move photos from folder to folder, resize photos for e-mailing, create simple slideshows, and more. Some are good at image editing and some are not.

^ Adobe's Bridge is an image browser that offers good tools for image organization, and serves as a gateway to Adobe's other image-editing tools.

One of the most popular names in image editing is Adobe, and their flagship application is Adobe Photoshop. While the CS4 version of Adobe Photoshop has an improved Bridge that can help organize photos, there are currently a number of other programs that help you view and organize your images.

NOTE: As manufacturers update their applications, they may add numbers to the application name, such as Photoshop CS4, Lightroom 3, or Final Cut Pro 7. For simplicity, in the rest of this chapter I refer to the basic name, without the version number.

ACDSee is a superb program with a customizable interface and an easy-to-use keyboard method of rating images. It also has some unique characteristics, such as a calendar feature that lets you find photos by date (though the best-featured version is Windows-only). Another very good program with similar capabilities is Microsoft's Expression Media (with equal features on both Windows and Mac versions).

Apple's Aperture (only available for the Mac) uses a digital "loupe" to magnify your images while browsing. Aperture is more than just a browser—it offers full image editing too.

Check out Canon's Digital Photo Professional, included with the software that comes with the 7D. It is the only software that is able to utilize Canon's Dust Delete Data system.

Adobe's Lightroom is also an option. Although its official name is Photoshop Lightroom, I like to leave off "Photoshop" because that label can intimidate photographers. Like Aperture, Lightroom is more than just a browser. It has full image processing tools and tools for printing pictures, making slide shows, and building web pages. The concept behind Lightroom (and Aperture) is to build an application that is specifically designed for photographers, rather than a program that has a lot of tools for other uses.

There is also Adobe's light version of Photoshop, called Photoshop Elements. Calling it "light" is a misnomer because it contains a lot of the functionality of Photoshop, but is less intimidating.

All of these programs include some database functions (such as keyword searches) and many operate on both Windows and Mac platforms.

An important function of browser programs is their ability to print customized index prints. You can then give a title to each of the index prints and list additional information about the photographer, as well as the photos' file locations. The index print is a hard copy that allows easy reference (and visual searches). If you include an index print with every DVD you burn, you can quickly see what is on the DVD and find the file you need. A combination of uniquely labeled file folders on your hard drive, a browser program, and index prints, helps you maintain a fast and easy way to find and sort images.

IMAGE PROCESSING

Once the files—JPEG or RAW—are organized on your computer, you must consider image processing. Of course, you can process the 7D's JPEG files in any image-processing program. One nice thing about JPEG is that it is one of the most universally recognized formats. Any program on any computer that recognizes image files will recognize JPEG. That said, it is important to understand that the original JPEG file is more like a negative than a slide. Sure, you can use it directly, just like you could have the local mini-lab make prints from negatives. But JPEG files can be processed to get more out of them.

RAW is an important format because it increases the options for adjustment of your images. In addition, Canon's RAW file, CR2, offers abundant flexibility and control over the image. But when you shoot RAW, you have to "process" every image; otherwise it will look dull and lifeless. This changes your workflow. You might want to take advantage of the 7D's ability to shoot RAW and JPEG simultaneously; that way you can save time and work with RAW only as needed.

A big advantage to the 7D RAW file is that it captures more directly what the sensor sees. It holds more information (14 bits vs. the standard eight bits, per color) and stronger correction can be applied to it (compared to JPEG images) before artifacts appear. This can be particularly helpful when there are difficulties with exposure or color balance. (Keep in mind that the image file from the camera holds 14 bits of data even though it is contained in a 16-bit file. So while you can get a 16-bit TIFF file from the RAW file, it is based on 14 bits of data.)

While RAW files offer more capacity for change, you can still do a lot with a JPEG file to optimize it for use. I shoot using JPEG format quite often when it fits my workflow, and no one complains about the quality of my images.

^ 7D RAW files contain an enormous amount of data and create images with outstanding tonal subtleties. They also give you much more control than JPEGs in fashioning the way you want the final image to look.

NOTE: EOS 7D RAW files are about 25MB in size so they fill memory cards quite quickly. With larger file sizes comes an increase in processing and workflow times.

Canon offers two ways to convert CR2 files to standard files that can be optimized in an image editor like Photoshop: a file viewer utility (ZoomBrowser EX for Windows or ImageBrowser for Mac), and the Digital Photo Professional software. In addition, Photoshop, Lightroom, and Aperture, have built-in RAW processing. There are also dedicated RAW processing applications like Phase One's Capture One. Each application has its own RAW processing engine that interprets the images, so there is a slight difference between programs in the final result.

NOTE: If you have an older version of any of these programs, you probably need to update your software in order to open the latest version of the RAW CR2 files. Unfortunately, the older versions of some image editing applications are no longer updated to handle the 7D's new RAW files.

^ Canon includes basic image browsers for both Mac and Windows. They can be used for quick browsing through your images and can connect with Canon's Digital Photo Professional.

The File Viewer Utility: Canon's ZoomBrowser EX (Windows)/ ImageBrowser (Mac) supplied with the camera is easy to use. It is a good "browser" program that lets you view and organize RAW and JPEG files. It will convert RAW files, though it is a pretty basic program and doesn't offer some of the features available in other RAW processing software. Even so, it does a very good job of translating details from the RAW file into TIFF, PICT, BMP or JPEG form. Once converted, any image-processing program can read the new TIFF or JPEG. TIFF is the preferred file format because it is uncompressed; JPEG should only be used if you have file space limitations. You can also use the software to create an image suitable for email, to print images, and even to present a quick slide show of selected images.

Digital Photo Professional Software: This is Canon's advanced proprietary program for processing RAW and JPEG images. Once an optional program and now included with the 7D, Digital Photo Professional (DPP) was developed to bring Canon RAW file processing up to speed with the rest of the digital world. This program has a powerful processing engine. It can be used to process both CR2 files and

JPEG files. The advantage to processing JPEG files is that DPP is quicker and easier to use than Photoshop, yet it is still quite powerful. For fast and simple JPEG processing, DPP works quite well.

∧ Canon's Digital Photo Professional allows you to process RAW images with very precise controls and is the only way to make use of Dust Delete Data to remove dust spots on your images.

I believe if you are going to shoot RAW, DPP is a must-use program. It is fast, full-featured, and gives excellent results. One big advantage that DPP offers over any other RAW processing program is the ability to use Dust Delete Data that is embedded in the RAW file (see page 30). It can also read the aspect ratio information embedded in the image files, so it can crop images automatically.

EOS Utility: This application serves as a gateway for several operations with the 7D and accessories. First, it is used to download images (all images or just those selected) when the camera is connected via USB to the computer.

EOS Utility is also used for remote or "tethered" shooting. When you start up this feature, you can use the computer to fire the shutter, choose an exposure mode, and adjust shutter speed, aperture, ISO, white balance, metering mode, and file recording type. There is limited access to menus: you can set Picture Style, white balance, JPEG quality, and white balance shift

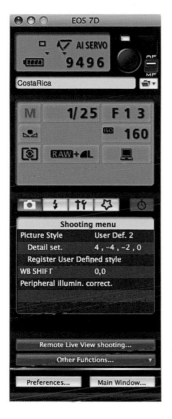

‹ The Canon EOS Utility is included with the software that comes with the 7D. It is an invaluable tool for shooting "tethered." It is also useful for setting up My Menu, copyright, and owner information.

in the Shooting menu displayed on the computer. In the Setup menu on the computer, you can give the camera copyright information, change the date and time, enable Live View, and update the firmware.

Access to the My Menu setup while tethered is a fast way to set up your My Menu. Even if you never shoot tethered, consider hooking up the camera to set up the My Menu. Instead of scrolling through seemingly endless options on the 7D's small LCD monitor, use the remote camera control to point and click your way through choices using your computer's much larger display.

While tethered, you can turn on Live View shooting for a powerful studio-style, image-preview shooting setup. An instant histogram and the ability to check focus are helpful during tethered Live View. You have the choice of capturing the images to the computer, or to the computer and the memory card in the 7D. As you capture each picture, it can open automatically in Digital Photo Professional or in the image editor of your choice.

EOS Utility also offers the option of timed shooting. The computer acts as an intervalometer, taking a picture every few seconds (from five seconds to 99 hours and 59 seconds). You can also do a Bulb exposure from five seconds to 99 hours and 59 seconds. In most cases, Live View shooting—timed or Bulb—will require the computer and camera to operate off AC power.

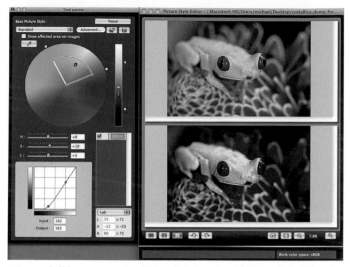

^ You can build your own custom Picture Style by using the Picture Style Editor that is supplied with the 7D. Rather than just looking at sliders and numbers, you can actually see what effect your changes will have on the image. The enhancements can be helpful if printing your photos directly from the camera.

Picture Style Editor: The Picture Style Editor lets you create your own styles. When you import a RAW image, you are able to adjust its overall tone curve much as you would in an image editor. You can also adjust the normal picture style parameters of sharpness, contrast, color saturation, and color tone.

But the Picture Style Editor's most powerful feature is the ability to change individual colors in the image. Use an eyedropper tool to pick a color and then adjust the hue, saturation, and luminance values of the color. You can pick multiple colors and also choose how wide or how narrow a range of colors (around the selected color) is adjusted. These custom picture styles can then be uploaded to the 7D using the EOS Utility. You can also download new picture styles that have been created by Canon engineers at: www.usa.canon.com/content/picturestyle/file/index.html or www.canon.co.jp/imaging/picturestyle/file/index.html.

^ Many photographers find it is both challenging and fun to print their own
pictures using an inkjet printer. © Kevin Kopp

PRINTING

If you use certain compatible Canon printers, you can control printing
directly from the 7D. Simply connect the camera to the printer using the
dedicated USB cord that comes with the 7D. Compatible Canon printers
provide access to many direct printing features, including:

O Contact sheet-style 35-image index prints
O Print date and filename
O Print shooting information
O Face brightening
O Red-eye reduction
O Print sizes (printer dependent), including 4 x 6, 5 x 7, 8.5 x 11
O Support for other paper types
O Print effects and image optimization: Natural, Vivid, B/W, Cool Tone,
 Warm Tone, Noise Reduction

NOTE: Because of the wide variety of printers, it is possible that not all the
printing features mentioned in this chapter are on your printer. For a detailed
list of options available when the 7D is connected to your Canon printer,
consult your printer's manual.

The 7D is PictBridge-compatible, meaning that it can be connected directly to PictBridge printers from several manufacturers. Nearly all new photo printers are PictBridge-compatible. (More information on PictBridge can be found at: www.canon.com/pictbridge/.)

> **NOTE:** Both RAW and JPEG files can be used for the direct printing options mentioned in this section, but movies cannot be printed.

^ You can crop and print an image without needing a computer when you use a PictBridge compatible printer.

To start the printing process, first make sure that both the camera and the printer are turned off. Connect the camera to the printer with the camera's USB cord (the connections are straightforward since the plugs only work one way). Turn on the printer first, then the camera—this lets the camera recognize the printer. Some printers may turn on automatically when the power cable is connected. Depending on the printer, the camera's direct printing features may vary.

Press Playback ▶. The camera will display a print screen with ⚐ in the upper left of the LCD, if it is successfully connected to the printer. Use ◯ to select an image on the LCD monitor that you want to print. Press ⊕ and the **[Print setting]** screen appears, listing such printing choices as

image optimization, whether to imprint the date, the number of copies, trimming area, and paper settings (size, type, borders, or borderless).

Trimming is a great choice because it allows you to crop your photo right in the LCD monitor before printing, tightening up the composition if needed. To trim, first use ○ or ✛ to select **[Trimming]** and press ⊛. Use ⊕ and ⊞·⊖ to adjust the size of the crop; use ✛ to adjust the position of the crop. Use INFO. to rotate the crop 90 degrees and ○ to rotate the image within the crop. Press ⊛ to accept the crop setting.

> **NOTE:** Depending on the printer, trimming and date imprinting may not be available.

Depending on your printer, you can also adjust print effects to print images in black and white—in a neutral tone, cool tone, or warm tone. Other effects include noise reduction, face brightening, and red-eye correction. You can also choose to use a natural or vivid color setting. Some printers may not support all effects.

Continue using ○ or ✛ to select other settings. These choices may change, depending on the printer; refer to the printer's manual if necessary.

Once you have selected the options you want, then use ○ or ✛ to select **[Print]** and press ⊛ to start printing. The LCD monitor confirms that the image is being printed and reminds you not to disconnect the cable during the printing process. Wait for that message to disappear before disconnecting the camera from the printer. If you wish to use the same settings for additional prints, use ○ to move to the next picture, then simply press ⊛ to print the next image.

> **NOTE:** The amount of control you have over the image when you print directly from the camera is limited solely by the printer. If you need more image control, print from the computer.

If you shoot a lot of images for direct printing, do some test shots and set up the 7D's Picture Styles (see pages 60 – 65) to optimize the prints before shooting the final pictures. You may even want to create a custom setting that increases sharpness and saturation just for this purpose.

DIGITAL PRINT ORDER FORMAT (DPOF)

Another of the 7D's printing features is DPOF (Digital Print Order Format) . This allows you to decide which images to print before you actually do any printing. Then, if you use a printer that recognizes DPOF, the printer automatically prints just the images you have chosen. DPOF is also a way to select images on a memory card for printing at a photo lab. After the images on your CF card are selected using DPOF, drop it off at the photo lab—assuming their equipment recognizes DPOF (ask before you leave your card)—and they will know which prints you want.

> The DPOF order screen is the pathway for selecting the images you want to print. It also allows you to select such parameters as imprinting the date on your image.

DPOF is accessible through the Playback 1 menu ▶ᴵ under [Print order]. You can choose several options: Select [Set Up] to choose [Print type] ([Standard], [Index], or [Both]), [Date] ([On] or [Off]), and [File No.] ([On] or [Off]). Once you set your print options, press MENU to return to [Print Order]. From there you have several ways to select images to print: Select [All image] [By ▬] or select images manually. To select images manually, highlight [Sel.Image], press ⊛ and then use ◌ to scroll through your images. Press ⊛ to "order" a print of the image. Rotate ◌ to increase the number of copies to print for the current image and press ⊛ to accept the quantity. If you are printing an index print, use ⊛ to select an image to include on the index print. You can also press ☒·⊖ to bring up a three-image display to select images. Use ◌ and ⊛ to go through and mark all of the images to be printed. Press MENU to return to the [Print order] screen. The total number of prints ordered appears on the screen.

NOTE: RAW and movie files cannot be selected for DPOF printing. If you shoot RAW+JPEG, then you can use DPOF. The JPEG versions of the files will be printed.

< When ordering prints via DPOF, the upper left of the LCD will show whether an image has been selected for printing and how many copies are to be printed.

If you are printing the images yourself, you may now connect the camera to the printer. Press ⊕ to start printing. Or go to the **[Print order]** screen in ⊒' and you will see a **[Print]** button. Use ✳ or ○ to highlight, and then press ⊕. Set up image optimization and paper settings, then select **[OK]** and press ⊕ to start the printing process. If you are using a photofinisher for DPOF, make sure that you back up your memory card and that the photofinisher supports DPOF.

WORKING WITH MOVIES

Workflow for movies is different from that used for still images. File sizes can be extremely large—often gigabytes instead of megabytes—and some editing programs work best if the files are in a certain place. Generally, movie clips need to be edited together, as opposed to an image that may stand alone as a single photograph. In other words, video clips are often "program" based; a single clip won't have the impact that a single photograph does. In addition, video may be scripted or storyboarded.

When you play back a movie, you will see VCR-style controls at the bottom of the LCD monitor.

You can trim the beginning and the end of the movie. A timeline at the top of the screen shows the entire movie, and pointers show the new start and end.

My workflow for video is very much project-based. It also requires a concerted effort to think about archiving even before I start editing the project. Once I have finished recording, I create a project folder on a high-speed external drive. Depending on the size of the drive, that folder might be within another folder that includes the year or the month, so I can keep projects separate. For example, I might have a structure of 2009/September/Costa_Rica/. Once the file structure is in place, I copy my footage into the new folder.

Depending on the software application I choose for video editing, I may then view each file and rename the files. If I were doing interviews, I would rename the file with the person's last name and then a take number, such as Ally01, Ally02, etc. If I use an editing application like Final Cut Pro, I might leave the file name alone and do all of the descriptive data entry in the editing program.

The nice part about changing the name at the file level is that it is more descriptive. You can search within the file system, rather than opening up an editing application. On the other hand, the advantage of changing the name in the editing program is that you can use longer names and you can include information like take number, comments, camera angle, script notes, whether a clip is good or bad, etc., in columns next to the file name (depending on your editing software).

NOTE: Once you bring the files into your editor and you start to edit, don't change the file names of the movies using the file system. The files may become unlinked from your project. Also, don't move them from the folders that they are in, as this could break the link too. Although there are ways to relink files, they don't always work.

Once I have the file names set, I copy the folder to my archive drive, or—if the folder is small enough—to an optical disc (Blu-ray). This way I have a working copy on the high-speed drive and an untouched copy for archive. When you edit video, you don't change pixels on the original files; to revise a project, all you need is the project file and the original movies the project is linked to.

VIEWING MOVIES

Canon's ZoomBrowser EX (Windows)/ImageBrowser (Mac), supplied with the 7D, can play back individual movie clips, trim them, and even save a still frame, but it can't edit the clips into a sequence. If you merely want to view your files, QuickTime player is a good (and free!) application. The Pro version of QuickTime lets you trim clips and even build a rough sequence, but it is not very intuitive and does not foster much creativity. For that, you need a real editing application.

> **NOTE:** If you are on the Windows platform, you may need to install QuickTime in order to view your movie clips. Download the Windows version at www.apple.com/quicktime/. For simple playback of movies, it is not necessary to buy the QuickTime Pro version or download iTunes with QuickTime. Download just the "plain" version of QuickTime.

MOVIE EDITING

There is quite an assortment of video editing applications for both Windows and Mac computer platforms, and for all budgets. On the Windows side, there are Adobe Premiere and Premiere Elements, Sony Vegas, Pinnacle Studio, and Corel VideoStudio Pro X2. For Mac users, there are Adobe Premiere, Avid's Media Composer and Xpress Pro, Media 100, and Apple's iMovie, Final Cut Express, and Final Cut Pro.

Costs for the software alone range from "included with your computer" to thousands of dollars. The less expensive options can work if you do simple cuts and dissolves and not much in the way of effects, layering, or complicated projects. The more expensive applications give you more options for the output of your finished project—compression for the web or authoring Blu-ray discs.

Manipulating HD video is very taxing on a computer. These are essentially large image files that are flying by at 30 or 60 frames per second, so you need a computer that can handle it. Bulk up on RAM and processor speed—as much as you can afford.

Several of the editing applications—Premiere and Final Cut Pro, for example—can edit natively (without having to convert to another file format) in the h.264 codec. The h.264 is a highly efficient algorithm. It reduces both file size and the data rate needed to record the movie. Unfortunately, it takes a great deal of computing power to make this happen. You may find that your computer, which worked fine running

Photoshop and editing RAW files, can struggle just to play back a single movie file without stuttering frames. Generally this is caused either by a slow disc drive or by a slow processor (CPU).

Will editing natively in the h.264 code work for you? It all depends on the application you are using, your computer's horsepower, and your tolerance for the process. Since h.264 is not really optimized as an editing format, there are several workarounds to overcome the need for the fastest computer and the most RAM. One method is to "transcode" the file to another codec. Transcoding a file means making a copy and recompressing it. If your computer is slowing down, try a codec that is uncompressed or one that is more suitable for editing (like XDCAM-HD or Apple's ProRes). Some problems with transcoding are that the color space, or dynamic range, might change; some highlights might change; detail may disappear; and/or colors might shift. Make sure you compare the transcoded file to the original. Another issue may be rendering times if you need to output back to an h.264 file. If this is the case, you should perform some test renders so you know how long it will take. You don't want to be surprised if your final project takes three hours to render, especially if it was supposed to be completed an hour ago.

Another option to reduce processor load is to edit in a low-resolution proxy mode. Proxies are to movies what thumbnails are to photos. They are low-resolution video clips. This is the technique that Corel VideoStudio Pro X2 uses. It converts the High-Definition movies to smaller movies that are easier to use during the editing process. Once the edit is complete, the software links up to the original high-definition files for output.

MOVIE OUTPUT

When you have finished editing, you'll have to output the movie. It is important to consider this process before you begin editing. When you work with still images, you have fewer output options: prints or digital files for computer display. (Of course there are others, but these two are the usual ones.) When you work with movies, it may appear there are only a few options, but they can quickly multiply.

For example, say you are asked to deliver to a web site. Once you start asking questions, you'll be surprised at the complexity. First, there is window size: most places can't take the full 1920 x 1080, or 1280 x 720, or even 640 x 480 file, and may ask for 1/2 size or 1/4 size. Then there is the file type: Do they want h.264, Windows Media (.wmv), Flash,

Quicktime? How about the file size? This is not the same as the window size. Internet delivery is highly dependent on connection bandwidth. The amount of compression you apply to a movie directly affects how much bandwidth is needed. Finally, there is frame rate. Some sites can play back a 30-frame-per-second movie; others require half that rate.

> **NOTE:** There isn't one "best" solution. Each website or host has its own requirements that, unfortunately, may constantly change. It is important that you do your research before you start shooting, so you know what you need to deliver. In fact, you may need to deliver multiple versions of the file.

If you want to deliver high definition on optical disc, there are two options. First, you can compress your finished program into a codec that is supported on Blu-ray. You then author a Blu-ray disc that can play on a set-top Blu-ray player. Many of the applications above can do this, or can tie into disc-authoring programs from the same manufacturer. Of course this requires your computer to have a Blu-ray drive that can write discs.

A second option is to create a high-definition file that you burn onto a regular DVD. You then play the DVD in an advanced DVD player that is capable of playing HD files. Although this is not a common feature on DVD players, there are some are out there that can do it. Before Blu-ray burners were available, this was one of the few ways to play back HD content in the field.

Whatever you have to deliver, the more you can control the compression, the better looking the final result will be. It is not uncommon for a file to be compressed more than one time, but you should avoid multiple steps of compression, just like when you work with image files. And remember, the large file sizes for movies means longer times to upload, download, archive, and transfer from one location to another.

Index

LCD PANEL

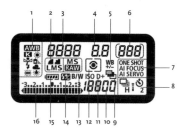

1. White Balance
2. Image-recording quality
3. Shutter speed/Busy/Built-in flash recycling
4. Aperture
5. White balance correction
6. Shots remaining on card/
 Shots remaining during WB bracketing/
 Self-timer countdown/
 Bulb exposure time
7. AF mode
8. Drive mode

9. Auto exposure bracketing
10. ISO speed
11. Highlight tone priority
12. Metering mode
13. Monochrome shooting
14. Flash exposure compensation
15. Battery check
16. Exposure level indicator/
 Exposure compensation amount/
 Flash exposure compensation amount/
 AEB range/Card writing status

QUICK CONTROL SCREEN

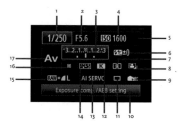

1. Shutter speed
2. Aperture
3. Exposure compensation / AEB setting
4. ISO speed
5. D+ Highlight tone priority (appears upon activation)
6. Flash exposure compensation
7. Metering mode
8. Auto Lighting Optimizer

9. Custom controls
10. Selected Quick Control screen function
11. Drive mode
12. White balance
13. AF mode
14. Picture Style
15. Image-recording quality
16. AF area selection mode
17. Shooting mode